For Kirra Hope and Emilyn Martha

Also by Mark Joseph

The Rock & Roll Rebellion

Faith, God & Rock & Roll

Wild Card: The Promise & Peril of Sarah Palin

Preface

C.S. Lewis has been a constant presence in my life. As a child I read the Narnia series and later as a teen was deeply influenced by his nonfiction works as well. As a young adult I switched to reading a wonderful book, *The Business of Heaven* which gave me a daily dose of the Oxford Don. In my life I've had the chance to meet many of the people I have admired, but sadly, was unable to meet Lewis, although I still hold out the hope of doing so one day. This book was written over the course of six years and it is my hope that it will be enjoyed by a variety of people on a variety of levels. First and foremost it is the story of how difficult it is for movies to be made, for it is true that any time a film is made it's a miracle. It's also a story of the faithfulness of two men, Philip Anschutz and Douglas Gresham and the courage it took for them to put their reputations on the line and devote their time, talent and treasures to bringing the Narnia films to life. Although I had a small role in the process, this book is written from my perspective as a cultural observer and commentator and as the reader will notice, most of the quotes are taken from the public record. It is my hope that this account will inspire future filmmakers and businesspersons to be as courageous as Anschutz and Gresham have been and aspire to do great things as they have.

Mark Joseph
November, 2010

Los Angeles, California

©2010 Bully! Pulpit Books

Requests for information can be addressed to: info@bullypulpitbooks.com

Cover Design: Yeesum Lo
Interior Design: Ronnie Gonzales and Yeesum Lo
Editorial Assistance: Yeesum Lo, Toni Burge, Ryan McDuff, Curby Gibson, Kimmy Hand, Ronnie Gonzales, Jesse Kleinjan, and Laura Kobzeff

ISBN 987-0-9827761-1-7

Printed in the United States of America

Contents

Chapter 1: A New Beginning — 1

Chapter 2: Life With Disney — 13

Chapter 3: The Captain — 29

Chapter 4: Food Fights — 39

Chapter 5: The Plan — 45

Chapter 6: Bringing Narnia To Life — 53

Chapter 7: Original Intent — 63

Chapter 8: On Location — 91

Chapter 9: Selling Narnia — 103

Chapter 10: Product Placement — 131

Chapter 11: The End Game — 141

Chapter 12: The Open & Beyond — 147

Chapter One
A New Beginning

Nursing two cups of coffee on a hot July day in 2001 at the legendary Bob's Big Boy in Burbank, California, veteran Hollywood producer Howard Kazanjian who had produced films like *Star Wars* and *Raiders Of The Lost Ark* was finishing lunch with an emissary from Walden Media, a meeting which had been set up to probe the producer and see what projects he might be interested in producing. As Kazanjian ticked off a list of films he was currently working on and planning to develop in the future, the executive dutifully took notes, then, setting aside his notepad asked Kazanjian, "What is your dream project – what's the project you want to do before you die?" "*Narnia*," replied Kazanjian, without a moment's hesitation.

He was not alone. Like millions of others around the world who adored author C.S. Lewis's seven-volume series about the adventures of four young children and a lion named Aslan, Kazanjian thought that the books would make great films and had once worked with a company which had for a time secured the rights.

Micheal Flaherty, co-founder of the recently formed film company Walden Media was not only aware of the *Narnia* series, but had been planning to make the books into films even before his venture. When he and his partner first sat down with industrialist Philip Anschutz, the man who would ultimately fund the venture, Anschutz told the pair that he had long admired the *Narnia* books and would be interested in seeing them made into films and, soon after launching

Walden, Flaherty had quietly begun a dialogue with the C.S. Lewis Estate, hoping to obtain the film rights to the fabled series.

In 2000, Flaherty had launched Walden in partnership with his Tufts University roommate, film executive Cary Granat. Granat, an industry veteran who had run Dimension Films for Bob & Harvey Weinstein had helped to develop pictures like the *Scream* series, *Scary Movie*, and *Spy Kids*, but becoming a father had changed his outlook on life and, eager to make films that could be enjoyed by families, he began to discuss a partnership with his old college roommate.

Far away from Granat's world of film premieres, Flaherty had spent years working in government, journalism and education. A stint writing for the political journal *National Review* was followed by a job as an adviser and speechwriter to Sen. Bill Bulger, where his time was spent tackling education issues.

Granat, meanwhile, had landed a job with Miramax and, according to a profile in *The New York Times*, was "given the task of turning the Dimension division into a youth-oriented, MTV-style, horror and action brand."[1]

"Harvey said: 'I'm giving you a runway to take off as often as you want. Just don't crash,'"[1] Granat recalled Dimension co-founder Harvey Weinstein saying.

"He didn't," noted the *Times*. "Working closely with Bob Weinstein, he made 'Scream' and Sequels 2 and 3, 'Scary Movie,' 'Spy Kids' and 'The Others,' all highly lucrative."[1]

Flaherty and Granat set out to find somebody to bankroll their dream of combining Granat's experience in filmmaking and Flaherty's work in education into a hybrid education and entertainment company that would tell stories to a mass audience. The duo found their backer in billionaire industrialist Philip Anschutz who was introduced to Flaherty and Granat by Howard Baldwin, a sports entrepreneur and professional hockey team owner who, together with his wife Karen, had also dabbled in film. Anschutz had already agreed to fund Baldwin's venture, Crusader Entertainment, and before long was also bankrolling

Flaherty and Granat's as well.

Anschutz had made billions in oil, mining, and telecommunications, and at one time was the fifth wealthiest person in the world with a net worth then estimated at 18 billion dollars. Although described in media accounts as "reclusive," Anschutz was actually merely a press-shy man who hadn't granted an interview to any media outlet since 1974 when he spoke to the Colorado Historical Society. Like many smart businessmen who fund competing entities in order to produce a better product, Anschutz decided to bankroll both Baldwin's Crusader Entertainment and Flaherty and Granat's Empower Media (later renamed Walden), but gave them slightly different missions: Walden would focus on bringing educational works to the big screen, while Crusader would have a broader mandate which would include bringing sports, action and dramatic works to market. Both, however, were given strict orders to only produce family fare and Anschutz himself gave Crusader its mission statement:

> "We believe that gratuitous violence, use of drugs and smoking, sex and profanity will obscure the positive message we wish to impart and compromise the entertainment and commercial value of our projects."[1]

The statement also promised that the company would only produce "inspirational, historical, sports and adventure films that offer compelling, positive messages to our audiences.... We will make only films that are G-rated or, in some instances, PG or PG-13."[1]

The results had been mixed. Crusader's first picture *Joshua* had stumbled at the box office, but had done respectable numbers at home video – selling nearly a half a million units at retail while its second offering *Children On Their Birthdays* went straight to video. By the time Crusader's brightest hope, *Sahara*, began filming in Morocco, the company was embroiled in a lawsuit with the series' author Clive Cussler. Shortly thereafter Crusader was restructured with Baldwin leaving to

form his own company and Anschutz's entertainment attorney David Weil taking over and renaming it Bristol Bay Productions. Not long after the reorganization, the Baldwins' pride and joy, the biopic *Ray*, which profiled the legendary singer Ray Charles, did strong box office numbers and won several Academy Awards.

As for Walden Media, its mission statement noted: that it would create "films, television shows, books and interactive media that inspire, engage, enlighten and entertain. Walden believes that quality entertainment is inherently educational and can capture the audience's imagination, rekindle curiosity and demonstrate the rewards of learning."[2]

In contrast to Crusader's difficult start, Walden had come out of the gate with two winners – the deep sea documentary *Ghosts Of The Abyss* which had performed well in limited release and won critical plaudits, and the Newbery-award-winning novel *Holes*, a surprise hit that took in upwards of 62 million dollars in its theatrical run. Although the company stumbled when *Around The World In 80 Days* failed at the box office, many in the industry nonetheless applauded the company's decision-making and the smart way it had snapped up quality properties.

But no decision was applauded quite as enthusiastically as Walden's purchase of the rights to *The Chronicles of Narnia* series. Flaherty had closely monitored the property and noticed that the rights, then owned by producer Kathleen Kennedy, were set to expire in late 2001. Within days of that expiration, Walden had pounced, making a deal with Lewis's estate that would give it the right to develop the series.

"The *Narnia* collection had been under option to Kathleen Kennedy and Frank Marshall's Kennedy/Marshall Co. until late November, when the shingle allowed the option to lapse and the rights reverted back to the C.S. Lewis Co.," observed *Variety* at the time. "Kennedy Marshall had been developing the films at Paramount until 1995, when they moved their pact to Disney. They continued to develop the

film at the Mouse House. Reps for Kennedy/Marshall were unavailable for comment."[3]

Kennedy was soon talking however, barely concealing her disappointment at having worked so hard for so long only to come up short in her own attempts to bring *Narnia* to the big screen:

"Every single studio in town passed, some of them twice," she noted. "Things are all about timing and luck, and this was certainly a very good example of both: bad and bad…There hadn't been any movie made for $100 million (and) this wasn't a movie that anybody was willing to break the $100 million barrier for, either: no stars… a children's book."[3]

Nobody except for Phillip Anschutz who, thanks to *Narnia*, had finally found a project that met all of the criteria for the kinds of movies which he had set out to produce in Hollywood: it was educational, had a profound Christian subtext which would still allow it to be enjoyed by non-Christian viewers as well, would likely be rated PG, and could be enjoyed by adults and children alike.

"These books were written some 60 or 70 years ago, and over 120 million of them have sold worldwide in some 80 languages – more than either Harry Potter or Lord of the Rings," Anschutz exulted in a 2004 speech. "I acquired the rights to make films from that set of books – there are seven of them – and the first will be released next year. We feel that this is a great responsibility and are determined that the film be very good."[4]

The fact that Anschutz was known to be a churchgoing Christian made many fans of the *Narnia* series, at least those who valued its underlying message, comfortable with the product that would likely ensue. On behalf of the C.S. Lewis estate, Lewis's stepson Douglas Gresham had long wielded control over what would be the finished product of any attempt to bring the books to film. For years Gresham had managed to veto sub-standard versions of *Narnia* which at various times had been attempted. An energetic and enthusiastic man with a goatee and a rapier wit, he had often regaled interested listeners with

stories of bad versions of *Narnia* that had been contemplated along the way.

"Several years ago, a prominent Hollywood production company tried to develop a movie based on... *The Lion, the Witch and the Wardrobe*," observed film reviewer Peter T. Chattaway. "The famed children's tale had been adapted for television a few times before, but *Narnia* fans like me were still waiting with high hopes for the definitive film treatment of Lewis's story. So imagine our shock, indeed our outrage, when Lewis's step-son, Douglas Gresham, reported that the screenplay he had seen had introduced all sorts of modern, and distinctly non-Lewisian, elements to the story. Cheeseburgers had replaced Turkish delight, and the Allied Leopards of *Narnia* had formed their own trade union. That movie, thankfully, was never made; the film rights reverted to the Lewis estate, which has since permitted an entirely different company to adapt the story."[5]

On other occasions, Gresham had let fly that yet another version had had the children growing up in Southern California's San Fernando Valley, present day, and included all manner of cursing, an account repeated in Australia's *Sunday Herald Sun*:

"In the late 1990s there were rumors of a script for *The Lion, the Witch and the Wardrobe* doing the rounds in which the non-*Narnia* sections of the book were updated from wartime Britain to modern Los Angeles," the *Herald* reported. "The children are staying with the professor in order to avoid an earthquake, rather than air raids – probably better than an earlier version that had them sent away after Edmund stole a CD. Other travesties apparently included a *Narnia*n trade union and Edmund asking the White Witch not for Turkish Delight but for a cheeseburger and fries."[6]

"'Once there were four children whose names were Peter, Susan, Edmund and Lucy.' So begins the children's classic, The Lion, the Witch and the Wardrobe. But that was before Hollywood gave them a makeover to produce Pete, Janet, Ed and Loo," observed journalist John Harlow of the *London Times* in a 1995 article on one of the most

serious attempts to bring *Narnia* to the big screen. "The most famous *Narnia* chronicle is about to be made for the screen. The perils facing the quartet in the magical land may be nothing compared to their fate at the hands of politically correct Californian film moguls.....in come transatlantic drawls, fast food and modern, streetwise aggression. The changes do not stop there, with dwarfs being turned into 'non-human creatures' to avoid offending persons of restricted growth."[7]

At the time, Gresham appeared to be willing to make at least some compromises which he deemed necessary in order to get the film produced:

"It's at early stages, but I expect the film will be set in America and we shall have to lose all the prep school mannerisms and related aspects," he had observed. "The trouble is that the English are not popular around the world at the moment."[7]

"Casting has not yet begun but Janet Jackson, the pop star, has already been mooted to play the elder sister, Susan," observed Harlow. "She will be rewritten from a pliant victim, who has to be rescued from a wolf by her big brother Peter, into an urban amazon."[7]

"Instead of tartan plaid, she might wear leather," Harlow quoted an executive inside Kennedy Marshall Productions as saying. "Susan is not a very sexy name over here: Sigourney Weaver dumped it before she broke through. Janet is a favored alternative and she must be a strong, PC woman. Other characters will be made less public school, more ghetto."[7]

An executive in charge of developing the script next focused on creating an updated reason for the children having to travel to the countryside in order to avoid the original theme of their escaping from the city during wartime:

"Maybe they are fleeing a family bust-up, something very 1990's like that," the paper quoted the executive as saying. "But we would never replace swords with ray-guns, for instance. Never."[7]

Many Lewis aficionados were aghast at the liberties apparently being considered with the stories and voiced their objections:

"Making the film politically correct is the quickest way to ensure it dates and falls out of fashion," said Walter Hooper, a longtime literary consultant to the Lewis Estate. "There will be many benefits from employing the kind of special effects seen in *Terminator II*, making things like mythical beasts come to life, but must this mean that the charm and spirit of the original are lost? I fear it might."[7]

Glyn Robbins, who had overseen a touring stage production of the series was more direct: "There is updating and there is tearing apart. My heart sinks at what Hollywood may do to make it a hit."[7]

According to Harlow, writing in 1995 when it appeared that Kennedy would be making her film with Disney, it was C.S. Lewis himself who had first had an unsavory experience with the film studio. Harlow noted that Lewis "loathed" Disney, "after a proposed cartoon version of the book collapsed."[7]

Although Lewis's stepson Douglas Gresham had publicly downplayed the significance of any hostility that Lewis may have harbored toward Disney, in a book entitled *An Enduring Friendship*, author Jane Douglass recounted an exchange she had had with Lewis about the company:

"He repeated his dread of such things as radio and television apparatus and expressed his dislike of talking films," remembered Douglass. "I said I quite understood this, and that nothing would distress me more than that he should think that I had in mind anything like the Walt Disney shows; I hoped nobody had suggested the book to Mr. Disney. This seemed to relieve Mr. Lewis to such an extent that I thought perhaps Mr. Disney had been after the book, but of course I did not ask. And in his usual generous way, Mr. Lewis said, 'too bad we didn't know Walt Disney before he was spoiled, isn't it?'"[8]

In a letter written to Alfred Jenkins, Lewis once observed: "What did you think of Snow White and the (Seven) Dwarfs? I saw it at Malvern last week on that holiday...leaving out the tiresome question of whether it is suitable for children (which I don't know and don't care) I thought it almost inconceivably good and bad – I mean, I didn't know

one human being could be so good and bad. The worst thing of all was the vulgarity of the winking dove at the beginning and the next worst thing was the faces of the dwarfs. Dwarfs ought to be ugly of course, but not in that way. And the dwarfs' jazz party was pretty bad. I suppose it never occurred to the poor boob that you could give them any other kind of music. But all the terrifying bits were good, and the animals really most moving: and the use of shadows (of dwarfs and vultures) was real genius. What might not have come of it if this man had been educated – or even brought up in a decent society?"[9]

Five decades later, it would be up to Gresham to try to imagine how his stepfather would have felt about the opportunity to bring his books to the big screen and he had obviously thought through the question of how Lewis, or Jack to his friends, might have felt about the endeavor:

"I know that Jack would want to protect the integrity of each of the books, and preserve very carefully the messages that each is intended to convey," Gresham noted. "I also know that Jack was not enamored of film as a medium of communication because he felt that too little care was taken about what was being said in the movies that he had seen. Also, one of the hardest things to do is to preserve the literary integrity of a book when adapting it to either stage or film, and it is probably far more difficult with film. I think though that Jack would be amazed and fascinated with the wonderful technology that has been developed recently but perhaps less than delighted with the uses to which it has been put. I hope we address that failing to some extent with LWW (The Lion, the Witch and the Wardrobe)."[10]

Asked about the challenge of essentially serving as the sole arbiter of what Lewis would or wouldn't have wanted, Gresham conceded that the role was sometimes a bit of a challenge:

"It's rather daunting to say the least," he said. "As to how I decide; I put together all my memory and love of Jack himself and also of Warne and my mother... everything that they taught me, my understanding of and love for the book, my understanding of the ne-

cessities of the film medium and the needs of modern human society worldwide, and I pray a lot. Once all those and other factors have come together and been thoroughly examined in the light of whatever decision is to be made, I then decide what to say."[10]

Nearly a decade later, as talks with Walden Media designed to bring the series to film progressed, Gresham's emphasis was on the spiritual nature of the work and the importance of finding the right team who would be faithful to the author's intent:

"I think his view of the *Narnia* films would be the same as mine which is I pray that they would be made the way the spirit of God wants them to be made," Gresham observed of his stepfather to a group of Christian college students. "I've got Christians all over the world praying that same prayer and I hope you'll join us in that. Pray that it will be made, it will be made soon, it will be made the way the spirit of God wants it to be made, and I'm given sufficient leeway to make sure it is made that way."[11]

A firm believer in Providence, Gresham was convinced that God had not allowed the film to come to fruition earlier for a number of reasons, including technological ones:

"I think the Holy Spirit has held off allowing anyone to make this movie until now because human beings had not evolved the technology," he said. "Now if you can imagine, we can film it, so I think now is the time to film it. I hope so because I really do want to be involved in making this movie. I don't want to wait until the next generation. I want to be the person. I'd love to make this movie. I'd enjoy it."[11]

Gresham repeated the line later to an interviewer:

"I believe the true author is the Holy Spirit of God."[12]

Bob Beltz, Philip Anschutz's pastor who worked as a consultant on the series on Anschutz's behalf agreed:

"God was protecting [the books], now the approach is different," he said, noting a "tremendous commitment to keep the film faithful. . . . we view it as a sacred trust."[13]

Asked by *World Magazine* about the most explicit Christian

imagery in the book, the scene at the Stone Table, Beltz noted that it had been recreated "with exact faithfulness... what C.S. Lewis wrote appears on the screen."[13]

 After many fits and starts, Lewis's beloved *Chronicles of Narnia* was finally on its way to the multiplex.

Chapter Two
Life With Disney

Although the film rights had been obtained from the Lewis Estate by Walden Media in late 2001, negotiations between the two would drag on for many months and grow complicated when Walden dropped a bombshell: It would partner with Disney to bring the films to market. Disney was an unusual choice for a number of reasons: It was thought by some that Lewis purists who had long dreaded a possible commercial exploitation of the series and in particular had nightmares of Aslan dolls and other character goods being sold, would not look kindly on Disney as a suitable partner for their beloved series. There was also the matter of Disney's having been on the receiving end of a decade-long boycott by numerous conservative Christian groups including Focus On The Family, The American Family Association, and the Southern Baptist Convention, each of which was unhappy with the company's moves including the providing of benefits for same-sex partners, as well as Disney's alliance with the edgy production company Miramax.

The boycott was launched in 1995 by an activist named Donald Wildmon, head of the Tupelo, Mississippi-based American Family Association. A longtime fixture on the conservative Christian political scene, Wildmon and his group had long railed against the output of Hollywood but were particularly angry with Disney because it had traditionally been seen as the family-friendly studio. But that trust had been betrayed and after calling for a boycott of Disney, in literature published by the group the AFA promised to call it off only when the

company:

- Ceased promoting "Gay Days" at its theme parks.
- Halted the publication of pro-homosexual books.
- Refrained from advocating the "radical homosexual agenda" through its broadcast wings.
- Established an advisory committee, which would include Southern Baptists and other Evangelicals to provide Disney with "advice and counsel."

Wildmon's actions were buttressed when several key Christian leaders and groups joined the boycott, including, most notably, the then 16.3 million member Southern Baptist Convention which signed on in 1996 when convention delegates passed a resolution that included the following language:

> "WHEREAS, Southern Baptists and their children have for many decades enjoyed and trusted the Disney Co.'s television programming, feature-length films and theme parks which have reinforced basic American virtues and values; and

> WHEREAS, The virtues promoted by Disney have contributed to the development of a generation of Americans who have come to expect and demand high levels of moral and virtuous leadership from the Disney Co.; and

> WHEREAS, In recent years, the Disney Co. has given the appearance that the promotion of homosexuality is more important than its historic commitment to traditional family values and has taken a direction which is contrary to its previous commitment; and

> WHEREAS, In recent years, we have watched the world's

largest family entertainment company with growing disappointment as Disney Co.'s moral leadership has been eroded by a variety of corporate decisions, which have included but are not limited to:

1. Establishing of an employee policy which accepts and embraces homosexual relationships for the purpose of insurance benefits;
2. Hosting of homosexual and lesbian theme nights at its parks;
3. Choosing of a convicted child molester to direct the Disney movie *Powder* through its subsidiary Miramax Productions;
4. Publishing of a book aimed at teenage homosexuals entitled *Growing Up Gay: From Left Out to Coming Out* through its subsidiary Hyperion, connecting Disney to the promotion of the homosexual agenda;

Producing, through its subsidiary corporations, objectionable material such as the film Priest, which disparages Christian values and depicts Christian leaders as morally defective;

WHEREAS, These and other corporate decisions and actions represent a significant departure from Disney's family-values image, and a gratuitous insult to Christians and others who have long supported Disney and contributed to its corporate success.

WHEREAS, Previous efforts to communicate these concerns to the Disney Co. have been fruitless…and

WHEREAS, Boycotts are a legitimate method for communicating moral convictions;

Now, therefore,

BE IT RESOLVED, We as Southern Baptist messengers meeting in annual session on June 11-13, 1996, go on record expressing our deep disappointments for these corporate actions by the Disney Co.; and

BE IT FURTHER RESOLVED, That we affirm the employees of the Disney Co. who embrace and share our concerns; and

BE IT FURTHER RESOLVED, That we encourage Southern Baptists to give serious and prayerful reconsideration to their purchase and support of Disney products and to boycott the Disney theme parks and stores if they continue this anti-Christian and anti-family trend;

BE IT FURTHER RESOLVED, That we encourage the Christian Life Commission to monitor Disney's progress in returning to its previous philosophy of producing enriching family entertainment; and

BE IT FURTHER RESOLVED, That we encourage state Baptist papers and national Southern Baptist publications to assist in informing the Southern Baptist family of these issues; and

FINALLY, BE IT RESOLVED, That the Convention requests the Executive Committee to send a copy of this resolution to Michael Eisner, CEO of the Disney Co., and to encourage the Southern Baptist family to support this resolution with our purchasing power, letters, and influence."[1]

"Southern Baptists were speaking as much to themselves as anybody else," declared the then president of the Convention. "It was a reminder that we need to be very careful what we choose for entertainment and, for that matter, how much time we spend with entertainment, period." He further noted that there were while there were other studios "as deeply into sin as Disney," that Disney shouldered a greater responsibility because it "claims to be an organization trying to make family life in America."[2]

Focus on The Family founder James Dobson, a man heard at the time by two million daily listeners added: "Let me just say how much I appreciate Southern Baptists and what you stand for. Thank you. Thank you for taking a position against the Disney Corp."[3]

Subsequently, others, including the 1.3 million-member Assemblies of God, Prison Fellowship's Charles Colson, Concerned Women for America, and Dobson also signed on to officially boycott Disney and Disney products. Dobson and Colson in particular were vitally important to the filmgoing habits of millions of American Christians and the fact that they were both officially boycotting Disney spelled trouble for *Narnia* and any association it may have had with such a controversial company. Years later, as Disney proposed to distribute *The Chronicles of Narnia*, at least one analyst wrote that the boycott had had little effect on Disney's bottom line:

"Leaders of the religious boycott, launched with great fanfare in the 1990's, accused Disney of betraying its family-values legacy by providing health benefits to same-sex partners, allowing Gay Days at theme parks, and producing controversial movies, books and TV programming through Disney subsidiaries," noted author and journalist Mark Pinsky. "Financial analysts said the boycott had no effect on Disney's bottom line. The Disney-*Narnia* campaign appears to acknowledge implicitly that the Disney boycott has been a failure."[4]

While there was equally credible evidence to the contrary, indicating that the boycott had indeed had an effect, by 2005, many in the

Christian community were ready to call a truce and move on:

"We have still told families there are disappointing elements at Disney," noted Bob Waliszewski of Focus On The Family. "We haven't changed that disappointment in Disney. But with Eisner leaving, we're all hoping that Disney will be a better company."[4]

Waliszewski's comments were echoed by another frequent Disney critic, Bob Knight of the conservative-oriented group, Concerned Women For America:

"The departure of the prickly, anti-Christian Michael Eisner, and the advent of the *Narnia* project, might open lines that could lead to a new understanding," noted Knight. "Political realities are catching up to Disney, as well, as wiggle room disappears in the culture war, until the Southern Baptists, American Family Association, Concerned Women for America, and others actually decide to call it off."[4]

That was exactly what Richard Land of the Southern Baptist Convention had in mind when he told journalist Pinsky that his denomination might well "declare victory and move on," when the group met for their summer convention in 2005. For its part, Disney was left in the difficult position of attempting to reach out to devout Christians without appearing to pander, all the while denying that moves toward movies like *Narnia* had anything to do with boycott pressures:

"I don't think that this movie is being done as a response to earlier criticism of the company," said Disney's Dennis Rice who had come to the studio from Walden Media. "We think it's a terrific property that's going to make a terrific movie."[4]

A great deal of the success or failure of the *Narnia* franchise would depend on the ability or inability of Disney to reach out and make peace with the company's many conservative Christian critics. In 1997 Eisner's attempt to reach out to such groups had consisted of an insult he delivered via an interview with the CBS Television show *60 Minutes* when Eisner famously said of devout Christians engaged in a boycott of his company: "They're nuts."[5]

Calling millions of potential consumers "nuts" was not a partic-

ularly brilliant strategy but Eisner had stuck with it for nearly a decade. But Eisner's days with Disney were coming to an end and Dick Cook, the company's new President was perceived to be Christian-friendly, and there were several other devout Christians like Mark Zoradi and Rick Dempsey at the highest levels of the company. Depending on their ability and willingness to reach out to the boycotters and the millions of people they represented, Disney was poised to reconnect with millions of formerly disenfranchised Christian fans.

Although Disney never formally invited the boycotters to Burbank to smoke the peace pipe, the group that had originated the boycott, the American Family Association, of its own accord, called a truce in the culture war in May of 2005. In a press release announcing its decision, the AFA gave its reasoning for making peace:

"After initiating a boycott against the Walt Disney Company in 1996, AFA has decided to end the campaign, citing new challenges in the culture wars and some positive signs at Disney, including the resignation of CEO Michael Eisner, effective this September," the group noted. "'We feel after nine years of boycotting Disney we have made our point,' AFA President Tim Wildmon said. 'Boycotts have always been a last resort for us at AFA, and Disney's attitude, arrogance and embrace of the homosexual lifestyle gave us no choice but to advocate a boycott of the company these last few years. From the very beginning, the Disney boycott was about raising issues that were of concern to AFA, — especially the promotion of homosexuality in the culture and in the media. For the first four years or so, the Disney boycott allowed us to do that in countless media outlets,' he said."[6]

Part of the reason for calling off the boycott, Wildmon admitted, was simply an acknowledgement of how far the culture had shifted in the years since it had been called. Faced with the reality of gay marriage in the state of Massachusetts and a concerted attempt to make it legal across the country, fighting Disney had simply become a low priority for the group:

"Since 2001, Wildmon said Disney almost became 'lost among

the other battles being fought on a crowded cultural battlefield,'" his group noted. "In fact, over the last several years, AFA has received numerous phone calls asking for updated information that justified the continuation of the boycott. But AFA had moved on to other important issues, such as an increasingly activist judiciary and the push for same-sex marriage. He noted the increasing success of AFA-supported Internet activist outlets like OneMillionMoms.com and OneMillionDads.com. 'These outlets are helping us fight the battle for decency across the board,' Wildmon said. 'We will continue to keep an eye on the decisions of Disney/ABC, and we may even have our supporters contact the company periodically about the decisions it makes in respect to decency and morality.'"[6]

Still, according to Wildmon, the decision wasn't merely made because the fight was running out of momentum, but as a direct result of the positive changes his group had seen over the course of the boycott:

"One of the positive things to come out of the boycott was that Disney seemed to become more cognizant of how it had hurt its family-friendly image among many Christians," his group noted. "'When those phone calls came in, asking for evidence of new missteps by Disney, we were pleased to discover that they weren't as plentiful as before,'" Wildmon said. Highlighted in AFA Journal articles in 1998, 2000 and 2001, Disney made what appeared to be a determined effort to clean up its act and return the company to its heyday as the preeminent platform for family-friendly entertainment."[6]

Not the least among these "lack of missteps" was the exit of Eisner, as well as the company's decision to sever its relationship with the equally controversial Miramax label:

"Wildmon said there were more recent events that lend hope for a more cautious Disney approach to entertainment," noted Wildmon's publicist. "One example, he said, is the coming departure of Disney CEO Michael Eisner, who will step down from his post in September — a year earlier than initially planned. According to a 1998

article in the AFA Journal, the group had placed much of the blame for Disney's turn for the worse on Eisner, who became headman at the company in 1984. Another positive sign for them was the break-up of Disney and Miramax, the production company that Disney had bought in 1993 for $80 million. Commenting about the recent Disney/ Miramax divorce, *Los Angeles Times* writers Claudia Eller and Richard Verrier noted that, after the two companies united, 'the marriage soon developed strains over such controversial Miramax releases as the 1994 gay-themed release Priest, the teen sex drama *Kids* in 1995 and the 1999 irreverent religious comedy *Dogma*.'"[6]

"We hope that the end of the partnership between Disney and Miramax will mean the end of films that were extremely offensive to Christians,"[7] said Wildmon.

But the trump card and what was largely responsible for groups like AFA's change of heart was the welcome news of Disney's involvement with their beloved C.S. Lewis and his *Narnia* series.

"Finally, the news that Disney was co-producing a film based on the Christian literary classic, *The Lion, The Witch and The Wardrobe*, by C.S. Lewis, has brought cautious approval from some evangelicals," the group noted. "The film, co-produced with Walden Media, will be released in theaters December 9."[7]

Although the AFA was calling off its boycott, it still used the announcement to issue a warning that that boycott might resume at any time and that some of its members may choose to continue the action on their own:

"While there are still troublesome stains on the Mouse House — the annual 'Gay Days,' for example — Wildmon said AFA was broadening its focus beyond Disney," noted the group's publicist. "'For AFA, the boycott of Disney is now a matter of personal conviction, rather than a matter of AFA ministry emphasis,' Wildmon said. 'We encourage people to continue boycotting if they believe that to be the right thing to do.' Still, that does not guarantee that AFA will never again call for a Disney boycott, should the company do something par-

ticularly egregious. 'If, for example, Disney removed the clear Christian symbolism from *The Lion, The Witch and The Wardrobe* film, then all bets would be off,' he said. 'So I guess one could say that, as far as we're concerned, Disney is on probation.'"[2]

Another take on the AFA's decision came from the gay-oriented magazine *The Advocate* which somewhat derisively noted the decision in an article posted at it's website:

"A notoriously antigay group, the Mississippi-based American Family Association, has ended its nine-year-old boycott of the Walt Disney Co," it noted. "AFA president Tim Wildmon announced the end of the boycott in an article published Monday in the group's subsidiary *Agape Press.* 'There are so many other issues we need to move on to and deal with that are taking our time and energy,' Wildmon wrote. 'If you're going to call for a boycott of a company--if something has become that serious--you need to have all your resources behind it.' AFA launched the boycott in 1996 in response to what its leaders perceived as the erosion of Disney's squeaky-clean image. The conservative Christian AFA has protested Disney's extension of benefits to domestic partners of gay employees, open promotion of gay-related events at its theme parks, and religiously objectionable movies created by Disney subsidiary Miramax Films. Longtime Disney chief executive officer Michael Eisner was another sticking point for AFA. 'He was involved in a media group that actively promoted the homosexual agenda,' Wildmon said. 'He was in your face.'"[8]

On the other side of the spectrum, *The Baptist Press*, the official organization of the Southern Baptist Convention which had also participated in the boycott of Disney with the AFA, also noted the group's actions:

"The American Family Association which led the charge against the Walt Disney conglomerate over moral values in the mid-1990s, is ending its Disney boycott," it noted. "The boycott shifted into high gear nationwide when messengers to the 1997 Southern Baptist Convention adopted a resolution, 'On Moral Stewardship and the

Disney Company,' in which Southern Baptists were urged to 'take the stewardship of their time, money, and resources so seriously that they refrain from patronizing The Disney Company and any of its related entities.' The resolution criticized Disney for 'increasingly promoting immoral ideologies such as homosexuality, infidelity, and adultery.... Disney has become one of the less egregious perpetrators of the homosexual agenda, so we have decided to focus our resources on more pivotal issues related to the same concerns we had with Disney,'" Wildmon said.[7]

Although it had become standard Disney talking points to suggest that the boycott hadn't affected the company's bottom line, Richard Land, president of the Southern Baptist Convention's Ethics & Liberty Commission disagreed and welcomed the news with a reminder that, in his opinion, the boycott had helped to foster many of the positive changes that Christian groups were now noting of the company:

"The Southern Baptist Convention's resolution on moral stewardship may well have ushered in a whole new era of corporate awareness and activism among evangelical Christians," he noted. "The resolution made the point -- straight out of God's Word -- that Christians have an obligation to take account of what enterprises they are supporting."[7]

"Land said it is his belief that many dollars had been diverted from the company's coffers because of the boycott and that Disney's perspective had changed as a result of the increased scrutiny being paid to its releases and corporate decisions," noted *The Baptist Press.*[7]

"The intention of the resolution was never to put the Disney Company out of business, but to awaken and energize families to the fact that Disney and every other Hollywood studio has changed course over the past 20 years," Land added.[7]

Although the Southern Baptist Convention itself officially remained in boycott mode, Land hinted that it too might change its mind in the months ahead:

"It may well be that the Southern Baptist Convention this June decides to declare victory in this matter and move on," Land said, "but I learned a long time ago not to predict what a Southern Baptist Convention meeting in session may or may not do."[7]

If Land were a prophet, he was likely a well informed one, for the convention did exactly as he had predicted, voting on June 22nd 2005 to end the group's eight-year boycott against Disney.

"After researching the matter, the Executive Committee, June 20th determined it would not be appropriate for the committee to present a motion to the annual meeting calling for an end to the boycott," noted *The Baptist Press*. "Instead, the Executive Committee referred the motion to the Ethics & Religious Liberty Commission, noting 'changes in Disney leadership, and other potentially positive developments.'"[7]

But the boycott wasn't called off without a fight from conservative voices within the convention who were still spoiling for a fight and didn't feel as though Disney had made any substantive concessions on the issues that had originally caused them to call for a boycott:

"While the resolution to halt the boycott gained near-unanimous support on the floor, William Dotson of Kentucky asked for convention-goers to turn it back, saying the convention wasn't wrong in 1997 in targeting Disney, but that it would be wrong to call off the boycott of Disney now," noted the paper.[7]

Others were more pragmatic, arguing that while the boycott should be lifted, Baptists would need to keep a close watch on Disney:

"Wiley Drake, a pastor and messenger from California who told the convention he lived within four miles of the company's west coast theme park, responded by saying, 'They have made some changes. It's time to drop that boycott.' But, Drake noted, 'this old war horse is not ready to quit either, and I'm going to keep fighting Walt Disney Company. I live within four miles of Disneyland and their headquarters, but it is time for us as Southern Baptists to say what we did was a boycott and it worked. We have cost them hundreds of millions of dollars.' Michael Eisner himself said, 'that blankety-blank Wiley Drake

cost me $10 million off of my bonus this year."[7]

"Southern Baptists have made their point," said Land who had long championed the boycott strategy, pointing to several key decisions made by Disney, including the "retirement" of Eisner, the separation from Miramax, and, the decision to make the *Narnia* series as proof that the boycott had worked. "Presenting C.S. Lewis to the American public is a public service. Hollywood is slowly discovering that America is a very religious country."[7]

Still, Land showed a combative side, arguing that even with *Narnia*, his group would likely not have called off the boycott had Eisner continued to run Disney:

"I don't think we would ever have considered ending the boycott if Eisner was still in operational control," he said. "Eisner is the one who demolished any vestiges of Disney being any different than any other sleazy Hollywood entertainment conglomerate....at one time they were the family friendly place. Under Eisner they became at best no better than any other entertainment company and were ripe for the kind of action Southern Baptists and others directed at them."[7]

"For a boycott to be effective it has to have a start and an end," noted Gene Mims, then-chairman of the Southern Baptist Convention's Resolutions Committee, adding that though he considered the boycott to be "definitely effective" it was still "arguable who caused the effects and what it means."[7]

Land remained convinced, as did some analysts, that despite Disney's arguments to the contrary, the studio had been hit hard in the pocket book:

"We had a significant impact on Disney's bottom line," he maintained.[7]

But Disney was not entirely unfriendly territory to American Christians. The Studio's then-president Dick Cook was sympathetic to traditional values, and *Narnia* had long had a champion in a Senior Vice President named Rick Dempsey, a graduate of the Christian-oriented Master's College in Southern California who had labored qui-

etly for more than a dozen years in the character voices department, quietly nursing a desire to bring the *Narnia* series to his company. A colleague of Dempsey's at Disney, Ned Lott, had struck up a friendship with a Walden executive who thought Disney was the best place for *Narnia* and when Dempsey received a green light from Cook to begin quiet conversations with Walden about the property, negotiations commenced which eventually brought Cook and other top Disney officials to Denver to begin formal talks with Anschutz and other top Walden executives.

As talks progressed in Denver, the parties quickly discovered that though generally on the same page on most issues, they were still far apart on the issues of ancillary rights which were of utmost importance to Disney. After months of intense negotiations and compromises which left Disney with less of an ownership stake in the property then they were used to having, the two companies concluded an agreement to jointly bring *Narnia* to the big screen. The agreement was kept under wraps for several months then finally announced on March 1st, 2004 in a joint press release issued from Disney's Burbank, California headquarters:

"The Walt Disney Studios has entered into an agreement with Walden Media to co-finance and distribute the long-awaited motion picture *The Lion, The Witch & The Wardrobe*, the first book published in C.S. Lewis' famed series, it was announced today by Dick Cook, chairman of The Walt Disney Studios, and Cary Granat, chief executive officer of Walden Media," began the announcement. "The live-action film will be directed by Andrew Adamson ("*Shrek,*" "*Shrek 2*") and is scheduled to be released Christmas, 2005, by Walt Disney Pictures."[9]

"With an exciting and meaningful plot and well-drawn, emotional characters, *The Lion, The Witch, and The Wardrobe* has the potential to be just the start of an extraordinary series of films," added Disney president Dick Cook. "The exceptional imagination present in the novels follows in the best Disney tradition. We're pleased to be partnered once again with Walden Media. I think this is just the kind of movie

audiences are looking for, and we're thrilled to be able to bring it to the screen."[10]

"Disney has been a great friend and partner, with our company, on *Holes, Ghosts of the Abyss*, and this summer's *Around the World in 80 Days*," added Walden co-founders Flaherty and Granat. "The combination of C.S. Lewis' visionary *Chronicles of Narnia* with the incredible strength and uniqueness of the Walt Disney brand and organization makes this a true dream project for us. This is one of the most imaginative novels ever written, and to bring it to the screen requires a director of equal inventiveness, ingenuity, and spirit. Andrew Adamson is just the guy – he knows better than anyone how to create magic on-screen and tell a story that touches the audience's hearts. His expertise in visual effects, animation, and live-action will be critical to a fantasy work of this magnitude."[9]

Andrew Adamson, of Shrek fame a relative newcomer to the world of directing was, for obvious reasons, elated at the chance to helm the picture:

"*The Chronicles of Narnia* was an important part of my childhood just as it is to millions of fans around the world. I hope to bring to the screen a movie that is as real to the audience as *Narnia* was to me as a child," he noted. "*The Lion, The Witch and The Wardrobe* tells an epic story of great heart, of a family torn apart by a war in our world who are united in their struggle to save the magical land of *Narnia*. It's been a long time dream of mine to bring these classic stories to a new generation of moviegoers and readers."[9]

And in an important signal to both the Christian fan base that held Lewis so dear and the literary aficionados who valued faithfulness to the author's intent, the press release also included a nod of approval from the most important voice of all: the keeper of the Lewis flame, his stepson Douglas Gresham:

"Fans of the series have been waiting for generations for a film that faithfully adapts the *Narnia* books for the screen," he said. "Disney and Walden are a perfect match for the magical world that C.S. Lewis

created, and we're as excited to see the movie as everyone else is."[9]

Those comments were later echoed by Walden's Flaherty:

"I love it because the director, Andrew Adamson totally 'gets it,'" he said. "As a company we also made a decision that we'd take an approach that would be completely faithful to the book. For example when *Holes* first came out, we made sure the author was intimately involved in adapting his book to the screenplay."[11]

After many false starts, *The Chronicles of Narnia* was finally going to be made into a motion picture and C.S. Lewis's little children's story was about to extend its reach around the world thanks to the powerhouse global reach of the Walt Disney Company. Aslan was *on the move* and millions of children - and adults - would encounter him in a most subversive way, sans the trappings of overt religion, as just another character associated with Disney, but with a deeper meaning, *for those who had ears to hear.*

Chapter Three
The Captain

By the time of the official announcement of the Disney-Walden partnership, pre-production had already been underway for over a year. Adamson had been brought aboard in July of 2002 and had set up shop in Glendale where he was hard at work on plans for *Narnia* even as he completed work on *Shrek 2*. Working out of a non-descript Glendale office building, Disney marketing officials occasionally entertained reporters and VIP's, giving them a tour of a room plastered with images associated with the film. For his part, Adamson, professed to share Walden's passion for bringing the series to a new generation of children around the world.

"*Narnia* was such a vivid and real world to me as a child, as it is to millions of other fans," he had noted. "I share Walden's excitement in giving those fans an epic theatrical experience worthy of their imaginations and driving a new generation toward the works of C.S. Lewis. Making a film that crosses generations is a far easier task when the source material resonates such themes as truth, loyalty and belief in something greater than yourself."[1]

Adamson had been brought to *Narnia* by Walden CEO Cary Granat and though subsequent statements by Adamson and a general lack of experience with directing actors would later call into question the choice, Granat seemed pleased:

"As we've seen with *Lord of the Rings* and *Harry Potter*, bringing to the screen a literary fantasy classic, beloved by millions of readers, requires both a reverence for the original material and a rich imagina-

tion to create a realistic fictional world," Granat noted. "Andrew Adamson knows better than anyone how to create magic on-screen and tell a story which touches the heart of an audience. His expertise in visual effects, animation and live action will be critical to a fantasy work of this magnitude."[1]

Adamson took the helm of a team that included screenwriter Ann Peacock, best known for her screen adaptation of the novel *A Lesson Before Dying*. But Peacock's first draft had been a controversial one that troubled at least a few Walden executives who were committed to staying true to Lewis' vision. As Peacock's script circulated among executives at the company, one raised objections, noting:

"Were this script to actually be made in its present form, there would likely not only be massive boycotts of the film, but possibly even organized protests outside theaters by enraged Christians and other traditionalists, outraged not only by the bad language of the children, but by the politically correct and apparently intentional omissions of some of the traditionalist themes running through Lewis' work. In addition, the children, (with the obvious exception of Edmund) portrayed in the book as being sweet and innocent, have suddenly become mean, cynical, jaded kids. This will be an outrage to many fans of the book-Christian or not. The other major objection has to do with the omission of the language wherein Aslan and Father Christmas both tell the girls they should not fight in battle, except in extraordinary circumstances. All of these problems, if left unaddressed, will offend *Narnia* devotees in incalculable ways. While the mechanics of the script and the general story line is solid, there need to be major re-writes that take into account not only Lewis's feelings and beliefs, but the tremendous well-spring of affection that traditionalist Americans have for Lewis. If one of the goals of this project is to earn revenue, then the first rule must be to do no harm. And this script does harm. It needs a re-write by somebody who is sympathetic to

the faith elements in the film and not ignorant of Lewis's own faith journey."[2]

If adding pages of her own dialogue to the script wasn't bad enough, Peacock had also inserted numerous curse words into the script, causing the executive to note:

"My purpose in bringing up the language issues is not to be a prude. If a film was being made about life in prison or in the 'hood, it'd be difficult for anybody to say there shouldn't be uses of hell, damn, s---, f---. But this is a beloved children's story, read to and by children around the world. What would posses a screenwriter to take such a story and insert 'sh--' 'damn' and 'hell' into their dialogue-I don't really understand. If there is even one profanity of any kind in this film there will be serious consequences."[2]

Subsequent revisions by Adamson and others removed all of the objectionable curse words and softened some of the darker themes that Peacock had added to *Narnia*, but other objectionable themes would remain and cause tension between Adamson and Gresham who had managed to reserve for himself unprecedented powers that would give him and the Lewis Estate control over the storyline and allow them to make sure that the film stayed as true to Lewis as possible. Gresham dutifully battled for his stepfather's legacy:

"The challenge was convincing the Lewis estate that those were all acceptable ideas, since it had to approve departures from the book," noted the *Los Angeles Times'* John Horn. "...Adamson and screenwriters Ann Peacock, Chris Markus and Steve McFeely made Susan far less passive than in the book; she now actually shoots an arrow in the film's final battle. The estate approved the change, on condition that Susan's shot wasn't lethal. Adamson also wanted to strip Lewis' 1950 book of language that today feels sexist. When the Pevensie children encounter Father Christmas in the book, he gives them weapons, telling Lucy as he hands her a dagger, '...battles are ugly when women fight.' The line in the movie now reads: 'Battles are ugly affairs.' Father Christmas also no longer instructs Susan, 'I do not mean you to fight in the battle.'"[3]

Adamson had clearly scored a victory for those who weren't enamored with Lewis's "dated ideals" and later seemed exultant at what he had managed to keep out of the film:

"C.S. Lewis may have had these *dated ideals* but at the same time there's no way I could put that in the film," he observed in the pages of the Christian-oriented periodical *World Magazine* later telling *USA Today*: 'It was a little sexist when Father Christmas gives the gifts — weapons — to all of the kids and then tells the girls not to use them because battles are ugly when women fight. I had just come off two films that I hope are empowering for girls. I didn't want to turn that message around. I told Doug Gresham, who was somewhat concerned about changing an idea C.S. Lewis put in there, 'Yeah, but he wrote this before he met your mother.' Interestingly, all of the books he wrote after meeting Joy (Gresham) have much stronger female characters. So I sort of felt Lewis wouldn't have had a problem with what we did, which was have Father Christmas say he hopes the children won't have to use the weapons because battles are ugly affairs. That applies to boys and girls equally."[4]

But some questioned such an approach, noting that it may have been more than mere alleged sexism but social and perhaps even theological commentary on the part of Lewis with regard to feminism, possibly indicating his opinion on whether women should be ordained for ministry. Lewis' contempt for feminism, argued writer Gregg Easterbrook in the pages of *The Atlantic Monthly*, was not limited to his refusal to let Susan and Lucy participate fully in battle:

"*The Chronicles* record the deeds of two fearless heroines, Lucy and Jill, but they also contain numerous digs at feminism," he observed. "When Lewis spoofs the postwar anti-traditionalist movement by having Jill attend a school called Experiment House, he gives the school a headmistress, which is supposed to signal its absurdity."[5]

There was clearly a battle going on behind the scenes of the film's development team between traditionalists committed to maintaining the integrity of the books even when it differed from modern

social morès and those who wanted to update it for the times, but it was equally clear that the traditionalists had won many of the battles. For his part Gresham seemed willing to make small concessions, well aware of the profound changes that he had successfully thwarted over the course of a decade and a half, which caused him to note of his current situation with Walden and Disney: "I suspect the major studios would not have allowed us this much input."[3]

As the keeper of the Lewis flame and the member of the Lewis Estate whose views most closely resembled those of his step-father, it would fall to Gresham to keep the spiritual integrity of the books intact and stave off Hollywood's attempts to gut the stories of their heart and soul. It was a role that Gresham clearly understood and relished as he recounted the multiple hats he wore to an interviewer:

"One of our producers on set one day was introducing me to someone who asked, 'what does he do on this project?'" Gresham observed after shooting had been completed. "His reply was 'he's to blame.' Actually I am responsible for consultation on all aspects of the production as a sort of in house *Narnia* expert. This extends to all spin-off materials, like toys, games, books and so forth. I work with the games guys from the companies contracted to Buena Vista, the merchandising guys from Disney, the publishing teams at HarperCollins and represent the C.S. Lewis Company as their creative and artistic director. Making the movie has been a dearly held ambition and project for me for about thirty years (my children remember me dreaming, scheming, planning, and talking about it all their lives) so every aspect of it is important to me. I suppose I represent Jack himself as a sort of creative ambassador. The aim of this is to use my abilities, knowledge and experience to make this movie as good as we can possibly make it."[6]

In spite of the imperfections of the first draft of the script, when it came to matters that were near and dear to the hearts of many *Narnia* fans, they could take comfort in the fact that unlike previous attempts to bring the beloved series to the silver screen, this time around there were several key players who shared Gresham's view of the world

who were involved to ensure that the finished product stayed true to Lewis's spiritual vision for the series. In addition to Gresham and Anschutz, there was Micheal Flaherty, Walden's president and co-founder, and Bob Beltz, a special consultant and advisor to Anschutz as well as several others within Walden and Disney. Anschutz's Presbyterianism was informed by Beltz, who for 22 years had pastored various churches including the one Anschutz had attended. To the chagrin of some and the delight of others, Beltz served as one of Anschutz's closest advisors, making sure that his boss's views were generally reflected in the choices that were being made by his entertainment-related companies. The author of several books on subjects like prayer and Scripture reading, Beltz was in a position to advise on any theological inconsistencies between Lewis's original writings and the forthcoming product.

Likewise, Flaherty was, in the tradition of Lewis's brand of Christianity, a "mere Christian," raised Catholic, but having begun attending a non-denominational Christian church in the wake of the Columbine shootings and keen to make sure that the film was faithful to the original intent of the book's author. The father of three, Flaherty described a typical workday:

"I have a six-year old daughter. And I have a four-year old and a soon-to-be-three-year-old, so it always varies in terms of when the day starts," he observed at the time. "I'm in Los Angeles about a week a month; but when I'm in Boston, things are pretty mellow until about noon. And then once everyone arrives in the Los Angeles office and the studios, things begin to get very busy; and that pace keeps up until about six or seven at night. During the day I spend a good part of the time working on the marketing campaigns for the films, finding new projects, and reviewing scripts."[7]

Walden had, at least in its early days clearly and enthusiastically embraced the notion that it could bring faith-based stories to a mass audience and had done so even pre-*Narnia* with films like *I Am David* and it was Flaherty who was the strongest advocate within the company of the strategy. When asked about Walden's tendency to find

projects with a strong faith element, he was unapologetic:

"Throughout human history most of the great events and fig-
ures have been motivated by faith," he said. "So you're not a good sto-
ryteller if you avoid that aspect. But then, at the same time, if it's not
in the DNA, you can't apply it like makeup-- like 'oh, we'll put a faith
scene here to appeal to the church crowd.' They are a sophisticated au-
dience, and they know when something isn't genuine and authentic."[7]

Andrew Adamson was Walden's choice to direct *The Lion,
The Witch & The Wardrobe* and at the time anyway, many considered it
a brilliant move. In addition to winning praise from the filmmaking
world as a result of his mastery of animated filmmaking in *Shrek*, the
selection of Adamson also pleased many in the faith community and
allayed the concerns of some Christians who were fearful that the film
would fall into the hands of a production team like the one that had
turned the best-selling *Left Behind* book series into a bad B-movie.
With Gresham making sure that the film stayed faithful to Lewis's
intent, these fans felt comfortable with Adamson taking the directorial
helm, free to work his magic in bringing the series to life. But for some,
the applause was short-lived however, when one of the film's producers
Mark Johnson quoted Adamson in an interview with a New Zealand
radio station:

"He said something very important to me, and insightful,
when we first met," Johnson said of Adamson. "He said, 'I'm *not* really
interested in making a movie based on the book, *The Lion, The Witch &
The Wardrobe*. I'm interested in making a movie based on my, sort of,
interpretation, and my reading, and my imagination of the book when
I read it.' So it really is the confluence of the book, and a filmmaker's
point of view, and a filmmaker's imagination turning this into a movie,
that it's sort of where, I think, one and one will add up to three."[8]

It wasn't the first time that Adamson had given an early indica-
tion that he intended to do more than take dictation from C.S. Lewis,
but rather seemed to see himself as a sort of co-author of the work,
intending to put a firm stamp of his own on the finished product, even

when it was at odds with Lewis's vision. In an interview with a New Zealand newspaper Adamson said:

"For me, the film I am working on at the moment is a book that was very important to me as a child and it's another movie that comes with a lot of expectations because it's a book that a lot of people enjoyed as children. And then going back and reading it as an adult I was surprised by how little was there. C.S. Lewis is someone who paints a picture and lets you imagine the rest. To me it's about making a movie which lives up to my memory of my book rather than specifically the book itself."[9]

For Lewis fans, fiercely committed to protecting the spiritual intent of their hero, these were fighting words, exactly what they had come to fear might be in the cards for their beloved author and his books. Adamson, a filmmaker, but clearly neither a publicist nor theologian, likely had no inkling of the fight which he had inadvertently stepped into however, for the battle for the soul of C.S. Lewis had been waged for many years between those committed to protecting the orthodoxy of his spiritual legacy and those who either wanted to broaden his reach, or "de-Christianize" his writings, in particular his fantasy writings. Lewis had infused his fictional writings with so much Christian doctrine that he was often criticized, including by some of his friends like *Lord of the Rings* author J.R.R. Tolkien for not even attempting to be subtle about the introduction of key doctrines of the Faith:

"Though the Christian themes are out in the open, the sheer charm of the books seems to disarm all readers -- all except Tolkien, who saw them as heavy-handed and inconsistent," observed Steven Hart of *Salon Magazine*. "Tolkien's chief objections... were those of a craftsman. He considered *The Lord of the Rings* a Christian work, but its religious themes were carefully buried in the story. (Even die-hard Lewis fans may be tempted to groan when, in the first *Narnia* book, Aslan sacrifices himself to redeem the human children.)"[10]

Such was the reaction to Lewis's wearing his religion on his

sleeve, even from those who might be considered his natural ideological allies. But if Tolkien thought Lewis failed to bury the Christian message further into the subtext of his *Narnia*n plots, that was an opinion shared by at least some readers who appeared to pine for a *Narnia* free of such underlying messages. In the war for the soul of C.S. Lewis between traditionalists and those who were open to new and innovative interpretations of his work, only time would tell which side would prevail when the first of Lewis's *Narnia* books was unveiled on the big screen.

Chapter Four
Food Fights

The battle between Lewis scholar Kathryn Lindskoog and the Lewis Estate's literary curator Walter Hooper was but one example of the war that was often waged over Lewis's legacy. As early as 1988, Lindskoog had been writing conspiratorial tomes with titles like *The C.S. Lewis Hoax*, which leveled serious charges at both Hooper and The Estate, accusing them of various forms of malfeasance. The most incendiary of Lindskoog's charges had to do with her accusation that Hooper had been passing off manuscripts *he* had written as Lewis originals. Lindskoog's claim to fame as a Lewis expert largely rested on her having received a letter from Lewis in 1957 praising her for her scholarly analysis of his work:

> "Your thesis arrived yesterday and I read it at once. You are in the centre of the target everywhere. For one thing, you know my work better than anyone else I've met; certainly better than I do myself. But secondly, you (alone of the critics I've met) realize the connection, or even the unity, of all the books--scholarly, fantastic, theological--and make me appear a single author, not a man who impersonates half a dozen authors, which is what I seem to most."[1]

Empowered by the confidence such a letter might naturally engender, Lindskoog doggedly pursued her contention that something nefarious was happening among the guardians of Lewis's legacy. In

2003, Lindskoog passed away, but not before living to see yet another squabble develop over the religious legacy of C.S. Lewis, this time over alleged attempts to purge Lewis's fiction writings of any theological dimensions.

The controversy first came to light on June 3rd 2001 when *The New York Times* published an article with the provocative title, "Marketing '*Narnia*' Without a Christian Lion," in which writer Doreen Carvajal asserted that the Lewis Estate along with publisher HarperCollins, "have developed a discreet strategy to avoid direct links to the Christian imagery and theology that suffused the *Narnia* novels and inspired Lewis."[2]

Carvajal quoted John G. West, co-editor of the *C.S. Lewis Readers Encyclopedia* as saying, "they're turning *Narnia* into a British version of Mickey Mouse. What they've figured out is that *Harry Potter* is a cash cow. And here's a way they can decompartmentalize the children's novels from the rest of Lewis. That's what is so troubling. *Narnia* is a personal creation, and they're turning it into a corporate creation."[2]

Carvajal's interest had been piqued when she obtained some leaked memos that had been exchanged between a documentary producer named Carol Dean Hatcher and executives at Harper Collins.

"Obviously this is the biggie as far as the estate and our publishing interests are concerned," Carvajal quoted an executive from HarperSanFrancisco an imprint of HarperCollins involved in the Lewis publishing program as writing. "We'll need to be able to give emphatic assurances that no attempt will be made to correlate the stories to Christian imagery/theology."[2]

The memo had been written in connection with the development of a public television documentary about the life of Lewis, and Hatcher, the producer, had negotiated contracts to create an illustrated companion book and teaching video for Zondervan Publishing House, the Christian publishing arm of HarperCollins. Zondervan was also poised to contribute $150,000 for the production.

The story was quickly picked up by *World Magazine*, a Chris-

tian-oriented publication in the U.S., which published an exposè of sorts, based on leaked emails and messages between the various parties with an interest in Lewis's writings - The Estate, Harper-Collins and others. The *World* investigative piece was aptly described by its chief competitor, *Christianity Today* this way:

"If you like conspiracy theories, you'll love this piece. It's got secret cabals running around from Singapore to Liechtenstein, nameless clandestine puppeteers using the British apologist's corpse for their own personal marionette, a heroic journalist stymied at every turn, and corporate bigwigs challenged to choose all that is good and holy above insidious Mammon. It's *The Insider* meets *The X-Files*, *Erin Brockovich* meets *The Pelican Brief*."[3]

The *World* cover story was titled "Off With His Head," and was written by the magazine's editor, Marvin Olasky, a heavyweight in American political and religious circles who coined the term "compassionate conservative" that became the mantra for the presidency of George W. Bush. Olasky, then a professor at the University of Texas at Austin, was a dogged yet principled journalist who was unafraid to take on sacred cows, be they secular or sacred. While Christians traditionally tended to shy away from attacking each other in the press, Olasky had no such inhibitions so long as it was in service to what he perceived to be the truth. His magazine was unafraid of hard-edged, investigative journalism and Olasky had only recently caused a stir in the Christian world when he published a similar exposé of Christian publishers who were seeking to create gender-neutral Bibles. Olasky, born Jewish, and an ex-Marxist convert to Christianity, was unafraid of a good fight and when he got a whiff of an attempt to water down the religious orientation of Lewis's writings, pounced:

"In two words, who was C.S. Lewis?" he asked. "The most popular answer: "Christian writer." But not according to those who now control his literary estate—and memos given to *World* show that they seem determined to downplay Lewis's Christian profession."[4]

While Olasky did not attack Douglas Gresham directly, he was

suspicious of a man connected with the estate named Simon Adley, of whom he wrote, "despite his relatively recent ascension, it appears that to HarperCollins his word goes. Steve Hanselman of HarperCollins observed in his crucial memo that 'Simon should be quite pleased' with planned appearances in the Hatcher documentary by Stephen King and J.K. Rowling, the author of the *Harry Potter* books. He wrote that 'Simon has made it pretty clear that the only way forward (without jeopardizing our business relationship) will include a provision for the Estate's consultation and approval, as well as granting them a stake in the project.'"[4]

But what outraged Olasky most was the news that the Estate and Harper-Collins were contemplating an updated version of the series, to be penned by contemporary writers:

"HarperCollins has shocked Lewis devotees with its plans to hire authors to write new *Narnia* books," Olasky observed. "As Susan Katz, president of HarperCollins children's division, put it, 'they will not be sequels as such, but books using the same characters and with story lines which fill in the gaps of existing ones.' Mr. Adley himself told reporters, 'We're looking for established children's fantasy writers who will not mimic Lewis.'"[4]

Olasky then quoted Lewis scholar Bruce Edwards who called the ploy "a dreadful idea.... I don't know that any effort will be made to ensure that the contracted writers will have any Christian worldview to bring to their enterprise. And even if they did, what guarantee of quality will there be?"[4]

But the effort was strongly defended by the voice that mattered, Douglas Gresham, who took to a Lewis fan email listserv to defend the move:

"All that is being attempted, is to make the original seven chronicles more readily acceptable to younger children by first introducing them to *Narnia* in stories aimed at younger and wider audiences," he wrote. "Children today are missing *The Chronicles of Narnia* because they are already hooked on computer games and pre-teen romances

before they are old enough to read the real thing. We have tried before to do this by abridging (something I have never liked) the *Chronicles* in picture books and such. It hasn't worked so we are trying something new. Admittedly my personal motivation may be somewhat different from that of others in publishing, but that is part of my personal commitment to Christ and I must not expect everyone else to share that, no matter how much I might wish it.... I have found that fewer and fewer children are knowledgeable or even aware of *The Chronicles of Narnia*. In fact in Boston, and remember this was a Christian school, I found that no more than ten percent of the children I asked were *Narnia* readers. This I feel to be something that should be addressed. It is important to look at such matters with the mind rather than with the emotions."[5]

Despite Gresham's protestations, the one-two punch from *The New York Times* and *World* - the secular left and the religious right- seemed to put the kibosh on plans to create such a series, but the controversy over who did and didn't represent C.S. Lewis and his ideas the way the late author would have wanted them to be represented raged on and would have implications for anybody who sought to bring Lewis's work to the big screen. *World*'s Olasky spoke for many in Lewis's Christian base when he wondered:

"What will happen to C.S. Lewis's enthusiasm for professing Christ? In *The Weight of Glory* (1945), Lewis wrote that 'the church will outlive the universe; the individual person will outlive the universe. Everything that is joined to the immortal Head will share His immortality.' Lewis never wanted to be disconnected from Christ, but his new marketers may find it advantageous to behead him."[4]

Despite his position as something of an arbiter of Christian sensibilities, Olasky's was not the only voice that fellow Christians would heed when it came to maintaining the Christian flavor in Lewis's work, for Douglas Gresham was also a devout Christian, firmly entrenched in the Lewis tradition of "mere Christianity." Gresham often found himself in the most unenviable spot of being caught between

two warring factions who had radically different visions for the way C.S. Lewis would be presented to the world nearly a half a century after his death. Although he himself was firmly in the traditionalist camp, he worked alongside those who in some cases for economic reasons were interested in broadening Lewis's appeal beyond its natural, sectarian, base. As the action moved beyond squabbles over proposed books and on to how Hollywood would handle the series, all eyes would be on Gresham and his skills as both a diplomat and keeper of the Lewis flame would be severely tested.

Chapter Five
The Plan

By the spring of 2004, pre-production on *Narnia* was well under way at the film's production offices in Glendale, California. As director Andrew Adamson and his team worked in their second story offices, a Walden marketing official was giving regular tours to key people including officials at Disney who would be charged with marketing the film. Ushering his charges into a room covered from floor to ceiling in panoramic fashion with images associated with the film culled from newspapers and magazines, the Walden official spent an hour going through each phase of the film and the images that the director associated with it. From snow-covered landscapes to artist renderings of what the characters might look like, guests were given a sneak peek at the wonders which Adamson's team was assembling.

At the same time, important casting decisions were being contemplated and rumors swirled that various actors and actresses were being considered for the various roles-most notably that of the Witch. The most persistent rumor had actress Nicole Kidman flying to New Zealand for talks that would have her taking on the role. On March 5th, 2004, the *Australian Associated Press* breathlessly reported:

"Nicole Kidman flew into Christ Church this week on a top secret visit to tour locations for New Zealand's latest fantasy epic, *The Chronicles of Narnia: The Lion, The Witch and the Wardrobe*, which Disney will distribute and is co-financing with Walden Media. The star arrived early on Thursday morning and took part in a whirlwind tour of Canterbury's high country in a helicopter, says the report. One of the

locations paid particular attention was Flock Hill station near Arthur's Pass where there were several sightings of the actress and accompanying crew. It's not clear what role Kidman might be up for in director Andrew Adamson's adaptation of the C.S. Lewis novel, but it may be the White Witch, who in the story has used her dark powers to keep *Narnia* in winter for 100 years."[1]

For weeks, rumors of Kidman's alleged involvement were repeated among *Narnia* fans. But though she had indeed been discussed among executives at Walden for the role, producer Mark Johnson was quick to debunk any suggestion that she had been seriously considered or had even visited the set, offering up his own idea asto why people might have thought they had spotted the actress on set:

"I don't know where that rumor came from," Johnson said. "But not only is Nicole Kidman not doing the film, but we've never even talked to her about it. So somehow, there was an early report that she was actually spotted on one of our location rekkies or surveys, which we're not quite sure who was mistaken for Nicole. There was only one woman, though our director, Andrew Adamson, has very long hair, so we think it might have been him."[2]

The rumors about Kidman were indeed unfounded, for shortly after they were first floated, many of Adamson's choices for the roles were soon revealed. Scottish actress Tilda Swinton was chosen to play the Witch, while Oscar winning thespian Jim Broadbent was selected to play Professor Kirke. Unlike others associated with *Narnia*, Swinton enthusiastically embraced the task of being faithful to Lewis's work:

"I'm going to make a realistic evil witch, just the way CS [Lewis] wanted her to be," enthused Swinton. "The Lewis story is for all generations. Imagine this story by theologian Lewis which he dreamed up first as a little boy in Belfast has sold 65 million copies around the world in 30 languages."[3]

However, Swinton was not exactly a household name in the United States and had read the books for the first time only a year before she took on the role. And while an American director might have

paid more attention to assembling actors who were better known to the American heartland which was clearly the first target audience, Adamson seemed to have no such considerations in mind as he assembled his cast of mostly unknown British actors. Still, to her credit, Swinton had become a big fan of Lewis's books in the short time she had spent with them:

"I read the books this very year," she noted. "...I think the world is divided between those who read it and those who didn't; or had it read to them. But those were the days before Disney's marketing machine actually got a hold of *Narnia*, you see. It's not like *Harry Potter* and *Lord of the Rings* now, which are pushed down everybody's throats. In those days people kind of discovered it. Let's hope children will still be able to discover it... it's about a children's world. *Lord of the Rings* isn't really. I think the real question, and I speak as the mother of two six-year-olds, the real question is 'what do the parents want to read?' And it's lovely to read the *Narnia* books to children. I'm not taken to the idea of reading *The Lord of the Rings* to my children. I'd be interested to know if most people discovered *The Lord of the Rings* by reading it themselves or whether people read it to them."[4]

Asked whether she was nervous about working with Adamson who was directing live actors for the first time, having previously directed films like *Shrek*, Swinton joked:

"I think we're greatly privileged, as human beings, to be working with him, 'cause we're the first humans he's ever directed," she laughed. "And it's great, because he's really interested in the drama of this. I mean, the creatures in the film and the effects — which will be amazing — he knows that stuff inside out. But he's so interested in us humans! You'll probably find the next film he makes will be a tiny independent with about five actors in a room, though I think he might be booked for another *Narnia* film already."[5]

Next to the tale's central character, the Christ figure Aslan, no role would be more important than that of the Witch and Swinton's ability to portray the seductive nature of evil would be on display for

viewers. Swinton said she had thought long and hard about how she would play the role.

"The look of the White Witch is something we all thought a lot about and all worked on very hard," she observed. "The character, Jadis, created *Narnia* as a state of mind and then she froze it. So I have this fantasy that she doesn't even have a body really. She's just this alien but she knows she needs to dress, so it's as if she just covers herself up in a bit of *Narnia*. So the dress is made out of a substance that's a little bit like the bottom of an amazing waterfall I saw in the middle of New Zealand. So it's like the White Witch is made of water or ice, or smoke, or, something natural. And being the epitome of all evil, of course, and this comes very strongly from the book, she's covered in fur. And she has hair that doesn't look like hair, it looks like it's come from the ground — maybe it's roots or something. And her crown is made of ice, and it melts throughout the film, so it's not going to look like a costume that she got out of a wardrobe anywhere. It's like she just whipped it up out of somewhere. And I wish that it were really a computer generated costume, cause it was really difficult to wear! In fact, it's all real."[5]

A veteran of screen and stage, Swinton was clearly looking forward to playing the role of a lifetime for her as an actress and her enthusiasm in early interviews was palpable. She was especially eager to make a film that her own children could watch and enjoy, even as she feared that the role might typecast her forever as the evil Witch:

"I've never made a children's film," she observed. "I've never made a film my children can see. I'm not even sure if they're going to see this one. I don't want them backing away from me for the rest of my life."[5]

Asked why she thought she'd been chosen for the role, Swinton responded, tongue firmly in cheek: "I'm very tall, very white and very, very evil!"[5]

As for Broadbent, best known for his role in *Gangs Of New York*, he was equally enthusiastic about his role as the Professor at

whose house the children would discover the wardrobe and the door to *Narnia*:

"I spent an absorbing week re-reading the yarn," he said. "Smashing stuff and I've got a great part as the Prof – just ask any little boy or girl who has had the story read to them at bedtime."[3]

The cast was rounded out by Rupert Everett as the Fox and Dawn French as Mrs. Beaver, while the children were to be played by British actors Georgie Henley, 9, as Lucy; Skandar Keynes, 12, as Edmund; Anna Popplewell, 15, as Susan; and William Moseley, 17. Scottish actor James McAvoy who played in HBO's *Band of Brothers*, was chosen for the role of Mr. Tumnus, the half-man half-faun who showed kindness to the children. Howard Berger whom Adamson had chosen to handle makeup, had hesitations early on about that casting in particular:

"When I saw photos, I thought, 'boy, he's really kind of young for Tumnus,'" Berger recalled, "but we had the full Aslan sculpture in the shop, and James came in and he was looking all around, and he looked and saw Aslan and said, 'my Lord,' and I went, 'this guy's gonna be great.' So I wrote a long letter to Andrew and said, 'this is the right guy, you were right! You were pushing us and you made it all happen.' That's the other thing. James is a hairless human being, so we had to lay all that hair. We had to put tons of hair all over James, so his make-up takes three and a half hours every day and, he's played a lot, probably almost 20 times. He was scheduled for, like 12, but he's been through the make-up 20 times."[6]

For his part, McAvoy seemed thrilled by the turn of events that had caused him to be cast as Tumnus, and exulted: "That is a hugely exciting adventure. It's not every job you get to travel 'round the world and go to New Zealand and visit the Kauaeranga Valley. I'm blessed... I'm getting to play one of my favorite characters again, so I'm very lucky."[6]

McAvoy had definite ideas about the nature of the character he was to play and brought those ideas to the role, believing that he was

somewhere in the neighborhood of 150 years old, adding that "I think he's probably got another 300, 400 years in him, so I think he looks around mid-20s. It's not just the expected middle-aged, slightly rotund, version of (Tumnus)."[6]

While some would come to question Adamson's faithfulness to his source material, McAvoy was pleased that the director was deviating from Lewis, in this case by giving his character a more prominent role in the film that what was warranted by the books:

"He's trying to make a film of how it made him feel as a kid, because that's all he can do, with any kind of truth and integrity," he said of Adamson. "I don't think he's made too many changes. Tumnus is in it a little bit more than he is in the book. In the book, it seems to work, but in the film, Tumnus would be there for a big bit, then basically disappear until the end. I think he (Adamson) thought that would be a bit weird. In the book, it works because the book is so quick to read. But you identify with Tumnus so much, it would be weird for him to disappear so early in the film."[6]

The only major role left, yet to be decided upon, was the all-important voice of Aslan. For years, fans had speculated about who would best fit the role and that speculation had predictably swirled around established voices like James Earl Jones and Sean Connery. A wild card that had never been mentioned publicly but had been mulled over privately by Walden executives was that of Mel Gibson. A Walden executive had heard Gibson's work narrating a documentary about the history of Christ in art called *The Face* and had been impressed with the timbre of his voice in the work and mentioned the idea to the actor. Showing some interest, Gibson volunteered that he had read the *Narnia* books when he was ten years old. Gibson as Aslan would have been a marketing coup, coming to the picture almost directly from his work on *The Passion of the Christ*, but the film had also made him a lightning rod for criticism and executives, already nervous about the associations that would be made between Aslan and Christ, simply were not willing to go down the road of having the director of a controversial film about

Christ step into the role of narrator of a film that many saw as an allegory about Jesus and be accused by critics of making *The Passion of the Christ* for kids. Instead, in late 2004, British actor Brian Cox, known for his work in *The Bourne Supremacy, The Rookie, Troy, X-Men II* and other films was announced as the voice of Aslan.

"Brian has an amazing resonance to his voice, a certain majesty, which suits Aslan perfectly," noted producer Mark Johnson. "I've always found Brian to be so versatile... we first talked to Brian about the role of Aslan maybe nine months ago, and I'm so glad it worked out."[7]

But controversy over the choice quickly swelled when Walden learned of controversial comments Cox had made about a recent movie in which he had played a pedophile:

"In this movie, people go through what I hope they go through, which is a sense of repelling, and then finally not knowing how they feel about John. I love that...," Cox had said about the film's main character.[7]

Having to defend their casting of an actor who seemed at the very least ambivalent about the issue as the all-important voice of Aslan, for many a stand-in for Christ himself, may have been too much for executives who began to look for other alternatives. The decision to replace Cox had been made but not announced when two Disney executives took to the stage at Biola University in suburban Los Angeles to show clips of the film and talk about their role in the development and production. During the conversation Rick Dempsey and Ned Lott revealed that Cox was no longer going to be the voice of Aslan:

"Brian Cox no longer has the job as Aslan," noted one attendee who quickly shared the information on a *Narnia*-related blog. "He lost 40 lbs and it changed his voice, so he's no longer able to be Aslan."[8]

Reaction from Cox's camp was swift and angry:

"What was said at the conference is categorically false. Brian left the production because of scheduling conflicts," his agent responded when asked the following Monday morning. "He is currently filming *Running With Scissors*, which is live action, and his weight loss is

certainly not affecting that production--and he is on camera. His voice is exactly the same as it was a year ago."[9]

Dempsey quickly issued a private apology to Cox's manager, and several weeks later Adamson himself did his best to be diplomatic in an interview with *USA Today*:

"Scottish actor Brian Cox was to speak for the main attraction in Disney's *Chronicles of Narnia*: The Lion, the Witch and the Wardrobe," the paper noted. "Those who know his work (*The Bourne Supremacy, X-2*) might think — as director Andrew Adamson did — that his commanding presence would translate vocally. But it wasn't a match made in heaven. 'I love Brian,' Adamson says, 'but we made a mistake. It has to do with the size of the lion and finding the right voice quality.'"[10]

Although Dempsey and Lott eventually settled on the less controversial Liam Neeson for the role, the dustup with Cox was an example of the difficulties that Walden and Disney faced as they navigated life in a post-Passion world in which traditional Hollywood-style decision making was undermined by the new rules of filmmaking with a faith-based audience in mind. Christian fans, uniquely incapable of or unwilling to separate the actor from the work, felt most comfortable enjoying entertainment in which they knew that the actors were at the very least not hostile to the underlying messages of the stories they were telling and that they at least shared some basic values. Cox may have been an early victim of the change in rules.

Once the main actors were decided upon, the focus soon shifted to the effort to identify hundreds of supporting players, and the call was quickly put out for the many actors who would be needed to play the various roles. The main actors who would carry the first installment of *The Chronicles of Narnia, The Lion, The Witch & The Wardrobe* were now in place and the focus of the effort to bring the beloved series to life would shift to New Zealand.

Chapter Six
Bringing Narnia To Life

Long before the first scene was shot, Adamson and his team would spend long hours trying to figure out the best way to bring the various elements to the big screen, but nothing was likely as singularly challenging as attempting to figure out how best to bring the *Narnian* characters out of the imagination of Lewis's mind and onto the screen. For Douglas Gresham, the work of bringing his stepfather's beloved book to film was a labor of love for which he had been preparing, for it seemed, all of his life:

"It will shudder the imagination," he noted. "The problem has been that the technology did not exist to do it justice. We now have the technology. If you can imagine it, we can film it. We have to try to produce an image of something unlikely that won't clash. *Narnia* is difficult to describe, but it was based on the varying landscapes of Ireland, north and south, the woodlands and fields....now is the right time to do this...we have come to a point where the technology in the film industry has reached a level at which we can do the book justice."[1]

Unfortunately, there had indeed been several versions of *Narnia* made *before* the appropriate technology existed, most notably one produced by the *BBC* which Gresham ready acknowledged he was not proud of.

"The previous films were made in an era where the technology that exits today didn't exist, nobody had invented computers let alone computer generated imagery when they did those other films," he noted. "We hope to make this film with a mixture of live action and

computer generated imagery, which will be so seamless that you won't be able to tell the difference. I don't want people walking out of the cinema saying 'what great effects;' I don't want people to notice that there are any effects. If they ask any questions it should be 'where on earth did they get a real sentinel?'"[1]

So intent was the new team on avoiding being associated with previous versions of *Narnia* that director Andrew Adamson actually made it a point to avoid viewing the BBC version, not wanting it to color his own vision as he embarked on re-creating Lewis's *Narnia* for the big screen:

"My wife had picked up the DVD of the BBC version, and I got partway through it, and I just kind of said, 'I can't watch this, it's going to affect me in ways I can't really say!'" he remembered with a laugh. "And I don't want to discredit them, they were done in a limited budget, for a TV audience, for a younger audience that was very different from what I wanted to do. And I so wanted to steer clear of the clichés, and I felt like there was a number of clichés in there, particularly with the White Witch, that I didn't want to have in my head, going into making this film."[2]

The question which was likely on the minds of many *Narnia* fans was how Aslan would be portrayed, and to Gresham it was that portrayal above all others which would serve as a sort of barometer by which they would know if they had been successful overall:

"Where are we going to get a lion that won't eat the cast—there are serious logistic problems involved with making this movie," he pondered. "We are going to have to use about three live lions, and they have to be lions that won't eat people. It's embarrassing. You may not be aware of it but there have been some various, serious accidents working with big cats in Hollywood movies. I wasn't kidding."[1]

Asked about the scenery that would have to be created to do the books justice, Gresham's response indicated just how deeply he had considered the issues related to the film in the many years since his beloved stepfather had passed away and was another indication of the

responsibility he felt to make the movie that Lewis would have wanted made:

"Logistically it's a difficult movie to shoot because we have to have a very, very cold winter," he said. "I'm talking probably 20-30 degrees below zero, and moving into spring and spring straight into summer within the time of principal photography which is a very short interval, we will have to film in the Northern Hemisphere and the Southern Hemisphere somewhere, so we'll be scouting locations all around the world. We are obviously going to have to transport our chosen cast from place to place. One will be picked particularly for his head and facial features and the others will be just body doubles. Then of course we have to build an army of White Witch's grooblies and the people of the toadstools for example, all of these things have to be created from scratch. I hate talking about it because you can get the idea of why it is going to be more difficult than anything we have ever done about *Narnia* before. It's a different ballgame altogether."[1]

Gresham had been entrusted with great power as co-producer to ensure that his stepfather's books would be presented nearly a half a century after he first conceived them, faithfully to the way they were written. But his was not the only voice at the table, and the opinions of others-chiefly director Adamson would also be crucial to how the film(s) turned out.

"As we've seen with *Lord of the Rings* and *Harry Potter*, bringing to the screen a literary fantasy classic, beloved by millions of readers, requires both a reverence for the original material and a rich imagination to create a realistic, fictional world," Walden CEO Cary Granat once said. "Andrew Adamson knows better than anyone how to create magic on-screen and tell a story which touches the heart of an audience. His expertise in visual effects, animation and live action will be critical to a fantasy work of this magnitude."[3]

It was Granat more than anybody else at Walden Media who had lobbied for Adamson, a New Zealand native who had gotten into filmmaking almost by accident, to helm *Narnia*.

"I used to draw cartoons a lot as a child," Adamson remembered. "I never anticipated working in animation... I used to thoroughly enjoy it.... I was planning to get into architecture, which, interestingly enough is a similar discipline to computer animation - it's science-based and art-based. But I missed university enrollment because the day before I was meant to leave Papua New Guinea, where we had been living, I had a car accident and broke my leg and smashed myself up. And so I had a year to kill waiting for the next year's enrolment. I accidentally got into this."[4]

Adamson had achieved notoriety directing the animated classic *Shrek* which earned $470 million worldwide and garnered an Academy Award in the category of "Best Animated Feature." Previous to his work on *Shrek*, he had served as visual effects supervisor for *Batman and Robin, Batman Forever, A Time To Kill, Angels In The Outfield, and Double Dragon*. *Shrek 2* which Adamson also helmed became the highest-grossing animated film of all time, earning $354 million in the U.S. alone. But Adamson had gotten his start not in film, but in animation for commercials and TV.

"I started out in computer animation which at that time was flying logos and the opening of *TV3* and *Radio with Pictures* and all that kind of stuff and commercials," Adamson recalled of his early years. "Then I went over to the States to work in commercials and then I moved into feature-film effects and then ended up back in animation completely by accident through somebody I met here.... I helped Peter Jackson out on *Frighteners* and met a producer, who for a short time ended up being one of the producers on *Shrek*, and kind of dragged me into that. So it was a very round-about route... I was actually planning after I did the *Batman* movies - the second *Batman* I did purely for the money - with the goal of spending some time working on my writing. I knew by that time I enjoyed the storytelling aspect, having gone from commercials where you have 30 seconds while somebody goes to the bathroom to actually telling stories through visual effects.... I realized I wanted to be a storyteller. I was planning to go and spend a year work-

ing on the writing when *Shrek* came up. I sort of went into it kicking and screaming and agreed to give it a three-month trial and then ended up just doing it for the next three and half years. But it really was story training. Because in animation when you work with storyboards and make the movie over and over and over again in storyboards, it's also like experimental film-making."[4]

A consistent criticism that Adamson faced was whether he could successfully transition from animation to live-action. One that would later dog him because of the lackluster performances of some of his characters, especially the Pevensie children. For his part, Adamson shrugged off such criticism, insisting that the differences between the two genres were minimal:

"You have actors in animation - it's just that you work with them separately," he said. "Strangely enough it's similar but the process is very different. You are still focusing on all the same things - story and performance. With the actors you have got to work from your gut more. In live action you don't get as many chances. Having come from live-action visual effects, I like that energy and excitement of making decisions on the spot that you have to stick with. Very often even in animation what I will often do is write down what my initial gut instincts are because a year from then looking at a sequence and wondering why it's not working I'll go back and see what I liked about it at the beginning - it's usually right."[5]

As a New Zealander, Adamson was also regularly compared to Peter Jackson, the director of the *Lord of the Rings* series. If he was annoyed by such comparisons, he did his best not to let it show:

"I wouldn't consider myself in his shadow," he said of Jackson. "I worked with Peter actually, he was sort of indirectly the person who got me into Shrek. I actually was down in New Zealand helping him out with some effects on *Frighteners,* when I used to do visual effects, and one of the executive producers on that project ended up being one of producers on *Shrek,* and he brought me into that. So he's somebody I've stayed in touch with since then, and he's always been incredibly

supportive of everything I've been doing, so I've actually really appreciated having him there, and certainly we've worked with WETA a lot on this film as well. It is very much a Peter Jackson country when it comes to filming, that's for sure."[2]

In fact, far from seeing Jackson and *Rings* as competing works, Adamson, understanding the close relationship that existed between Tolkien and Lewis, believed that the success of the *Lord of the Rings* had in some way paved the way for *Narnia*'s own journey:

"Tolkien and Lewis... were very good friends, and actually Lewis helped Tolkien get his books published, because he'd succeeded with a number of his publications before *The Hobbit* was published," he noted, "and there's a very nice article I read, I think in *The New York Times*, a little while ago, that was kind of relating that to how the making of *Lord of the Rings* actually made it easier for us to get this project off the ground. It was a sort of nice thing, kind of correlating the two and saying how Lewis and Tolkien were still helping each other out, which I thought was a really sweet sentiment. We definitely had to be careful not to use the same locations, you know it was kind of New Zealand obviously has a lot to offer, location-wise, we had to be careful that it didn't look the same."[2]

Because of the dark history of mistrust that had long existed between Hollywood and devout Christians, (the natural fan base of the books,) any film director, and especially one who wasn't very devout, himself, would come under immediate suspicion as one who might attempt to destroy or downplay the true religious intent of the story's creator. It's not clear if Adamson understood the dynamic that he found himself thrust into, but the challenge he faced of filling in the blanks of what Lewis had left behind was a daunting one.

"C.S. Lewis painted a picture and left a lot to your imagination," Adamson once noted. "Our challenge is to fulfill people's expectations and bring the film up to the level of their imaginations."[6]

Shortly after joining the *Narnia* team, Adamson showed that he was going to direct with a firm hand. Not satisfied with the first

draft of the script (though likely for entirely different reasons than traditionalists who objected to the language,) which included curse words, Adamson quickly took on the additional role of co-screenwriter, massaging Peacock's first draft until he felt it was just right.

At a premiere party in Hollywood for the Walden/Disney film *Holes*, Adamson, a dead ringer for rocker Tom Petty, mingled anonymously and somewhat awkwardly among cast and crew and executives from both companies, accepting congratulations from the few people there who recognized him or knew the difficult path that lay ahead for him. Pulling off a movie that seamlessly blended live action and animation would depend largely on the director and Adamson immediately set about to gather together a team with the expertise to make it happen. In addition to producer Mark Johnson, Adamson turned to Philip Steuer, a man who had successfully helmed films such as *The Alamo* and *The Rookie*, to executive produce. Adamson was also able to bring on Donald McAlpine an Oscar-nominated cinematographer who had worked on *Moulin Rouge* and *Peter Pan*, production designer Roger Ford known for his work on *Babe* and *Peter Pan*, and costume designer Isis Mussenden who worked on both *Shrek* movies as well as the sequel to *Dirty Dancing*. For editing, Adamson turned to Sim Evan-Jones with whom he had worked on *Shrek* and Jim May, known for his work on *Van Helsing*. For music, Adamson utilized the talents of composer Harry Gregson-Williams another *Shrek* veteran.

But fans of the *Narnia* series, especially those Christian fans who worried that the film would be made in a low-quality manner as many films with strong Christian themes and helmed by Christians had been in the past, were especially relieved to hear of the involvement of the WETA company, Peter Jackson's team of animators who had so successfully incorporated elements of animation into live action with the *Lord of the Rings* series. With the Internet abuzz, the first reliable reports began to trickle out about the WETA involvement in November of 2003.

"A spokeswoman for WETA confirmed it was working on the

$170 million film project, but refused to go into detail," noted reporter Bess Manson. "Secret negotiations have been going on for months among Walden Pictures, Economic Development Minister Jim Anderton and Bob Harvey, mayor of Waitakere, where much of the filming is expected to take place."[7]

With WETA on board, the company's head, Richard Taylor, along with two associates, visual effects supervisor Dean Wright and makeup expert Howard Berger spoke at the Armageddon Pulp Culture Expo in the city of Wellington and gave fans of the *Narnia* series some juicy tidbits into how work was progressing on the beloved series, touching on the challenges he and Adamson faced in bringing *Narnia* to life:

"Lewis has woven such a rich tapestry of cultural references as he cooked up this world," Taylor observed. "Andrew Adamson was almost scholarly in his knowledge of C.S. Lewis' world. Once again, some of the designers of WETA that proved to be such a valuable resource on *Lord of the Rings* learned so much and also turned out to be incredibly knowledgeable about C.S. Lewis' work...when you read, as a child, the pages of *Narnia*, at the end of *The Lion, The Witch and The Wardrobe*, you felt as though you'd read a 200-page, massive, sweeping battle. If you go back and read today, you'd be startled to discover it's only about a page and a half...Tolkien would have quite happily spent a whole 600-page book writing about that battle, but not C.S. Lewis. It's all about suggestive description. And that makes for a very precarious position when a director has to then change that to the vision on the screen."[8]

Perhaps the most difficult task the WETA crew faced was deciding *how* to bring Aslan to the big screen. Designed by Richard Taylor with input from Gresham, Adamson and others, Aslan would have to live up to the dreams of millions of children *and* adults who had grown up reading the stories:

"Richard designed a beautiful, beautiful Aslan... I had to cut his mane yesterday. We're shooting it backwards. He's a beautiful lion,"

noted Berger.[8]

Dean Wright, the visual effects supervisor, believed his most difficult task would be, without question, Aslan:

"I'm expecting Aslan to be the most challenging," he observed. "We've got Mr. and Mrs. Beaver and they're gonna be funny... The kids really enjoy that. Aslan's got to have nobility and...he can't be boring. All the other guys have great lines and comic moments, but Aslan's got to be central to the story...we're attempting to motion-capture a lion, which will be interesting...getting a lion's face and actually having him talk, that's nothing like just doing another silly animal.....in terms of bringing Aslan to life, in terms of the other animal features we've done, there's this fine line and, taking an animal character, having it talk and relate to humans and not crossing the line of becoming cartoonish...we want to keep it real....the photorealism and the movement and they do have to have a hyper-reality to them in that they can think more than you expect a lion to think... that's gonna be our struggle as we look through the animation."[8]

Wright also gave fans a hint of some of the characters that would make their appearance on the screen.

"These guys have designed these really badass creatures," he observed. "The minotaurs and the minobaurs, which are really tough looking, bullish monsters. Even though it's a film for kids, I think LOTR has actually helped us as to how far we can push the intensity."[8]

Howard Berger was an industry veteran whose most recent work, *Kill Bill*, had broken new and important ground in filmmaking. Though he would not let his own children view that film, he was enthusiastic about the prospect of them watching his work on *Narnia*. If Berger's reaction were any indication, *Narnia* would likely draw a large audience, not just of Christians seeking to have their Christ-story told to a mass audience, but of children everywhere.

"Of the four hundred films I've done, five of them have been good," joked Berger. "I'd have to say that, when we did *Kill Bill*, I went to China with two other people...we did everything. Three people did

all that stuff. It was intense…but it was really rewarding, especially when the film ended up being so great…but I have three young children, and they won't ever see *Kill Bill* until they're older. They want to see *Kill Bill*, but they're not going to. But this film, when I first told them that I got a call that I may be working on *The Lion, the Witch and the Wardrobe*, they lost their minds. At that point, I knew I had to get this job. Richard recommended me very highly…there were four other very large shops that I was bidding against. I think that my passion for the project and perhaps me talking to Andrew and saying, 'my kids think it should be like this, my kids think it should be like that' really helped sell how much I really wanted to do this… I feel that this is the one movie that I'm going to work on that will be for my children and that hopefully they'll love this movie and it will be with them forever and when I'm long gone they'll still be able to watch it and remember their Dad."[8]

Perhaps to compensate for his lack of experience in live-action filmmaking, Andrew Adamson had surrounded himself with a strong supporting cast and under the ever-watchful eye of Douglas Gresham, production on what they hoped to be the first of seven movies was underway.

Chapter Seven
Original Intent

The hope of the entire *Chronicles of Narnia* production team was undoubtedly that they too would create a work that would be as treasured five decades later as Lewis's books had been. As such, understanding Lewis's intent in creating the series and dreaming up the characters would not only prove to be important to the filmmakers but was also a constant source of interest and concern to Lewis's diehard fans. Although Lewis had written explicitly apologetic Christian works such as his landmark *Mere Christianity* which had originated as a series of radio addresses on the BBC, he had clearly intended to write a series for children that could be appreciated by two types of people: those who saw the deeper meanings that Lewis intended to convey and those who simply enjoyed them for the great storytelling that they were. If the reaction of Jewish readers and others who had no specific dogma were any indication, Lewis had succeeded. One such fan was Suzanne Rosenthal Shumway who had read the books as a child. In a talk she gave entitled "Reading Lewis from a Jewish Perspective," Shumway articulated the experience common to many non-Christian *Narnia* fans:

"I first began reading Lewis—by which I mean *The Chronicles of Narnia*—as an adolescent looking for an escape from a world I found bewildering and very often inhospitable," she remembered. "I raced through *The Lion, the Witch, and the Wardrobe*, devoured *The Magician's Nephew*, and absolutely adored the Dufflepuds—or is it the Monopods? It didn't matter: I was looking for a world that was inviting and appealing, and Lewis obligingly delivered. But as a youngster I never

read *The Last Battle*. Friends warned me that that was the volume that got 'serious,' the book in which Lewis pulled it all together and revealed the key behind the allegory. It was here, they said, that Lewis uncovered the Christian element behind the fairy tale. Of course, this isn't true: the Christian element is plainly apparent from at least the sacrifice of Aslan in *The Lion, the Witch, and the Wardrobe* on. But for me, a non-Christian, there was something comforting in believing that you could take all the Christian messages in *The Chronicles of Narnia*, lump them all together in the final book of the series—and then refuse to read it."[1]

Shumway, steeped in Lewis and *Narnia* since her childhood, clearly understood Lewis's intent, but had chosen to accept his stories without regard for the underlying and clearly stated intention of Lewis in transmitting spiritual messages to his readers:

"...As a non-Christian—indeed, as a Jew—I can't accept the allegorical message Lewis presents in *The Chronicles of Narnia*, and his prose works on Christianity hold little interest for me," Shumway observed. "In other words, Lewis's ideological work is unrewarded in a reader like me, who cannot be persuaded either to become a Christian or to develop into a better Christian by reading these books....I hope to show how even those of us who cannot be influenced by Lewis's Christian message can still profit from reading his works."[1]

That was clearly the spirit that Disney, Walden, Harper Collins and the Lewis Estate had hoped to tap into by broadening Lewis's audience for the big screen version of *Narnia* and if Shumway were any indication, there would be millions of moviegoers who, though aware of Lewis's evangelistic intent in writing the stories, would still enjoy the movies for their entertainment value. Still, for millions of others who enjoyed the *Narnia* books *because of* and not *in spite of* their spiritual imagery, Lewis's intent was a key reason for the deep devotion the series engendered. And while that intent was unlikely to sway readers like Shumway, it was a key ingredient in the devotion that Christian fans felt for Lewis and his stories and was an important factor to be properly understood.

"I can remember well the Christmas morning when I received a box set of *The Chronicles of Narnia* by C.S. Lewis," remembered another Lewis fan, Cassandra Kish. "I had read the first, and most well known of these books, *The Lion, the Witch, and the Wardrobe* a few months earlier. Being a curious girl, I wanted to see what else happened to the characters I had come to know as friends in this book. So, it was only natural that I ask my parents to give me the whole series for Christmas....when I read these books at age ten, I was not aware that they contained the Bible, morality, or philosophy. They were merely enjoyable stories. However, a few months ago, they came to signify much more. Having recently read some of Lewis's 'adult' works, most of which are on Christian apologetics, I decided to revisit *Narnia*. I admit I have never lost my love of fairy tales; and I was curious to see if these stories in particular were of any value to a grown-up like myself. So, I set aside Plato and Locke and opened up *The Magician's Nephew*."[2]

Lewis was that most unusual public Christian who both burned with zeal to see his fellow travelers convert to Christianity while managing to convey his passion in a way that didn't seem to turn them off. Significantly, he also carried on his work in both fiction and non-fiction and was careful to avoid the trappings of the religious subculture, writing for "secular" publishers and recording radio programs for the state-owned British Broadcasting Corporation. Fans like Kish seemed to grasp Lewis's heartbeat and drank deeply of his theology:

"Nearly everything in these books can be traced back to something in the Bible," she observed. "For example, the lion Aslan is a godlike figure. In *The Magician's Nephew*, Lewis devotes several chapters to describing how Aslan sings *Narnia* into existence. Aslan's voice literally causes things to be. First comes light, then plants, then animals just as they do in the first chapter of Genesis. The story goes on to describe how evil entered *Narnia* through the free actions of a man and a woman, again as it does in Genesis...of course, Aslan cannot allow this evil to exist unfettered and destroy all he has created, so something must be done to defeat it. *The Lion, the Witch, and the Wardrobe*

deals with this issue specifically. Here, Aslan is seen as God the Son, as opposed to God the Creator. The story shadows the Gospels rather closely. Aslan literally has to die and be resurrected to defeat the witch, Jadis. Before this can happen though, he has to have followers to carry on his teachings. This is what the children do, acting as disciples of Aslan. These disciple-children provide a wonderful example of what a Christian should be. They are painfully human and make several mistakes throughout their journey. Once the children become aware of their flaws, they are ashamed to go before Aslan. However, they know that they must do this. Aslan is gentle and patient with them, as Christ was with his disciples. The children go away from Aslan changed as a result of this."[2]

In many ways Lewis's *Narnia* tales were like Christ's parables, eluding the many and understood by a select few, something Christ himself seemed to understand when he urged, "he who has ears let him hear." Lewis was also an inspiration to many Christians especially in America who had found it difficult in the 20th century to find new and interesting ways to convey the Christian Gospel to an increasingly distracted and disinterested culture. Lewis had managed to do just that, and in a purely "secular" context, something his devoted readers understood and appreciated him for accomplishing:

"If the *Narnia* books are to truly follow the Bible, they must begin with Genesis and end with Revelation," Kish observed. "The final book of the seven, *The Last Battle*, serves this purpose. There is a false Aslan in *Narnia* who deceives many Narnians, just as the book of Revelation discusses the coming of a false prophet. The children continue in their role as disciples, trying to help the Narnians see the false Aslan for what he really is. In the end, there is a battle between the followers of Aslan and those of the imposter, which turns out victorious for Aslan. When this occurs, *Narnia* fades away leaving the children and Narnians quite distraught. This does not last for long because the characters then see a land more beautiful and more wonderful than the former *Narnia*. What follows is a glorious description of this Real *Nar-*

nia. Aslan explains to the children that the *Narnia* that they previously knew and loved was only a pale reflection of what *Narnia* should be. In essence, the glorious reign of Christ discussed in Revelation has come in Narnian form."[2]

While Lewis would have likely welcomed all readers regardless of their religious orientation, he also left little doubt about his intent to bring core Christian doctrines to the attention of all who might enjoy his works. Before his death in 1963 he had often commented on his intent in writing the *Chronicles* and acknowledged that he saw great power in the ability of fiction and fantasy to transmit great moral and spiritual truths.

"Any amount of theology can now be smuggled into people's minds under the cover of romance without their knowing it,"[3] Lewis once wrote.

At the same time, he was eager to diffuse rumors that he had somehow set about to write theology via his fiction or was merely "using" beloved children's tales to trick unsuspecting children into salvation:

"Some people seem to think that I began by asking myself how I could say something about Christianity to children," Lewis wrote, "then fixed on the fairy tale as an instrument; then collected information about child-psychology and decided what age group I'd write for; then drew up a list of basic Christian truths and hammered out 'allegories' to embody them. This is all pure moonshine. I couldn't write in that way at all. Everything began with images; a faun carrying an umbrella, a queen on a sledge, a magnificent lion. At first there wasn't even anything Christian about them; that element pushed itself in of its own accord."[3]

Of course what made Lewis so hard to pin down and so maddeningly elusive to his enemies was precisely that combination of intentional evangelism combined with a nonchalance that at times found the Oxford don almost seeming to disavow that very evangelistic intent. Critics and fans alike however saw a clear blueprint unfolding in

the *Narnia* series, whether calculated or otherwise, that laid out the broad outlines of the Christian faith throughout the seven-book series:

"In the process of writing *The Chronicles of Narnia*, C.S. Lewis gradually expanded the breadth and scope of his literary ambitions," observed Lewis scholar Mark Bane. "What was foreseen from the outset as a collection of stories for children developed into a complex depiction of an entire moral universe. As the seven books progress, Lewis unfolds the whole divine plan for this universe from its creation to its apocalypse. However, the uniqueness of Lewis's literary achievement stems from the fact that Lewis manages to do two things at once. That is, he remains faithful to his original intention to write stories for children while adding in subtle moral and spiritual complexities. These complexities do not seem like authorial intrusions or editorializing. They are instead woven into the very fabric of Lewis's creative universe. Thus, *The Chronicles of Narnia* is a series of books that can delight the senses as they challenge and stir the soul."[4]

Lewis's keen insights into the importance of myth and fantasy in communicating orthodox spiritual and religious concepts was steeped in his own love of fantasy and likely had its roots in his early fascination with the occult as well as his later friendship with fellow scholar and author J.R.R. Tolkien. While all orthodox Christians would frown on any and all occult practices as Lewis himself likely did after his conversion, in his early years he seemed to have an affinity for elements of fantasy, including the occult:

"Lewis's early favorite literature included E. Nesbit's trilogy: *Five Children and It*, *The Phoenix and the Wishing Carpet*, and *The Amulet* -- all occult fantasies," noted Albert James Dager. "So much was Lewis's life steeped in fantasy that he wrote, 'the central story of my life is about nothing else.' From Nesbit and Gulliver he advanced to Longfellow's *Saga of King Olaf* and fell in love with the magic and pagan myths of Norse legend. By the age of twelve, there had grown in Lewis's mind an intense relationship with the world of fantasy and elves: 'I fell deeply under the spell of dwarfs -- the old bright-hooded,

snowy-bearded dwarfs we had in those days before Arthur Rackham sublimed or Walt Disney vulgarized, the earthmen. I visualized them so intensely that I came to the very frontiers of hallucination; once, walking in the garden, I was for a second not quite sure that a little man had not run past me into the shrubbery. I was faintly alarmed.'"[5]

Lewis's beloved mother had died when he and his brother were very young and they were left with their cold father who promptly sent them off to boarding school. It was there that Lewis's love for fantasy grew and initially took him in a darker direction:

"Although one would expect childhood fantasies to subside after a time, in Lewis's case they became more a delight as he grew older," noted Dager. "When Lewis was sent to boarding school in Hertfordshire, England, his first impression was one of revulsion toward the unpleasant urban environment compared to his Irish countryside. He immediately hated England. Of this same time he writes: 'I also developed a great taste for all the fiction I could get about the ancient world: *Quo Vadis, Darkness and Dawn, The Gladiators, Ben Hur* ... the attraction, as I now see, was erotic, and erotic in rather a morbid way... what I took to at the same time, is the work of Rider Haggard; and also the 'scientification' of H.G. Wells...the interest, when the fit was upon me, was ravenous, like a lust.' After advancing to preparatory school at Wyvern, Lewis gradually 'ceased to be a Christian.' He became interested in the occult and embraced an attitude of pessimism about what he considered a faulty world. His taste for the occult was nurtured and grew as he became enthralled with Wagnerian operas and their Norse sagas derived from Celtic mythology."[5]

Embracing a career in academia, Lewis continued in his fascination of all things fantasy and began to meet others who would both nurture his interest as well as lead him away from some of the more occultic elements of the world of fantasy he had developed such a fascination with. One of those new friends was a man whose works would also one day dominate the Silver Screen:

"At the age of twenty-seven, after having been elected Fellow

and Tutor in English Language and Literature at Magdalen College, C.S. Lewis met John Ronald Reuel Tolkien at a meeting of the English faculty at Menton College," continued Dager. "J.R.R. Tolkien, though wary of Lewis at first, enrolled him in the 'Coalbiters,' a club founded by Tolkien for the study and propagation of Norse mythology. The two became close friends, sharing their common interest in occult fantasy. Tolkien argued that there is an inherent truth of mythology: that all pagan religions point in the direction of God. Through this faulty argument, Lewis reasoned the story of Christ to be a 'true myth' -- a myth much the same as others, but a myth that really happened. It was during their long association that both Lewis and Tolkien developed their most prestigious 'sword and sorcery' material. Tolkien, of course, became well-known for his mythological tale, *The Hobbit*, and his later work, *The Lord of the Rings*, released as three volumes: *The Fellowship of the Ring, The Two Towers, and The Return of the King*. Lewis turned to expounding intermittently on Christian apologetics and to writing fantasy."[5]

Though his embrace of Christianity would take him away from the obviously occultic fantasy he had once been enthralled with, Lewis still professed to enjoy a good yarn, even if it sometimes included darker elements. But what made C.S. Lewis particularly engaging for much of Christendom in the 20th century and would cause one of Christianity's leading lights to label him "our patron saint" was his notion of *Mere Christianity*, an attempt to unite all Christians, or perhaps as many as possible, around certain core doctrines upon which, Lewis reasoned, there should be easy agreement. Author Steven P. Mueller noted Lewis's emphasis on such common elements:

"In the preface to *Mere Christianity*, Lewis explicitly noted his purpose: 'The best, perhaps the only, service I can do for my unbelieving neighbors is to explain and defend the belief that has been common to nearly all Christians at all times.' He decided not to discuss differences between denominations or attempt to convert anyone to his own Anglican faith. Instead, he presented the basic teachings of or-

thodox Christianity — teachings he labeled '*Mere Christianity.*' Lewis had three motives for this focus: First, he believed that the disputed doctrines required a depth of theological and historical understanding that he did not possess. He humbly considered others better qualified to discuss such topics. Second, Lewis said that this type of writing, while important for those who are already Christians, would not bring unbelievers into the church. His goal was not to persuade those who were debating which denomination to join or which congregation to attend; rather, he wrote for those who did not know Jesus Christ. Third, he noted that many writers already addressed the controversial points, but few focused on the basics. The emphasis on common teachings makes Lewis quite appealing. Nonbelievers find that he presents the central beliefs of Christianity clearly. Christians generally find significant agreement with his presentation."[7]

Central to Lewis's notion of *Mere Christianity* was his use of the metaphor of a hallway where those who were interested in the Christian faith could get their bearings before entering a particular "room."

"I hope no reader will suppose that 'mere' Christianity is here put forward as an alternative to the creeds of the existing communions — as if a man could adopt it in preference to Congregationalism or Greek Orthodoxy or anything else," Lewis wrote. "It is more like a hall out of which doors open into several rooms. If I can bring anyone into that hall I shall have done what I attempted. But it is in the rooms, not in the hall, that there are fires and chairs and meals. The hall is a place to wait in, a place from which to try the various doors, not a place to live in. For that purpose the worst of the rooms (whichever that may be) is, I think, preferable."[7]

Mueller concluded that although there was merit in Lewis's notion of the common hall, it had its limitations as well, noting that Lewis didn't intend for his readers to remain in the hallway forever:

"The 'common hall' of Christianity — the teachings and practices shared by all Christians — is not the end," noted Mueller. "Chris-

tians should rejoice in this commonality but not overlook the significant challenges that remain. Lewis encouraged those who have entered the common hall to seek a 'room' where true doctrine and holiness may be found, but he gave little counsel on which room to choose. He left that task to others. He did, however, caution Christians to be charitable toward those who dwell in other rooms and those who had not yet found a room of their own."[7]

While generally supportive of Lewis and his Common Hall, Christians like Mueller, associated with a theologically conservative group called the Christian Research Institute, were also cognizant of its challenges and limitations:

"Lewis's common hall is a helpful illustration of the common faith of the church, but it is accompanied by two challenges," he noted. "First, who determines what is common to all Christians? No individual Christian can express what is common only in terms of his or her church or his or her own particular beliefs. Lewis, consequently, was careful to note that his definition of *Mere Christianity* was not intended to be a summary of Anglicanism (though Anglican influences on Lewis's work are evident), nor was it meant to be a complete summary of his own faith. Some (including myself) have suggested that the ecumenical creeds comprise a summary of essential Christianity, yet not all Christians formally acknowledge the creeds. It may be simply that each reader has his or her own definition of *Mere Christianity* through which he or she evaluates Lewis's words; but, if the definitions vary, does a common hall truly exist? It is clear, moreover, that not all Christians share Lewis's beliefs on certain points. We will consider three of them: the authority of Scripture, the existence of purgatory, and the inclusivity of salvation. Lewis addressed other issues that are disputed by Christians as well, such as the nature of Christ's atonement, the existence of human free will, the depravity of fallen humanity, principles of Christian behavior, and the possibility of evolution."[7]

While Lewis was indeed admired by many modern Christians, there had long been a group of dissenters who were deeply suspicious

of his theological bonafides. Fundamentalists had long viewed Lewis with a wary eye and though grateful for his bringing Christian themes to the surface of popular culture, questioned a number of Lewis's views on several key issues of Christian dogma:

"Lewis claimed to have limited his apologetic writings to *Mere Christianity*, however, there were times when he addressed teachings that are not held by all Christians," noted Mueller. "He believed, for instance, that Scripture is in some sense the word of God, but he questioned its inerrancy. He also believed in the existence of purgatory, though he did not consider it to be a place of punishment. Lewis, rather, believed saved people were purified of their sins in purgatory before entering heaven itself. Another controversial belief he held was that a person could belong to Jesus Christ and be saved without necessarily knowing Him specifically. This is not exactly universalism, but it goes beyond the clear teaching of Scripture."[7]

In response to such perceived straying from their core beliefs, Mueller, like many other conservative Christians, merely concluded that Lewis was a writer not a theologian, and while noting the "flaws" in his theology, tended to overlook any inconsistencies they saw, focusing instead on the good that he had done in bringing Christian ideas to the masses:

"He was a human being who made a significant contribution, but his writings contain some flaws," Mueller noted. "A legitimate assessment of Lewis must account for both. Lewis offered a diverse yet consistent presentation of Christianity. Through many literary genres and in a variety of settings, he winsomely presented his faith to a modern audience. Though raised in a Christian home, Lewis abandoned his faith at a young age and became a self-professed atheist. He had many objections to Christianity and did not return to it until these objections were answered satisfactorily. With those answers, he answered the objections of others. His writings, therefore, focus on the most essential teachings of Christianity and on obstacles that unbelievers often face. Some of these obstacles are addressed in his apologetic works: Is

there a universal moral law? If so, must there also be a universal moral lawgiver? Is the universe a closed system, or is supernatural intervention possible? Is it logical to consider Jesus to be a good ethical teacher while denying His deity? Can miracles really occur? How can an omnipotent God allow suffering and still be good? Lewis addressed such questions with candor and ease. He, moreover, 'translated' theology into ordinary speech, making it more intelligible to laypeople. Part of the reason Lewis was able to do this is because he was a layman. He did not make his living from religious writing but from his secular professorship. This outsider status helped make him a more engaging and effective writer."[7]

Despite such generous assessments, suspicions lingered for at least some Christians on several key issues. The first had to do with Lewis's alleged "low" view of Scripture or an unwillingness to acknowledge that the Bible spoke without error. For much of the 20th century, Christians had been engaged in an intraparty fight over the role of Scripture. Was it truly God's words, or a collection of man's ideas about God? While these arguments raged between Modernists and Fundamentalists, Lewis, seemed to fully please neither camp:

"Attracted by Lewis's clear presentation of Christianity, readers often are surprised when they discover Lewis's assessment of the Bible," noted Mueller. "He discussed questions such as: What does it mean for Scripture to be 'inspired by God?' Is it true and trustworthy? At first glance, readers may assume that Lewis had a high view of Scripture. He had said that the Gospels were not myths. He had been critical of those who reject supernatural elements of Scripture and had observed that modern theologians often base their conclusions on naturalistic assumptions instead of the biblical text."[7]

Lewis seemed to have a strong sense of self-awareness, always cognizant of what his critics were saying about him. Attacked by both Fundamentalists and Modernists for different reasons, he addressed the questions swirling around his views:

"I have been suspected of being what is called a Fundamental-

ist," he once wrote. "That is because I never regard any narrative as un-historical simply on the ground that it includes the miraculous. Some people find the miraculous so hard to believe that they cannot imagine any reason for my acceptance of it other than a prior belief that every sentence of the Old Testament has historical or scientific truth. But this I do not hold, any more than St. Jerome did when he said that Moses described Creation 'after the manner of a popular poet' (as we should say, mythically) or than Calvin did when he doubted whether the story of Job were history or fiction."[8]

"Lewis believed that 'all Holy Scripture is in some sense — though not all parts of it in the same sense — the word of God.'" Mueller noted. "The book of Job, for instance, lacking historical details and context, appeared to Lewis to be unhistorical. The idea that the creation account in Genesis was derived from earlier mythical and pagan accounts did not trouble Lewis. These earlier stories were retold and modified (whether consciously or unconsciously) until they became an account of 'true Creation and of a transcendent Creator.' When this happens in Genesis, Lewis concluded, there is no reason to 'believe that some of the re-tellers, or some one of them, has not been guided by God.' In Lewis's thought, Genesis conveys divine truth but not necessarily scientific or historical truth; still, God reaches us through its message."[7]

"The total result is not 'the Word of God' in the sense that every passage, in itself, gives impeccable science or history," Lewis concluded. "It carries the Word of God and we (under grace, with attention to tradition and to interpreters wiser than ourselves and with the use of such intelligence and learning as we may have) receive that word from it not by using it as an encyclopedia or an encyclical but by steeping ourselves in its tone and temper and so learning its overall message."[9]

Lewis also wrote that, "the over-all operation of Scripture is to convey God's Word to the reader (he also needs inspiration) who reads in the right spirit, I fully believe. That it also gives true answers to all the questions (often religiously irrelevant) which he might ask, I don't.

The very kind of truth we are often demanding was, in my opinion, not even envisaged by the ancients."[10]

Although not quite as objectionable to Evangelicals as a "low" view of Scripture, Lewis's views on the issue of purgatory were still troubling to many, for he had somewhat wistfully once observed that he would prefer a place to go to before he went to heaven where he could be "cleaned up."[10]

Mueller noted that Lewis seemed to advance the idea in *The Great Divorce*, where "the damned are allowed a brief respite from their suffering to travel to the fringes of heaven. There Lewis showed the choices that they made in their earthly lives and demonstrated that their own rejection of God's grace had damned them. In Lewis's narrative, one of the damned spirits is told that if he doesn't return to hell, that place can be called purgatory."[11]

In *Letters to Malcolm: Chiefly on Prayer* Lewis unabashedly declared, "I believe in purgatory. Mind you, the Reformers had good reasons for throwing doubt on 'the Romish doctrine concerning Purgatory' as that Romish doctrine had then become."[10]

Whereas "Romish" doctrine saw purgatory as a place of punishment, Lewis himself believed it to be a place of purification. In *Mere Christianity*, he imagined Jesus addressing the issue this way:

"If you do not push me away, understand that I am going to see this job through. Whatever suffering it may cost you in your earthly life, whatever inconceivable purification it may cost you after death, whatever it costs Me, I will never rest, nor let you rest, until you are literally perfect — until My Father can say without reservation that He is well pleased with you, as He said He was well pleased with me."[12]

Lewis reportedly also wrote a friend shortly before his death saying, "When you die, and if prison visiting is allowed, come down and look me up in Purgatory."[13]

But nothing Lewis wrote would be as controversial as the accusation that Universalism, or the notion that salvation was possible apart from Christ, popped up from time to time in his work. Whereas

Purgatory was problematic for Biblical literalists who didn't find it in the text of Scripture, and a lower view of Scripture somewhat upsetting to them, Universalism was considered by most traditionalist Christians to be a deadly enemy of the faith, and anybody seen as advocating it would immediately be suspect. In Lewis's final *Narnia* book, *The Last Battle*, he offered the account of Emeth, a soldier who spent his life worshipping the god Tash.

"When the world of *Narnia* comes to its final end, Emeth finds himself in King Aslan's country before the Lion (Aslan) Himself," observed Mueller. "Emeth kneels before Aslan, expecting to be judged and executed, but Aslan welcomes him. Confused, Emeth asks if Aslan and Tash are names for the same God. Aslan emphatically asserts that He and Tash are opposites, and explains why Emeth has been saved."[7]

"I take to me the services which thou hast done to him, for I and he are of such different kinds that no service which is vile can be done to me, and none which is not vile can be done to him," Lewis had written in *The Last Battle*. "Therefore if any man swear by Tash and keep his oath for the oath's sake, it is by me that he has truly sworn, though he know not, and it is I who reward him. And if any man do a cruelty in my name, then though he says the name Aslan, it is Tash whom he serves and by Tash his deed is accepted."[14]

Lewis had also touched on a similar theme in *Mere Christianity*, where he laid out theology unencumbered by fiction:

"There are people in other religions who are being led by God's secret influence to concentrate on those parts of their religion which are in agreement with Christianity, and who thus belong to Christ without knowing it," he wrote. "For example, a Buddhist of good will may be led to concentrate more and more on the Buddhist teaching about mercy and to leave in the background (though he might still say he believed) the Buddhist teaching on certain other points. Many of the good Pagans long before Christ's birth may have been in this position."[15]

It was enough to cause many of Lewis's detractors to accuse him of believing that all who sincerely worshipped *a god* could be wel-

comed by *The God*, but others, like Mueller had a different interpretation of Lewis's words:

"A closer examination of *The Chronicles of Narnia* shows that Lewis was not a Universalist," Mueller noted. "Emeth does, indeed, arrive in Aslan's country, but all those who were truly serving Tash pass into Aslan's shadow. This damnation is irreconcilable with Universalism; if some are damned, then not all are saved. The passage in *Mere Christianity*, while holding out hope for a righteous pagan, also notes that many do not belong to Christ — even those who call themselves Christians may really be unbelievers. Throughout his writings, Lewis consistently maintained that hell exists. He explained in *The Great Divorce* 'there are only two kinds of people in the end: those who say to God, Thy will be done, and those to whom God says, in the end, Thy will be done. All that are in Hell, choose it. Without that self-choice there could be no Hell.' Lewis explicitly denied Universalism."[7]

Of Universalism, Mueller noted that the topic had come up in theological conversations between Lewis and fellow writer and friend, George MacDonald causing a disagreement among the two. Still, even as Mueller defended Lewis against the Universalist charge, he was clearly disturbed by what he considered Lewis's penchant for making theological pronouncements that Mueller believed to be suspect:

"When a reader asked why Lewis disagreed with George MacDonald on Universalism, Lewis answered, 'I parted company from MacDonald on that point because a higher authority — the Dominical utterances themselves — seemed to me irreconcilable with Universalism,' Mueller noted. "Lewis was not a Universalist; nevertheless, his description of salvation lacks biblical support. Lewis said salvation is through Jesus Christ our Lord but also asserted that a person might belong to Christ without realizing it or explicitly knowing Him. The only way to the Father is through the Son, but 'we do not know that only those who know Him can be saved through Him.' In other words, there can be anonymous Christians. It appears that here the medieval conception of the 'righteous pagan' influenced Lewis. The passage from

Mere Christianity describes such 'good pagans' who may have belonged to Christ. Elsewhere, Lewis suggested Akhenaten, Plato, and Virgil as examples of righteous pagans. The problem with Lewis's presentation is that he gives a specific answer about these cases without clear biblical support. God certainly can do whatever He pleases, and He alone sees and judges the heart, but Lewis's speculation on this topic goes beyond God's clear revelation. It is particularly disturbing that he did this in a children's story. The story of Emeth would have been no less compelling if Emeth had known and loved Aslan while his countrymen served Tash. Lewis did not present universalism, but through speculation he did cloud the issue of salvation."[7]

Although Lewis was never fully embraced by Fundamentalist Christians who would find plenty to quibble about when it came to his beliefs, to other Christians he remained, a much loved hero for their times who bravely took a stand for faith in the public square:

"Lewis's...concentration on the main doctrines of the church coincided with evangelicals' concern to avoid ecclesiastical separatism," noted *Christianity Today* in a 1993 essay and later, in 1998, the magazine declared that he had "come to be the Aquinas, the Augustine, and the Aesop of contemporary Evangelicalism."[17]

However, this love for Lewis may have extended too far for most in the Christian community who did not believe Mormons to be Christians, if Robert Millet, dean of Brigham Young University were to be believed. Of Lewis, Millet wrote that he was "well received by Latter-day Saints because of his broad and inclusive vision of Christianity."[18]

In the early 1900's the term Fundamentalist was coined by those inspired by a series of books called *The Fundamentals* and Fundamentalists had done fierce battle with Modernists over such issues as the reliability of Scripture. Evangelicalism, an off-shoot of Fundamentalism most prominently articulated by Evangelist Billy Graham, was essentially an attempt to put a friendly face on Fundamentalism by softening but not changing those fundamentals of the Christian faith.

Fundamentalists though largely overtaken by Evangelicals, still existed, though in far smaller numbers and were among Lewis's most vocal critics. The Evangelical desire to overlook Lewis's problematic theology was not shared by Fundamentalists who made no bones about their dislike of him.

"Lewis believed that we're to become 'gods,' an apparent affirmation of theistic evolution,"[19] noted one critical publication, *Biblical Discernment Ministries*. "He also believed the book of Job is 'unhistorical'...and that the Bible contained 'error'.. and is not divinely inspired...Lewis used profanities, told bawdy stories, and frequently got drunk with his students...Christians need to read more critically *The Abolition of Man, The Problem of Pain, Miracles, The Great Divorce,* and *God in the Dock.* For example, Lewis never believed in a literal hell, but instead believed hell is a state of mind one chooses to possess and become -- he wrote, 'every shutting-up of the creature within the dungeon of its own mind is, in the end, Hell.'"[20]

Of course it was nothing new for Fundamentalists to savage their less doctrinally rigorous Evangelical cousins. Billy Graham had been attacked for years for his willingness to cooperate with more liberal Christians who supported his evangelistic crusades, and his more conservative cousins were sometimes mocked as "Fighting Fundies," for their love of a good intraparty theological fight. True to form, this wing of Christendom remained unimpressed by both Lewis and his writings:

"If it is true to say that 'you are what you eat,' then it is also true to say that 'a Christian is what he hears and reads,' since this is how he gets his spiritual food," observed *Biblical Discernment Ministries*. "Thus if Christians are brought up on a diet of C.S. Lewis, it should not surprise us to find they are seeking 'to continue the legacy of C.S. Lewis.' The apostle Paul said, 'a little leaven leaveneth the whole lump.' Thus, if evangelicals read and applaud such books as *Mere Christianity*, it should come as no surprise if we find them 'working towards a common mission' with the enemies of the gospel. The young Christian should be

very careful what he reads, and those in positions of authority (pastors, teachers, parents) should be very careful what they recommend others to read."[18]

Still, for the most part, modern conservative Christians loved Lewis and Lewis himself was well aware of his Christian constituency in the United States in particular and once granted an interview to the writer Sherwood Wirt who was affiliated with Billy Graham and his magazine, *Decision*. It was 1963, shortly before Lewis's death and at least some American Christians were still suspicious of the British professor who professed to be a Christian, but drank, smoked and wrote books about witches. Wirt would be the proxy interviewer for millions of them and the resulting interview, one of the last given by Lewis, would appear in Graham's magazine. It was May 7th, just six months before Lewis's death, when Wirt paid his visit.

"I sat in Professor Lewis's quarters in Magdalene College, Cambridge University, for what became among the most fascinating 90 minutes of my life," Wirt later wrote. "Not only was this quiet man the most educated, the most brilliant person I had ever met; he was also one of the most thorough and solid believers in Jesus Christ. Four decades have passed since that interview, and only now am I realizing the depth of its significance."[21]

Though always respectful in tone, Wirt appeared to be asking questions with his proxy role in mind, eager in his apparent attempts to tease out of Lewis a bold and unambiguous declaration of faith in Jesus Christ. Wirt began his interview by asking how Lewis would advise a hypothetical young writer who was intent on writing about Christian themes:

"I would say if a man is going to write on chemistry, he learns chemistry. The same is true of Christianity," Lewis responded. "But to speak of the craft itself, I would not know how to advise a man how to write. It is a matter of talent and interest. I believe he must be strongly moved if he is to become a writer. Writing is like a 'lust', or like 'scratching when you itch'. Writing comes as a result of a very strong impulse,

and when it does come, I for one must get it out.... there is no formula in these matters. I have no recipe, no tablets. Writers are trained in so many individual ways that it is not for us to prescribe. Scripture itself is not systematic; the New Testament shows the greatest variety. God has shown us that he can use any instrument. Balaam's ass, you remember, preached a very effective sermon in the midst of his 'hee-haws.'"[21]

Wirt was a canny interviewer who seemed to have made it his mission to use the occasion to coax orthodox answers out of his charge and wondered aloud in front of Lewis if his secret of success in conveying orthodox Christian notions so effectively to a wide mainstream audience might have been rooted in his famed "light touch," when it came to explaining weighty theological topics.

"I believe this is a matter of temperament," Lewis replied. "However, I was helped in achieving this attitude by my studies of the literary men of the Middle Ages, and by the writings of G.K. Chesterton. Chesterton, for example, was not afraid to combine serious Christian themes with buffoonery. In the same way, the miracle plays of the Middle Ages would deal with a sacred subject such as the nativity of Christ, yet would combine it with a farce.... I think that forced jocularities on spiritual subjects are an abomination, and the attempts of some religious writers to be humorous are simply appalling. Some people write heavily, some write lightly. I prefer the light approach because I believe there is a great deal of false reverence about. There is too much solemnity and intensity in dealing with sacred matters; too much speaking in holy tones...there is a difference between a private devotional life and a corporate one. Solemnity is proper in church, but things that are proper in church are not necessarily proper outside, and visa versa. For example, I can say a prayer while washing my teeth, but that does not mean I should wash my teeth in church."[21]

It's not clear what if any charge Wirt had been given by his boss, Billy Graham, or if Graham had even known ahead of time about the interview, but what was undeniable was that Graham and Wirt's readership was, if not Fundamentalist in its outlook, nonetheless op-

posed theological liberalism and Wirt managed to elicit a response that was sure to please such readers when he despaired to Wirt about the liberalism that had infiltrated much religious writing:

"A great deal of what is being published by writers in the religious tradition is a scandal and is actually turning people away from the church," Lewis said. "The liberal writers who are continually accommodating and whittling down the truth of the Gospel are responsible. I cannot understand how a man can appear in print claiming to disbelieve everything that he presupposes when he puts on the surplice. I feel it is form of prostitution."[21]

Wirt appeared equally intent on eliciting a clear response from Lewis on one key theological question that had proved to be the raison d'etre of Billy Graham's burgeoning Christian movement: the importance of making a decision to accept the claims of Christ and thus become a Christian. While some wings of Christendom held to infant baptism or confirmation as a means of entering the Kingdom of God, Evangelicalism believed in the importance of the decision, and it was no coincidence that Graham's magazine went by that name. Each night at his crusades Graham fished for decisions, decisions to move away from or toward God, and Wirt pursued Lewis on his views on the subject by first inquiring about whether Lewis still believed in the divinity of Christ, a doctrine of utmost importance to most serious Christians.

"You wrote 20 years ago that 'a man who was merely a man and said the sort of things Jesus said would not be a great moral teacher. He would be either a lunatic on a level with a man who says he is a poached egg or else he would be the Devil of Hell. You must make your choice. Either this man was, and is, the Son of God: or else a madman or something worse. You can shut Him up for a fool, you can spit at Him and kill Him as a demon; or you can fall at His feet and call Him Lord and God. But let us not come any patronizing nonsense about His being a great human teacher. He has not left that open to us. He did not intend to.' Would you say your view of this matter has changed since then?"

"I would say there is no substitution change," Lewis responded.

Like a prosecutor intent on using his witness's previous statement to take him to an area he didn't want to go to, Wirt proceeded:

"Would you say that the aim of Christian writing, including your own writing, is to bring about the encounter of the reader with Jesus Christ?"

"That is not my language, yet it is the purpose I have in view," Lewis responded diplomatically. "For example, I have just finished a book on prayer, an imaginary correspondence with someone who raises questions about difficulties in prayer."[21]

One of the key components of modern Evangelicalism was the notion that it was the sacred duty of each and every Christian to evangelize, or spread the news about Christ to friends, family and colleagues. Seizing on and taking quite literally Christ's words known as "The Great Commission," in which He had told his disciples to: "Go ye into all the world and proclaim the Gospel," modern Evangelicalism and Fundamentalism were both quite different from an older, more polite form of Christianity that seemed intent on keeping religion a private matter. In contrast, this new muscular form of Christianity exhibited by Graham insisted on creating opportunities to meet God. Was Lewis just a keen observer who liked to ponder religious thoughts in print, or an active evangelizer intent on seeing non-Christians become Christians? Wirt prodded Lewis further, intent on finding out on behalf of his readership:

"How can we foster the encounter of people with Jesus Christ?" he asked.

"You can't lay down any pattern for God," Lewis responded. "There are many different ways of bringing people into His Kingdom, even some ways that I especially dislike! I have therefore learned to be cautious with my judgment. But we can block it in many ways. As Christians we are tempted to unnecessary concessions to those outside the Faith. We give in too much. Now, I don't mean that we should run the risk of making a nuisance of ourselves by witnessing at improper times, but there comes a time when we must show that we disagree. We

must show our Christian colors, if we are to be true to Jesus Christ. We cannot remain silent or concede everything away. There is a character in one of my children's stories named Aslan, who says, 'I never tell anyone any story except his own.' I cannot speak for the way God deals with others; I only know how He deals with me personally. Of course, we are to pray for spiritual awakening and in various ways we can do something toward it. But we must remember that neither Paul nor Apollos gives the increase. As Charles Williams once said, 'the altar must often be built in one place so that the fire may come down in another place.'"[21]

It was a solid answer to be sure, but Wirt was not through and pressed in further, pursuing a line of questioning that seemed intent on trying to get at the key question of the importance of individual choice and decision in the salvation process. Was faith something that was mysteriously bestowed only on the chosen, or a gift that God made available to all but which had to be received? Wirt was determined to get an answer out of Lewis:

"In your book *Surprised by Joy* you remark that you were brought into the Faith kicking and struggling and resentful, with eyes darting in every direction looking for an escape," Wirt noted referencing Lewis's autobiography. "You suggest that you were compelled as it were, to become a Christian. Do you feel that you made a decision at the time of your conversion?"[21]

Lewis likely knew exactly what Wirt was trying to get him to say and refused to bite:

"I would not put it that way," he responded. "What I wrote in *Surprised by Joy* was that 'before God closed in on me, I was in fact offered what now appears a moment of wholly free choice.' But I feel my decision was not so important. I was the object rather than the subject in this affair. I was decided upon. I was glad afterwards at the way it came out, but at the moment what I heard was God saying, 'put down your gun and we'll talk.'"[21]

"That sounds to me as if you came to a very definite point of

decision," Wirt persisted.

"Well, I would say that the most deeply compelled action is also the freest action," Lewis parried back. "By that I mean, no part of you is outside the action. It is a paradox. I expressed it in *Surprised by Joy* by saying that I choose, yet it really did not seem possible to do the opposite."[21]

Appearing to be vaguely unsatisfied with that answer, Wirt would later in the interview re-approach the subject from a different angle, still appearing to try to get to the bottom of the question of Lewis's view of "the decision" for Christ:

"Do you approve of men such as Bryan Green and Billy Graham asking people to come to a point of decision regarding the Christian life?" Wirt asked.

"I had the pleasure of meeting Billy Graham once. We had dinner together during his visit to Cambridge University in 1955, while he was conducting a mission to students," Lewis remembered. "I thought he was a very modest and a very sensible man, and I liked him very much indeed. In a civilization like ours, I feel that everyone has to come to terms with the claims of Jesus Christ upon his life, or else be guilty of inattention or of evading the question. In the Soviet Union it is different. Many people living in Russia today have never heard of those claims. In the same way, we who live in English-speaking countries have never really been forced to consider the claims, let us say, of Hinduism. But in our Western civilization we are obligated both morally and intellectually to come to grips with Jesus Christ; if we refuse to do so we are guilty of being bad philosophers and bad thinkers."[21]

It was an answer that apparently satisfied Wirt as the conversation moved on to other fundamental questions that would help reassure American Evangelicals and convince them that Lewis was one of them: Did Lewis, as Evangelicals like Graham emphasized, read his Bible and pray daily? Lewis may have been unaccustomed to being asked in such a forthright manner about his spiritual practice, but Wirt pressed in:

"We have our New Testament regimental orders upon the subject," Lewis responded with characteristic aplomb. "I would take it for granted that everyone who becomes a Christian would undertake this practice. It is enjoined upon us by Our Lord; and since they are His commands, I believe in following them. It is always just possible that Jesus Christ meant what He said when He told us to seek the secret place and to close the door."[21]

Several more key questions that would help ascertain Lewis's Christian credentials remained unasked and Wirt wasn't about to miss any of them. American Christians had long complained about the coarsening of the nation's popular culture and Wirt inquired as to whether or not Lewis believed that "the use of filth and obscenity is necessary to establish a realistic atmosphere in contemporary literature?" and whether popular culture was being de-Christianized:

"I do not," Lewis responded, about the desire on the part of some to create a "realistic atmosphere." "I treat this development as a symptom, a sign of a culture that has lost its faith. Moral collapse follows upon spiritual collapse. I look upon the immediate future with great apprehension..... I cannot speak to the political aspects of the question, but I have some definite views about the de-Christianizing of the church. I believe that there are many accommodating preachers, and too many practitioners in the church who are not believers. Jesus Christ did not say, 'Go into all the world and tell the world that it is quite right.' The Gospel is something completely different. In fact, it is directly opposed to the world. The case against Christianity that is made out in the world is quite strong. Every war, every shipwreck, every cancer case, every calamity, contributes to making a *prima facia* case against Christianity. It is not easy to be a believer in the face of this surface evidence. It calls for a strong faith in Jesus Christ."[21]

Finally, pre-dispensationalist millennialism, the notion that Christ's return to earth to rapture his church was imminent, was a staple among many Evangelicals. Wirt appeared to be looking for Lewis's opinion on this hot topic when he asked for his views on the future, the

end of the world and what he thought it held:

"I have no way of knowing. My primary field is the past," Lewis countered. "I travel with my back to the engine, and that makes it difficult when you try to steer. The world might stop in minutes; meanwhile, we are to go on doing our duty. The great thing is to be found at one's post as a child of God, living each day as though it were our last, but planning as though our world might last a hundred years. We have, of course, the assurance of the New Testament regarding events to come. I find it difficult to keep from laughing when I find people worrying about the future destruction of some kind or other. Didn't they know they were going to die anyway? Apparently not. My wife once asked a young woman friend whether she had ever thought of death, and she replied, 'by the time I reach that age science will have done something about it!'"[21]

Though Lewis appeared to be on the hot-seat, grilled by Wirt as if the authenticity of his faith were on the line, Wirt would later recall that it was he who had been profoundly affected by the encounter:

"Professor Lewis is now considered the outstanding Christian author of the 20th century. Forty years after his death his books are still best-sellers," Wirt later observed. "Just what was it that made his writings so significant and popular? What was it that made me realize that I needed to overhaul my own theology and bring it out of the church's broom closet? I don't like to write this, but it was God Almighty. Admitting he was neither theologian nor clergyman but only a layman in the Church of England, Mr. Lewis stirred churchgoers all over the world by the depth of his faith in Jesus Christ."[21]

Long looked upon at the time with suspicion by some Christians in the United States, the grilling by Billy Graham's trusted associate Sherwood Wirt was instrumental in giving many American Christians a certain comfort level with Lewis. Perhaps chalking up his drinking and smoking to his being European, and overlooking his sometimes problematic theology, they nonetheless over the next four decades voted with their pocketbooks, declaring that Lewis was one of

them by making his books like *The Screwtape Letters* and *Mere Christianity*, as well as *The Chronicles of Narnia*, perennial bestsellers.

Chapter Eight
On Location

As *The Chronicles of Narnia's* development continued, and Andrew Adamson who had won the coveted role of director was busy scouting locations around the world, finally settling upon his native New Zealand and the Czech Republic. By early summer 2004, Walden and Disney made it official:

"*The Chronicles of Narnia: The Lion, the Witch and the Wardrobe* will film on both the north and south islands of New Zealand over a five-month period," the companies announced in a joint press release. "After almost four months of sound stage work in Auckland, the company will move to the breathtaking locales of Queenstown, Oamaru and the Christchurch area in the nation's south island before heading to London and the Czech Republic for additional filming. Production will conclude in January, 2005, before Adamson embarks on a yearlong post-production schedule leading to the December, 2005, worldwide release."[1]

"In C.S. Lewis' timeless literary classic, *The Lion, the Witch and the Wardrobe*, the portal to the magical land of *Narnia* is discovered by four siblings within an old wardrobe in an elderly professor's country home outside of London," observed *IGN Filmforce*. "In director Andrew Adamson's movie adaptation of Lewis' beloved book, that entryway into the land of giants and fauns frozen under the icy spell of the evil White Witch is situated in an old equestrian center about 30 kilometers outside of Auckland, New Zealand, one of three facilities being used by the production for various sets (both interior and exterior)

designed and constructed for the Disney/Walden Media film."[2]

Before shooting began in late June of 2004, Adamson and his team of 40 arrived in West Auckland and were welcomed by Waitakere City Council Mayor Bob Harvey who expressed his excitement about the revenue his city was scheduled to enjoy as a result of the shoot as well as the jobs that were to be created. For obvious reasons, another who was excited about the prospect of having the series of films filmed in New Zealand was WETA head Richard Taylor, since the location would allow Taylor and his team to be able to work from their home base:

"We're very thrilled it was chosen to be shot here because our workshops are here," he noted. "Imagine how difficult it's been for Howard having to bring the people from his workshops down to New Zealand for the opportunity to make this project. We've got the great luxury of going back to Wellington and a one-hour flight north or south, we'll be able to shoot the stuff that we've made."[3]

While some producers tended to be detatched from their productions once shooting was underway, Douglas Gresham was a hands-on presence who made several trips to the set throughout the long shoot, ensuring in every way possible that the film remained true to the intentions and values of his late step-father.

"I made three or four trips out there last year spending a total of probably about four or five very enjoyable weeks in all," Gresham recalled. "It's a bit hard to remember exactly as the time seemed to go past very quickly while I was there, but when I got home after spending a week or so in Narnia, it seemed as if I had been away for ages and yet no time had passed. I suppose I should have expected that....for the most part it has been a very enjoyable time. The crew were all extremely nice people as also were the cast. I never encountered any nastiness on set or at any of our locations from anyone, and that is pretty rare in filmmaking. Come to think of it, it's pretty rare in any endeavor. One of my particular friends on set was annoyed by something on one occasion so she went off and sat by herself for a few minutes until she had

overcome her annoyance. She did not blaze up at anyone, or inflict her feelings on anyone else. I found that interesting, for while she is a pretty impressive person in her own right, it seemed to me to be what I would expect from members of that crew. An atmosphere of friendship and good-heartedness pervaded the work; in fact it was a bit like being in *Narnia* during the Golden Age. Andrew is a very nice bloke, and has a way of applying quiet charm to get things done his way."[4]

While Gresham's presence as co-producer loomed large, the day-to-day tasks of producing the film belonged to veteran producer Mark Johnson who planned the shooting schedule for *The Lion, The Witch & The Wardrobe*. Utilizing his years of experience on a variety of films like *The Alamo* and *The Rookie*, Johnson laid out a schedule that was, at least by industry standards, fairly relaxed.

"The first half, we're looking at an approximately 100 day shooting schedule, half of that, approximately, will be shot in and around Auckland," observed Johnson. "And we're going to do our studio work here, and then use some local locations. And then we will move sometime in the end of September, to the South Island, and shoot in a number of different locations."[5]

Adamson, known for his careful and methodical approach to filmmaking, took advantage of the generous schedule by paying careful attention to details, especially in his attempt to recreate Mr. Tumnus's home as he sought to bring key details of the book to life:

"The interior of Mr. Tumnus' house, as illustrated by Pauline Baynes for Lewis' book, included two lounge chairs, a dining table, a mantle and fireplace, a bookshelf and hutch," noted *Narniaweb*. "Adamson has imagined a setting very similar in his collaborations with production designer Roger Ford and set decorator Kerrie Brown...the inspiration for the exterior of Mr. Tumnus' house was a structure seemingly built into rocks in the Czech Republic. For the inside, Baynes' drawing served as Adamson's and Ford's inspiration in envisioning Tumnus dwelling, a cavernous space cluttered with bookshelves (over 30 cartons of vintage books were rented from shops around Auckland),

chairs, a table, fireplace and an iron stove....the dozen or so pieces of prop furniture fashioned for the three-day scene were created under the supervision of two key Kiwi craftsmen on the project – Roger Murray, who runs the prop making department, and Adrian Bennett, who supervises the prop furniture. With the exception of Mr. Tumnus' chair (re-fashioned from one found by Brown in a Sydney antiques shop), everything was manufactured from scratch, including the dishes and tea set that adorn the dining table."[6]

With preparations successfully completed, on June 28th 2004, shooting finally commenced in New Zealand and Adamson immediately surprised the filmmaking world by announcing that he would be filming his first live-action film in sequence. While most filmmakers shot their films with little or no regard to the actual sequence of the film, shooting ending scenes at the beginning and vice versa, Adamson chose a different path, beginning at the beginning and filming in sequence the rest of the way.

"His first 17 days of production depicted the evacuation of the four siblings from their war-torn London home out to the pastures of rural England (the lush, green hills of the Tahekeroa District some 45 km from Auckland)" noted one observer, "and their relocation into the plush surroundings of the kindly Prof. Kirke's Victorian country home (built on sound stages at Auckland's Henderson Studios), where the youngster Lucy unexpectedly discovers the magical wardrobe while playing hide-and-seek with her family."[2]

Adamson, Johnson and crew had carefully chosen an abandoned riding center to serve as *Narnia* and after the first two weeks of shooting was in the can, moved cast and crew to the new location. The riding center's natural beauty was supplemented by trees and a magical, if artificial, landscape of snow:

"Adamson... led his cast and crew into Narnia for the very first time as he filmed actress Georgie Henley's (playing Lucy, the youngest of the four Pevensie children) first footsteps into the sprawling, snowy landscape envisioned by production designer Roger Ford on a set that

measures approximately 80x50x18 meters," observed *IGN Filmforce*. "The Narnian landscape is one of over two dozen sets being created by Oscar-nominated production designer Ford, who was inspired by the wintery countryside found when the filmmakers visited the Czech Republic in 2003 in their search for a place to mount the film project (Ireland and Chile were also scouted as possible locations for the film). The now-defunct riding center had the necessary dimensions for the first Narnian set, christened Lantern Waste by the filmmakers. In addition to the creative visions of director Adamson and designer Ford, two other film craftsmen were key in creating the eye-popping magic envisioned by Adamson – head greensman Russell Hoffman, who 'planted' almost 200 trees (firs, pines and oaks) to create the dense frozen forest, and special effects supervisor Jason Durey, whose crew dusted the icy snowscape with over 28,000 lbs. of insulating foam, 'paper' snow and a detergent (called 'Snow Business') that turns into wet, falling snow when blown through a special compressor."[2]

While shooting was taking place in New Zealand, controversy swelled stateside over issues related to music. A Disney music executive had suggested the rock band Evanescence as a possible artist to sing the film's theme song and shortly after taking a meeting with the group's singer Amy Lee during which the issue was discussed, Lee gave an interview to *MTV* in which she all but killed her chances of ever being in the film. It wasn't the first time Lee had used the media to damage her career. In 2003, Lee and her bandmate Ben Moody had given an expletive-laden interview to *Entertainment Weekly* which had resulted in the band's CD's being banned from Christian-oriented retail outlets which until then had eagerly carried them. Previously thought to be devout Christians, Lee and Moody responded to questions from *EW*'s Chris Willman with near-denials of their faith and a request to have their music pulled from such chains, a request the latter was only too happy to oblige.

"Lee has also been working on music for the upcoming film *The Chronicles of Narnia: The Lion, The Witch & The Wardrobe*, inspired

by the children's book by C.S. Lewis," *MTV* declared. "The dark and morose tale, about four children who discover a magical land in the clutches of an evil witch, not only was a childhood favorite of Lee's, but its aesthetic suits the gothic-leaning singer perfectly."[7]

Walden Media had long anticipated a two-pronged marketing campaign that would quietly target traditionalist filmgoers with obvious nods to Lewis's faith and the true identity of Aslan while maintaining strong mainstream credibility for the overall film. As such they were not likely eager to have their children's tale positioned as "dark and morose," and were likely further shocked when Lee described the series in equally disturbing terms:

"I love the kind of stranger children's stuff," Lee declared. "I think that's very much what our music is inspired by. Not only death and the morbid stuff, but that it comes from the perspective of a child and things relating to childhood, because that's what I went through."[7]

"Lee was offered a small role in the film, currently in production in New Zealand, but considering the role she requested, the film's producers may have been too freaked out to give her a part," *MTV* noted, quoting Lee as saying, "They were like, 'Do you want to do a cameo?' And I was like, 'Hell yeah! Let me die. I want to be somebody who gets murdered.' So I don't think that's going to happen."[7]

Lee was right about that. A singer begging to be a murder victim who saw an ultimately uplifting children's tale as "dark and morose" was not exactly who the producers likely had in mind for the film, and she was quickly distanced from it by executives who were hoping to market to members of the red states, not scare them away. For their part, Disney music executives were defensive of Lee, noting that she herself was a Christian, but Walden executives made it clear that the discussions which had gone on between Disney and Lee were merely speculative and that no offer had been made regarding her involvement in any aspect of the film.

Back on the set, however, trouble of a different sort was brewing between the production team and local environmentalists, unhappy

with what they believed were special concessions being made to the production in exchange for the millions of dollars that were to be pumped into the local economy. On November 8th, 2004, with production just a month from completion, The Royal Forest and Bird Protection Society issued a press release listing their grievances with the production crew and more specifically with the local district council which had approved the production's requests.

"The Selwyn District Council appears to be applying an environmental double standard to ensure no obstacles are placed in the way of multi-million dollar overseas film production *The Lion, the Witch and the Wardrobe*," the group stated in their complaint. "Forest and Bird is concerned that five meter wide new roads with substantial earthworks, cuts and high batters have been constructed through an area of outstanding natural landscape above Cave Stream on Flock Hill Station adjacent to the scenic Arthur's Pass Highway corridor. The roads are to provide access to one of the locations for the filming of *The Lion, the Witch and the Wardrobe*. This was in spite of the construction work clearly breaking rules in the Council's own planning documents requiring a consent to be granted before work could begin, and acknowledgement in the plan that the area had outstanding natural landscape values and features. Even then construction work was allowed to continue while the consent was being applied for and processed. The consent has since been granted by council staff without public notification or even any referral to the councilors themselves who represent the public interest in this matter."[8]

Selwyn officials were quick to deny that they had either approved the destruction of any natural habitat or shown favoritism of any kind toward the *Narnia* production team. For their part, a representative of the *Narnia* production also denied not following correct procedures:

"We wanted to make it work there (Flock Hill) and did everything they asked of us,"[9] said the film's spokesman Ernie Malik.

It wasn't the first dustup or hint of controversy in the process

of bringing *The Chronicles of Narnia* to the big screen, nor would it be the last and as production shifted into high gear, the focus for many Narnia fans turned to the set where an unusual marketing strategy that involved giving key leaders access to the set was about to kick in.

Before shooting wrapped in late December, several groups of journalists and other key figures were invited to the set to get a look at the *Narnia* set and were given access to many of the key players. One group however, consisting of important religious leaders organized by an outside consultant hired by Disney, Paul Lauer, which was initially scheduled to travel to New Zealand was canceled at the last minute. Though the cancellation was attributed to a scheduling conflict it may have had more to do with Disney getting cold feet about such a nakedly religious appeal. But one group that wasn't disinvited included a writer known as Indiana Sev of the *Joblo.com* website, and upon his return he quickly spread the word among faithful *Narnia* fans of what was happening in New Zealand. Among the first independent reports from the set, Sev claimed to have initially been hesitant about traveling to Narnia, but after deplaning in New Zealand found himself at the production offices and his own magical adventure into the land of Narnia quickly commenced:

"Things got started pretty quickly, as we were whisked off to the sound stages and production offices of the film soon after checking into our hotel rooms in the city of Auckland," he observed. "Ernie Malik, the film's location publicist was the one who showed us around for most of our five-day tour and coordinated the cast & crew interviews that we did. As far as the sets go, we were asked not to take photographs so I'll describe, as best I can, what I saw. The White Witch's Courtyard was the first one we were taken to and it was easily the one that impressed me most. We saw close to two-dozen life-size creatures (meaning there weren't any miniatures), frozen in statuesque form and in mid-animation; all very eerie, precise and realistic. 90+ creatures, we were told, had been constructed in this form. The other statues will be used in the lengthy final battle between good & evil at the tail end

of the film. The gray and stony centaurs (male & female), hedgehogs, lions, boars, bears, rhinos and the rest all looked truly extraordinary but nothing was more awing and magnificent than Rumblebuffin the giant, frozen in space with his weapon raised above his head (in mid-battle) with that horrific, fierce look on his face. Close to three times my height, it was odd to see the giant that I had read about for the first time on the plane just a few hours ago, in front of me and among all the rest of Aslan's virtuous 'soldiers' – dead, for the time being."[10]

Sev was one of several journalists allowed to roam the set for nearly a week and he moved from one soundstage to another where he was given sneak peeks at several of the different key locations where stories that were central to the film were to be played out:

"The next soundstage we visited was the White Witch's Great Hall, as they've come to call it," recalled Sev. "It was a colossal, completely iced over, ballroom-like locale which showcased at the far end her glorious and immense throne (naturally larger than normal as the witch is larger than humans, as mentioned in the book). Huge columns surrounded the room and a large green screen enveloped the entire background of the area as they intend to make the room even larger in scope and feel. A crewmember was walking around with a special video-recorder capturing every angle and dimension of the place, which was in turn being fed into a nearby computer. This would allow them free reign to manipulate the entire 3D range of the witch's hall. All that to say it would look even more grandiose than it already was. Again, having just pictured this room a little earlier during my reading, I was happily surprised to see the vision they ended up with for this place. This is the room in which Edmund shows up about halfway through the book, without his siblings, much to the dismay and fury of the Witch. That scene, we were told, had already been shot."[11]

Another journalist who toured the set, Glen Bucher, offered up his observations in a report for the website *Comingsoon.net* in early December as shooting was preparing to wrap, but unlike Sev, Bucher had no hesitations about visiting Narnia and immediately leapt at the

opportunity:

"When I was asked to go to New Zealand to take a look at the filming, I realized that it had been over 20 years since I had read the stories, but I still had very strong and fond memories of them," he recalled. "Moments after I said 'yes, I'll go,' I dashed up to my game room/library and started sorting through all of my boxes of old books that I had yet to unpack from a move four years ago. After a thorough search, I had collected my complete set of *The Chronicles of Narnia*. The pages had yellowed and, even with the packing, a layer of dust had collected upon them. A quick swipe of my hand and the familiar faces of the Pevensie children were staring back at me. To my mild surprise, the books were all much shorter than I remembered. At ten, 186 pages seemed like an incredibly large tome to wade through. Now it seemed best to wait to reread it until the plane trip to the filming locations in New Zealand so that they would be fresh on my mind, and to give me something to do during the flight."[12]

Bucher captured the difficulty Andrew Adamson would have in attempting to translate *Narnia* to the big screen in light of C.S. Lewis's lack of attention to certain details as the work transitioned from printed word to visual image:

"C.S. Lewis never really described some of the locations in the book, leaving the reader to fill in the gaps," noted the journalist. "Andrew Adamson decided that he would not make the movie directly from the book, but make a movie of how he remembered the book to be, filling in those gaps. Coming back to the story after twenty years and getting a preview look into Adamson's vision, I have to say that I am very happy and excited by it. The entire story is there, and it will be presented in a state-of-the-art way. You can see it in the attention to detail in the sets, as well as the passion that many of the people working on the movie so clearly show for books."[12]

Bucher's foray onto the set of the *The Lion, The Witch & The Wardrobe* unearthed an important clue about the film: a great deal of the work would follow the actual shooting of the film, rendered in digi-

tal studios months after the sets had been broken down.

"While walking through this set we had to dodge several men with military grade laser range finders," he noted. "The entire set, down to handprints in the molded walls, was being digitally rendered so that the CGI effects could be seamlessly meshed with the physical set. Giant translucent ice columns rose forty feet up into the rafters (special effects plans on doubling that), the walls also have the same ghostly green ice effect."[12]

Still another visitor to the set, going by the name Tehanu, filed a final report for the website *theonering.net* on January 22nd, detailing a visit to the Witch's house:

"Things are a lot quieter in the Henderson film lot, and I have the chance to watch people preparing some of the other sets," he observed. "The first thing I see is the great hall in the Witch's House. Again, it's built inside one of the big packing sheds that are used as soundstages, but once inside you forget that. The set builders have made a grim, grey, imposing space. The architecture is not exactly spiky, but the details on the walls are full of angles, like Art Deco only more threatening. Ranks of icebound pillars march down either side of the hall, and stalactites hang from above. It is truly a winter palace. It's a place designed to put the White Witch's subjects in their place. The main floor is a sunken court surrounded by steps on all sides - no doubt the Queen's guards and bullies can look down from there onto anyone standing before her throne."[13]

Ever the dutiful fanzine correspondent, Tehanu had heard a disturbing rumor on a previous visit that the children had been spotted rescuing Edmund instead of Aslan, and had come to wonder if that meant a diminished role for Aslan.

"What if Aslan doesn't rescue Edmund?" Tehanu asked. "I'm able to ask the film's publicist, Ernie Malik, about this apparent plot change. He stresses that the film follows C. S. Lewis's works very closely and keeps its themes intact. The official word on that is, Lamp Post Productions confirms that Edmund's rescue is very faithful to Lewis'

book. There's a point beyond which it doesn't pay to press my informant too hard, so I leave it at that… Edmund may be imprisoned, and the children may intend to rescue him, but apparently they do not carry out their plan. The Beavers are there, after all, to warn them not to attempt it. There is time for Edmund to be taken away on the dreadful sleigh journey by the Witch first, and her plans for him can be thwarted by Aslan as in the book…. Certainly the Stone Table exists for Aslan's pivotal scene, and film crews have been working around it for over two weeks."[13]

The very fact that grown men and women would travel thousands of miles and report so breathlessly about the latest developments on the set of the first in the *Narnia* series was something of a testament to the power that the magical story of *Narnia* had over its fans. It was also a testament to a marketing strategy that understood that energized fans would report back to their counterparts in the United States and keep interest in the film alive. The selling of *Narnia* was well under way.

Chapter Nine
Selling Narnia

It was C.S. Lewis's good fortune that his series of beloved books would come to the big screen on the heels of Mel Gibson's ground-breaking film *The Passion of the Christ*, a film which had broken all the rules of filmmaking yet took in an astounding $115 million in its first five days of release. In the months leading up to the release, the conventional wisdom in Hollywood had held that Gibson was setting himself up for a major fall, for not only was he attempting to make a film about the life of Jesus which was based on a book, *The Dolorous Passion of Our Lord Jesus Christ*, which some Jewish leaders considered anti-Semitic, he was doing it with subtitles in a long-forgotten language called Aramaic. There was also the matter of the film's over-the-top violence and what was certain to be an *R* rating. But Hollywood hadn't factored into its calculations a massive hunger on the part of traditionalist Christians for films that affirmed their values, and a canny marketing man named Paul Lauer.

Lauer was a devout Catholic who had deftly managed to put together what he called "channel partners" comprised of like-minded traditionalist groups who would help him promote *The Passion* and bring out a massive audience of devout Christians to theaters. Most of the channel partners were not paid, but were often rewarded with personal visits with Mel Gibson and invited to Gibson's office for a private screening of the film. Lauer had managed to assemble a rag-tag group of co-belligerents across the nation, all united for various reasons behind his effort to turn out a massive audience to see Gibson's film

and his genius was in finding key players with massive rolodexes to help him as consultants, with fees ranging from nothing to $50,000, often the former.

In 2004, a year out from *Narnia's* release, Lauer was hired by Disney to market the film to the faith community. Months later his work would be complimented by publicist Jonathan Bock who ran the marketing firm called Grace Hill Media. Bock had worked for a time in the marketing department of Warner Brothers, before he discovered his niche as a go-to-guy to reach evangelical Christians and traditionalist Catholics who were not heretofore known as big consumers of Hollywood films.

Bock who got his start first as a sitcom writer and later as a publicist in the Warner Brothers shop was aptly described by the *Los Angeles Times* as a "churchgoing Presbyterian from Santa Monica, who looks the part of a hip Hollywood promoter: goatee, stylish clothes, easy smile. He believes that studios haven't learned to reach a vast segment of the market."[1]

For movie studios which had long ignored people of faith as a group to be catered to, Bock's work was invaluable:

"He uncovered a great deal of support for the picture within the Christian community....It's been very valuable to us," said Debbie Miller, a Warner Brothers executive describing the publicist's work on one of her films, noting that Bock's work had shown "an incredible example for other studios that the religious market is a really, really important area that's not to be ignored."[1]

"Bock's sales pitch to the movie studios is based on simple math," noted *the Times*. "On any given weekend, the number of people who attend religious services—roughly 122 million--is vastly greater than the number who go to the movies—and that kind of ticket-purchasing power can be tapped. Warner Bros., Disney and Universal have hired him to promote movies."[1]

Contrary to his critics, some of whom argued that Bock was a corporate shill or a hired gun aiming to lure Christian America into

movie theaters and give their seal of approval to evil Hollywood fare, Bock instead saw his role as just the opposite-that by showing his bosses in Hollywood that the Christian audience existed, he could convince them to make movies suited to their tastes:

"Any marketing department at a studio can tell you what a divorced Native-American single mom with two kids wants to see," Bock said. "But they don't know what kind of movies that Catholics, Jews or Protestants want...the studio is paying close attention to whether people of faith are a viable market for them to be involved with... the studios are just beginning to see the tip of the iceberg."[1]

Warner Brothers' Miller agreed: "A lot of this is circular. When an audience supports a film, it gives studios a lot more incentive to green-light a movie."[1]

The fact that *Narnia* would have both Lauer and Bock on board to promote it was something of a coup, for the two rarely worked the same project, and though they basically did different things, they were considered by some to be competitors of sorts. In fact, before Lauer had been brought on board as marketing director for *The Passion*, Bock had been invited in by Icon president Bruce Davey for a pitch meeting, but the job had instead gone to Lauer. Whereas Lauer focused his work on getting the word out through grass roots channels to key leaders, at the time anyway, Bock focused primarily on getting the word out to the faithful through existing media channels and in particular faith-based journalists both in and out of the mainstream world. Whether Christian groups and leaders like James Dobson, Chuck Colson and others would be as excited about *Narnia* as they were about *The Passion of The Christ* was an open question however, and much would depend on the way Disney handled its strained relationship with the Christian world.

Disney's hiring of Lauer and later Bock were early indications that the company was going to connect with at least parts of the Christian audience and on January 27th, 2005, the company made its first official and overt outreach to a community that had long objected to it, and was, officially anyway, still boycotting it. Weeks earlier, invita-

tions had been sent to dozens of key Christian leaders inviting them to Burbank for a dog and pony show that would roll out the first seven minutes of the film along with a briefing by key Disney officials. In the audience that day on the Disney lot were Christian ministers like Greg Laurie and Chuck Smith Jr. as well as key cultural leaders like Bob Waliszewski of Focus On The Family, Ted Baehr of Movieguide, Stan Mattson of the C.S. Lewis Foundation, as well as reporters from publications like *Christianity Today* and *World Magazine* among others. Lauer, dressed in pressed slacks and turtleneck, began the session by welcoming his guests and quickly turned the podium over to one of Disney's publicists, Dennis Rice, who briefed the audience on the company's desire to stay faithful to the books, using reassuring code words which meant that those who understood and read into the *Narnia* stories what their author intended would not be disappointed or have their interpretations interfered with by any attempts to change Lewis's writings.

Following the Disney marketing and publicity executives to the podium were two unexpected guests: producer Mark Johnson and director Andrew Adamson, neither of whom were scheduled to make an appearance, but had happened to be on the lot that day and accepted an invitation to appear before some of nation's top religious leaders and cultural gatekeepers. Johnson gave an overview of the shooting schedule and singled out Adamson for special praise while Adamson repeated comments he had earlier given in the press that he had sought to make a film based on his own memories of the books as he had read them as a child.

After Johnson and Adamson's presentations, Lauer and Rice took to the podium and opened the floor up for questions from the audience. One of the first questioners was *Movieguide* publisher Ted Baehr, a powerful figure in Christian circles who was an important arbiter of Christian taste and whose reviews of films were read and considered by many. Baehr, concerned as to whether or not Disney and Walden's version of *Narnia* would maintain the spiritual integrity of

the original books, in a room teeming with reporters and Christian leaders, prefaced his question by saying that he had seen earlier versions of the script which had included numerous profanities uttered by the Pevensie children. If the problems with the early versions of the script were intended to be kept secret, Baehr's turn in the question and answer session ensured that the secret was now out. In spite of that, Baehr later praised the session, calling it a "wonderful dog-and-pony show," adding, "I think they're going to do a great job marketing to the church."[2]

Reaching out to devout Christians a full year before the film's release was a risky move for Disney. While some key executives understood the importance of reaching out to Christian leaders early and often, they were also eager not to appear to be pandering in a way that would alienate more secular Disney fans or garner the attention of the same press corps which had often critically reported on Lauer's efforts in marketing *The Passion of The Christ*. Disney and Lauer had gone to great pains to make sure that all in attendance on this day were *friendlies* and that had indeed been the case. But modern journalism, complete with bloggers and online versions of print magazines and newspapers made keeping secrets increasingly difficult. Within weeks of the briefing, *the New York Times* was doing just what Disney was hoping to avoid: linking early attempts to market *Narnia* to the campaign to market Gibson's epic film. *The Times* had not been invited to the briefing but *World Magazine* had and though it was unlikely that very many *New York Times* reporters were also *World* subscribers, they were able to access the magazine's content via the worldwide web. *World* was represented at the briefing by the magazine's film critic Andrew Coffin.

"Listening to him speak, Andrew Adamson sounds a lot like Peter Jackson. And it's not just because the director of *Shrek* shares the distinctive accent of his fellow New Zealander," noted Coffin. "Mr. Jackson took on the enormous task of translating J.R.R. Tolkien's beloved *Lord of the Rings* novels to the screen, and succeeded in large part due to an almost fanatical dedication to his source material. Now, Mr. Adamson has taken on the similarly daunting task of bringing C.S.

Lewis's *The Lion, the Witch and the Wardrobe* to theaters. At the Disney Studio complex in Burbank, Calif., to introduce the film to the 'faith community,' Mr. Adamson enthusiastically explained that he had read all seven books in *The Chronicles of Narnia* series in about 10 days when he was eight years old. And as with Mr. Jackson, this dream project was guided by a strong sense of responsibility to its source. 'I want to be very faithful to the book, very true to the book, true to my childhood memories of the book, he said."[3]

The part of Coffin's piece that likely caught *The Times'* attention was his bemused observation that Disney, widely regarded as being hostile to the interests of devout Christians, was seeking to make amends to the Christian community by giving its leaders an early look at one of their films:

"...Disney and Walden took the unique step of introducing the film to a segment of their audience most concerned about the integrity of the final product," noted Coffin. "Over 30 faith-based and educational organizations were present at the preview, organized by Motive Entertainment's Paul Lauer. Disney and Walden 'felt it was important to assure you that they intend to get this movie right,' explained Mr. Lauer.... Since when does a major Hollywood studio care this much about the response of the Christian community? Well, at the very least, since *The Passion of the Christ*. Mr. Lauer is no stranger to the marketing strategy that propelled that film to worldwide success, having developed the grassroots campaign that mobilized churches and schools around the country behind *The Passion*. Mr. Lauer has similar plans for *Wardrobe*. The marketing of this film will be the most comprehensive program for faith and family groups that Disney has ever undertaken, Mr. Lauer told *World*. As with *The Passion*, that will entail meetings with church and education leaders, public events at churches and schools, advance screenings, corollary educational materials, outreach to youth groups and colleges, and a strong emphasis on internet resources."[3]

If Disney hoped to avoid comparisons to the marketing cam-

paign it was planning that engineered on behalf of *The Passion*, the British newspaper *The Telegraph* quashed all such hopes when its reporters Chris Hastings and Charles Laurence filed a story on March 3rd entitled "Disney Sets Out to Make '*The Passion* for Kids.'" It was exactly the kind of story that Disney was desperate to avoid, and was a factor in both Walden and Disney passing on the idea of Mel Gibson being the voice of Aslan, despite the interest Gibson had expressed in the notion.

"Walt Disney is to promote its $100 million adaptation of C. S. Lewis' *The Lion, the Witch and the Wardrobe* as a '*Passion of the Christ* for kids' in an attempt to secure worldwide Christian support for the film," began the piece. "Disney executives have organized private meetings with several church groups in America to emphasize the themes of Christian redemption and sacrifice contained in the film, which will open in December with an all-star cast. They have also hired a public relations company to market the film directly to Christian groups to ensure that the powerful evangelical movement, which is particularly strong in America, is happy with the content."[4]

Though acknowledging that Lewis himself had written the *Narnia* chronicles with specifically Christian intent, the reporters believed such a link would trouble at least some *Narnia* fans:

"Lewis made no secret of the fact that the epic children's stories were Christian allegories and that Aslan, whose death and resurrection is pivotal to the saga, was a Christ-like figure," the paper noted. "Now, however, some fans of the Narnia novels, which have sold more than 85 million copies worldwide, say that Disney could be in danger of over-emphasizing the religious elements of the stories. Internet message boards set up by Lewis enthusiasts are cluttered with complaints by people worried about the likely content. Others have expressed concern that cinemas will be block-booked by Christians or that audiences will be targeted by evangelicals looking for converts."[4]

The notion that Christian groups might use the *Chronicles of Narnia* as opportunities for proselytizing was of course not altogether an unthinkable one in a post-*Passion* world. Devout Christians had in

fact purchased tickets to *The Passion* in bulk to be given away to non-Christians and many churches had bought out entire screenings of the film, ensuring that it's opening weekend numbers would be staggeringly high. Sarah Arthur, however, identified in the piece as an organizer of a C. S. Lewis festival in Michigan, told the reporters that it was Lewis, and not Disney or Motive who had first injected religion into *Narnia*:

"Lewis, himself, in his letters to children was very specific about the faith elements being deliberate," she noted. "I can't imagine a secular or neutral version. It would be like taking the mythological elements out of *The Lord of the Rings* films."[4]

She was joined in that opinion by Rev. Michael Langrish, the Bishop of Exeter:

"You cannot understand the story in *The Lion, The Witch and the Wardrobe* without reference to God," he said. "One of the key themes of the book is that for the forces of good to triumph over evil it is not enough that they are simply stronger. They can only triumph through grace and sacrifice."[4]

But not all the sources *The Telegraph* spoke to were as enthusiastic about such links being made for viewers and readers. Playwright William Nicholson who had helped to produce *Shadowlands*, which told the story of Lewis's relationship with his wife Joy Davidman cautioned:

"There can be no doubt that the books contain Christian allegory. But I think the majority of people read them as wonderful children's stories. I think he would have been distressed if he thought they were being introduced to the stories in any other way."[4]

A few weeks earlier, on February 20th, less than a month after the briefing, *The Times'* David Kehr filed a story entitled, "Disney's Next Hero: A Lion King of Kings (Hollywood Nervous About Christian Narnia)," noting:

"Disney is already putting out feelers to the religious audience. It has hired Motive Marketing, a California public relations firm that specializes in cultivating Christian audiences, to design and direct a

faith-based marketing and publicity campaign. The company, founded by Paul Lauer, performed similar duties for Newmarket Films on *The Passion of the Christ* and for Warner Brothers on *The Polar Express*. Motive Marketing recently held a reception for some 30 members of the faith-based press and educational organizations at Disney's Burbank headquarters, where they were addressed by Mr. Adamson and Oren Aviv, the president of Disney's Buena Vista Pictures marketing unit. As the residents of Narnia like to whisper, 'Aslan is on the move.' And so he is. But for the moment, Walt Disney Pictures has him on a very short leash. Aslan, a talking lion with mystical powers, is the central figure in *The Chronicles of Narnia*, the much-beloved seven-volume series of fantasy novels written by the British academic C. S. Lewis in the 1950's. By the year's end, if Disney marketers have their way, he will have joined Mickey Mouse, Pinocchio and Buzz Lightyear in a long line of characters that have periodically provided the giant with entertainment's most valuable asset, a new fantasy to trade on."[5]

But what likely irked Disney the most about Kehr's piece was his linking of the studio's efforts at outreach to faith groups with Mel Gibson's marketing and outreach efforts on behalf of *The Passion of the Christ*, a natural inquiry for *The Times* to pursue as a result of the company's decision to hire Motive.

"This time, the pros at Disney are wrestling with a special challenge: how to sell a screen hero who was conceived as a forthright symbol of Jesus Christ, a redeemer who is tortured and killed in place of a young human sinner and who returns in a glorious resurrection that transforms the snowy landscape of Narnia into a verdant paradise," *The Times* noted. "That spirituality sets Aslan apart from most of the Disney pantheon and presents the company with a significant dilemma: whether to acknowledge the Christian symbolism and risk alienating a large part of the potential audience, or to play it down and possibly offend the many Christians who count among the books' fan base."[5]

If Kehr & *The Times* seemed mildly troubled by Disney's attempts to do outreach to the faith community, *World*'s Coffin was not.

Although *World* and its editor Marvin Olasky had a history of being suspicious of the activities of members of the C.S. Lewis Estate and Lewis's publisher Harper-Collins, it was generally supportive of the attempts to bring *Narnia* to the big screen and praised the outreach efforts:

"The strategy makes sense, and films like *The Passion* and even *The Lord of the Rings* trilogy proved that it could be effective," Coffin noted. "The *Narnia* stories, Mr. Lauer points out, have already been embraced by Christians—it's just the studio's job to convince them that the films do the books justice. Oren Aviv, president of Buena Vista Pictures Marketing and representing Disney at the event, understands what's at stake here: 'Our goal is to make sure that we make and market the movie so that it has the same significance that the book has had,'... Mr. Lauer told the audience in Burbank that all of this was designed to allow faith groups to 'use the film for their purposes.'To 'leverage' its impact of course, all of this is also designed to sell tickets, something in which Disney and Walden certainly have a stake, with *Wardrobe* promising to be one of the most expensive films ever produced by either company. (Estimates suggest that the budget will run over $150 million.)"[2]

The Times however, was not quite so ebullient, predicting that Disney would proceed by marketing the film to the faith community with extreme caution:

"The company will probably proceed gingerly," it noted. "Look for, at most, study guides to be prepared for Sunday school classes, local discussion groups to be organized and blocks of tickets to be offered to churches at a discount (a technique that figured heavily in the box-office triumph of *The Passion of the Christ*). Those who want to see Aslan as a Jesus figure or the White Witch as his satanic opponent will find little to encourage or discourage their interpretation, even though that interpretation was its author's own."[5]

For his part, Dennis Rice, a recent hire who had made his way to Disney courtesy of his work as a consultant for Walden Media on

the film *Holes* which had been developed by Walden and distributed by Disney, emphasized to the *Times* the word which had by then become a mantra of sorts, repeatedly using the term "faithful," a term which would sound benign enough to those outside of the Christian community while simultaneously communicating to those in the faith world that the film would not disappoint those who read Christian themes into Lewis's work:

"We're lucky that there are millions of devoted fans, who probably cross four generations," he noted. "We want to reach all of those devoted fans...we are trying to make this movie to be as faithful to the book as possible. And if you connect to the book, we think you will connect to the movie."[5]

Some critics were unhappy with Disney and Walden's plans however and among these was Peter Sealey, described in newspaper reports as an adjunct professor of marketing at the University of California, Berkeley and a former film and beverage company executive who told *The Times* that combining religion and children's entertainment was "an absolute time bomb in these days of extreme sensitivity."[5]

Mr. Sealey, apparently unaware of hot sellers like the *Veggie Tales* series which had managed to do exactly that, urged Disney to stop being coy:

"Either don't do it, or come completely clean, like a *Ten Commandments* or a *Passion of the Christ*," he said. "It seems duplicitous just to repress the religious aspects, and certainly they will all come out in this age of the Internet and strident voices on both the left and the right."[5]

Martin Kaplan, of the University of Southern California on the other hand found plenty of examples in pop culture history of popular entertainment being informed by religious traditions of various kinds:

"P. L. Travers, the author of the *Mary Poppins* books, was actually a follower of the mystic G. I. Gurdjieff," he noted. "Her books were imbued by mysticism, the idea that all is one and one is all. But the film became a family drama in which domestic issues, the role of the

children and the prospect of the working world were the themes, rather than the great chain of being or the universality of humanity."[5]

Kaplan argued that Lewis's *Narnia* series, could, in much the same way, serve to operate on several levels, allowing the spirituality within to merely be a subtext:

"There's enough story and traditional emotion in the *Narnia* books that they can let the Christian mysticism in it either be a subtext or not a part of it at all," he noted. "I suspect you can portray resurrection in the same way that E. T. comes back to life, and that practically every fairy tale has a hero or heroine who seems to be gone forever but nevertheless manages to come back."[5]

Mark Moring, an editor at *Christianity Today* echoed Kaplan, believing that Disney had picked a winner which would connect with Christian fans everywhere.

"The *Narnia* books are very well loved in evangelical households," he noted. "Just about everyone I know at work and at church read these books as children, and now they're reading them to their children. They are definitely on the A-list," adding that any attempts to strip *Narnia* of its Christian themes would be a "dumb thing to do. It would be self-defeating."[5]

On March 16th, noted newspaper columnist and author Mark Pinsky, a keen observer of pop culture and religion, weighed in with his take on the unfolding campaign, taking special note of Disney's long history of carefully avoiding overt religious messages:

"The Christian marketing campaign represents a sharp break with corporate policy," Pinsky noted. "Apart from Disney World's annual *Nights of Joy* concerts, the film is the company's first undertaking with the religious community. For some evangelical leaders, it represents the effective end of their Disney boycott. The entertainment giant, which bills itself as a 'Magic Kingdom,' has carefully avoided religion for most of its history. Yet Disney has launched a 10-month campaign aimed at evangelical Christians to build support for *Narnia*, a $100 million, live-action and computer-generated animated feature it is co-

producing with Walden Media."[6]

Like *The Times* and *The Telegraph* before him, Pinsky also noted *The Passion* connection, in particular Lauer's involvement in both:

"In a marriage of modern mythmakers, the Walt Disney Co. is marketing a film based on C.S. Lewis' *The Chronicles of Narnia*. And in doing so, Disney will take a page from Mel Gibson's *The Passion of the Christ*," he noted. ".... Disney has hired several Christian marketing groups to handle the film, including Motive Marketing, which ran the historic, grass-roots efforts for *The Passion*."[6]

Other observers, however thought Disney's faith-based marketing attempts were right on target, including the deployment of Lauer:

"Disney, as the consummate corporate animal, is looking at Paul as the guy who delivered the audience of *The Passion*," noted Barbara Nicolosi, of Act One, a Hollywood-based screenwriting program devoted to training Christian filmmakers and writers. "Disney and Walden Media are aware that there's a proprietary sense about *The Chronicles of Narnia*. C.S. Lewis is our guy. They better not take that away from us."[6]

"From a marketing point of view, it could be a marriage made in heaven -- if the movie is any good,"[2] added Adele Reinhartz, professor of religion at Wilfrid Laurier University in Canada.

Harvard professor and noted C.S. Lewis expert Armand Nicholi added that a large audience existed "that embraces a spiritual world view," noting that successful marketing to faith based groups "will determine how successful this marriage is."[6]

Ever the public relations guru *and* diplomat, Disney's Rice sought to reassure those outside of the Christian camp that they wouldn't be left behind in such specific and targeted marketing efforts:

"We don't want to cater to one fan base over the other, or at the expense of another,"[6] he noted.

Lewis's books were filled with "adventures with more than such whimsical beings as Mr. Tumnus, a gentle faun forced to do the

Witch's bidding, and Mr. and Mrs. Beaver, talking animals that aid the children in their quest," noted *USA Today*. "The tales also are infused with Christian allegory, and the heroic Aslan is meant as a Christ figure, a redeemer who resurrects in triumph. The challenge: to attract the spiritual-minded moviegoer without turning off the secular crowd. Disney, along with other studios, has often courted the so-called faith community when the appropriate movie comes along, including such religious-themed comedies as *Sister Act* or uplifting sports dramas like *The Rookie*."[7]

Rice, however, took issue with what he believed to be the press's fixation on the issue of religious marketing:

"It is natural that the press will manufacture more importance about the religious significance than is our intent," he said. "We are not going to reach out to one group over the expense of another, but embrace and acknowledge the fans of a very important piece of literature."[7]

"Yes, the filmmakers hosted representatives of more than 30 faith-based and educational groups at a preview held at Disney's Burbank, Calif., headquarters earlier this year," *USA Today* noted, "but says Rice, 'we're also at Comic-Con in July,' referring to the annual San Diego fantasy, sci-fi and comic-book convention."[7]

David Koenic, the author of *Mouse Under Glass: Secrets of Disney Animation and Theme Parks* told the paper that he thought the strategy was a sound one:

"*Left Behind* would have been risky," he observed, "*Narnia* isn't risky. It's the safest way for Disney to reconnect with a large section of its core audience that it has alienated over the last decade."[7]

Such comments notwithstanding, Disney was in the business of selling movie tickets and having identified devout Christians as one of the film's core audiences, the company was enthusiastic about welcoming the faith audience to what promised to be one of the biggest blockbusters in movie history, and the faith community was feeling the love. One target, Jim Burns, president of the HomeWord radio station

in San Francisco which claimed to broadcast to a million Christian families a day, said that his station would be encouraging its listeners to see the film.

"We are very, very optimistic about what Disney is doing with the film," noted Burns. "Our people have seen some footage and it is wonderful from the Christian point of view…the Christian community will provide opportunities for people to take their kids to this movie through block-booking and church outings and we will be making sure that Christians go in droves. Then we and other organizations will give people who listen to our station and go to our website the opportunity to use this movie as a tool for learning in the family."[4]

Another Christian leader, Kyle Fisk, then of the National Association of Evangelicals, calling *Narnia* "one of the great stories of the Christian faith," made it clear that true believers would come if the filmmakers remained faithful to Lewis's intent:

"There is a big connection between this film and *The Passion of the Christ*," he noted. "Mel Gibson proved you could make a film with moral values which could be embraced by people with faith. Hollywood is now waking up to the fact that people want this kind of entertainment. If *The Lion, the Witch and the Wardrobe* is a fabulous movie then we are going to see it used in churches, youth groups and outreach programs….we are committed to using elements of popular culture to underline our message. We are committed to making it hard for people to go to hell."[4]

For Lewis aficionados and Christians concerned about the film, the most reassuring words came from Douglas Gresham whose statements soothed the fears of those concerned that the film would be unfaithful to Lewis's spiritual intent:

"I am a committed Christian and I am very happy with the script,"[4] Gresham noted.

It would be up to Gresham in particular to not only protect the spiritual content of Lewis's books, but also to navigate the difficult terrain of translating a book into a film:

"Obviously a lot of what Jack could do with narrative, we have had to translate into action," Gresham observed. "Jack could tell about it, we have to make it happen. Also, for reasons of character development, balance and pacing, there will be things in the movie that do not appear in the book. I think and hope that we have added more value to it than we have taken from it. However, as a Narnian purist I feel that any and every change from the original book is bad and thus have to contend with my emotional attachment to the book warring with my intellectual faculties and understanding of filmmaking. I have probably been a pain in the neck at times to my colleagues in the production."[8]

But not everybody in the faith community had heard that quote of Gresham's nor were they aware of his involvement as a producer. Typical of the reaction among Lewis's core fans was a question and answer session that took place early in the campaign between a Disney official and a teacher at Biola University's media conference. The conference was an annual event that took place at the campus of the historic, Christian-based University which featured top industry professionals who discussed their projects and doled out advice on how to make it in Hollywood. During a question and answer time, a teacher sitting in the midst of the 500 or so attendees raised her hand to ask the three panelists from Disney and Walden Media a question, but not before complaining about Disney's inability to get the Pocahontas story right. It was just one among many beefs that some in the Christian community had had in the past with what had been termed "Disneyfication."

"Assertive and free-spirited, the new Disney heroine models today's feminist ideal," asserted a Christian writer named Berit Kjos author of such books as *Brave New School,* in an online essay. "*Pocahontas* follows her dreams and submits to no one. Brave and athletic, she scales mountains, climbs trees, and steers a canoe better than a man. Like 'women who run with wolves,' she does what she wants--and does it well."[9]

Such critics often focused on what devout Christians consid-

ered attempts to rewrite the spiritual background of a hero or heroine and Disney was not exempt from the charge of whitewashing or erasing a historical character's true spirituality:

"The true story about Pocahontas would have undermined Disney's politically correct message," asserted Kjos. "It tells about a girl between 10 and 14 years old, who helped the settlers of the Jamestown colony. They, in turn, shared their Christian faith with her. Pocahontas apparently accepted Christ and was baptized. After she married John Rolfe, the two traveled to England where she was 'received at the court.' On the return trip, the brave 22-year-old died of smallpox. Pocahontas' tribe belonged to the Algonkin family, a nation at war long before European settlers came. Dr. Clark Wissler, an anthropologist recognized as a world authority on the American Indian, tells how the 'warlike' Iroquois invaded Algonkin country. Like other nations throughout history--Greek, Aztec, English, etc.--they expanded into new territories. The Algonkin were not merely at war with Iroquois but often with each other. There were about a hundred Algonkin tribes... In revenge for past injuries, a few members of one tribe would stealthily approach the camp of a hostile tribe, take a scalp or two and escape.... the highest honors went to the man who was the most daring and ruthless in such raids.... ...Not unique to Indians, brutality has characterized all cultures inspired by occult powers--Norse, Aztec, Babylonian, Nazi.... Disney simply twisted the fact. Remember, history documents Pocahontas' conversion to Christianity, not Smith's conversion to pantheism....But do the facts really matter? After all, this is only a Disney movie!"[9]

Beyond the issue of whether or not Pocahontas had become a Christian, critics like Kjos focused particular ire at broader and perhaps more subtle attempts to change the nature of a particular character's worldview along with whom was chosen to be villainous, citing several specific objections in the film. It was a charge that Disney often faced, not only from religious viewers but from political conservatives:

"'What is my path?' she asks the wise old spirit of Grandmother Willow, a magical tree in the forest," Kjos observed. "'How am I ever

going to find it'·'Listen...' says her enchanted counselor. 'All around you are spirits, child. They live in the earth, the water, the sky. If you listen, they will guide you.' The Indian maiden believes. Why shouldn't she? Not only does the tree spirit's advice fit the context of Disney's fictionalized history, it also fits today's cultural shift toward a global spirituality, a seductive blend of all the world's religions. Few realize that when children learn to see the world through a pantheistic lens, our Christian words take on a new universalist meaning....the villains in Disney's new fantasy are the greedy white males who have come to exploit the land and steal its gold. Even the best of them, handsome John Smith, is made to look foolish compared to the nature-wise woman he loves. Their exchange of wisdom flows one way only: from Indian to European. So when Smith unwittingly offers to build an English civilization on Indian lands, Pocahontas shows her disgust, then teaches him a lesson on pagan oneness. Her message now echoes in the hearts of children everywhere through the hit song 'The Colors of the Wind,' which keeps reminding them that mountains, trees... everything is filled with spiritual life and linked in a never-ending circle."[9]

The Biola questioner had a specific line of inquiry for the two Disney executives. How could she be assured that her beloved C.S. Lewis and the brilliant characters he created wouldn't end up as Pocahontas had-stripped of her true spiritual identity? Rick Dempsey, the Senior Vice President of Disney's character voices division and an instrumental part of *Narnia*'s introduction to Disney, referencing Pocahontas, indicated that Lewis would be in good hands in contrast to Pocahontas because her "great, great, great, great-grandson" wasn't involved in the project, on obvious reference to Gresham's role as co-producer. Dempsey had played an important role in particular in convincing Gresham that Disney would work hard to maintain the integrity of the characters in *Narnia* and had at least at the outset endured a suspicious step-son who was reflecting Lewis's own feelings:

"Disney is the last place that Jack wanted to make *Narnia* into a movie,'"[10] Dempsey quoted Gresham as having told him, adding that

the company was, as a result of its negotiations with the Lewis estate, 'contractually obligated' to make the film accurate per the books. Dempsey put a fine point on the matter with a sound bite which likely allayed the fears of the questioner, and the millions of devout Americans whom she represented:

"We cannot sneeze without Doug Gresham's permission."[10]

Controversy later erupted when the trailer shown at the conference was splashed across the Internet the next morning, a trailer Dempsey had managed to secure which had been completed the night before and was shown by three executives who had been interviewed by Biola's communications department chairman, Craig Detweiler. At the conclusion of the talk, the trailer was introduced and shortly thereafter a young man in the second row raised his hand and asked if it could be shown again. Dempsey gave the OK and that was apparently when someone in the audience sitting near the front (possibly the questioner) began to record what he or she was seeing. The result which was sometimes out of focus showed up online the following morning causing something of a panic among Walden and Disney officials. *Narnia* fans eager to see how the depictions would look on the big screen buzzed at websites about what they had seen:

"The Professor: He kinda looks like a leprechaun, so far the only character that I'm not thrilled about," observed one fan who had been at the conference. "Mr. Tumnus(!): I wish I had a picture of him right now to show you guys, not how I pictured him, but better. He looks so *real*, not like a guy in a costume....Mr. (or) Mrs. Beaver: I had to take a double take here, I thought this was a clip of a nature video or something. Wow has technology come a far way, they look exactly like real beavers!! It's amazing! If it had not been in this context I would have sworn they were real until they started moving, then it was obvious these aren't your everyday beavers.....Dwarves: They look exactly like dwarves. But not like Middle Earth dwarves. You couldn't get the two mixed up....Santa Claus: Ok, I kinda thought it would be a given that this part of the story (when ol saint nick comes by and gives

everyone Christmas presents) would be the Tom Bombadil of *Narnia*, but no, there was quite clearly a fat guy, with a beard, and a bag of stuff and a sleigh."[10]

By May of 2004, *Narnia* fever was in full swing, and two publications, *USA Today* and *Newsweek* helped to stoke the fires with pieces that though enthusiastic, still offered only a glimpse of the full *Narnia* fever which was still to come. Titling her piece "The Wonderful World Of *Narnia*," *USA Today* scribe Susan Wloszczyna gave readers a sneak peek into what Disney hoped fans could expect from *Narnia*, with some digs at Disney classics:

"The majestic lion doesn't pal around with wacky sidekicks, the haughty White Witch doesn't cast a spell on a princess, and the stately wardrobe, with a secret passageway that leads into an enchanted kingdom, doesn't break into a jaunty chorus of 'Be Our Guest,'" she wrote, noting of the trailer: "When the first trailer for *The Chronicles of Narnia: The Lion, the Witch and the Wardrobe* makes its U.S. premiere Saturday night during ABC's showing of *Harry Potter and the Chamber of Secrets*— airing at the same time in 30-plus countries — viewers are apt to gaze in wonder. And be taken aback. The TV audience may feel as disoriented as the tale's four young siblings — curious Lucy, disgruntled Edmund, smart Susan and sensible Peter — after they enter the wooden closet and suddenly stumble into Narnia, a frozen paradise terrorized by a power-mad sorceress. Before their eyes, the snow-globe fantasyland of the most popular book in C.S. Lewis' treasured literary collection comes to swirling life with mythic beasts, snarling wolves and white vistas punctuated by a thunderous roar. No cutesy creatures. No anachronistic wisecracks. What rushes by is like flipping through a picture book full of rich images. Those who catch the preview of the epic adventure due out Dec. 9, either on TV or when a longer version is attached to the May 19 arrival of the Star Wars finale *Revenge of the Sith*, may ask themselves, 'Can this be Disney?'"[7]

The answer it seemed was clearly yes. From Bruce Willis's *The Kid* to the more recent smash hit *National Treasure*, Disney had once

again shown its commitment to creating entertainment which could be enjoyed by children and adults alike and was becoming increasingly welcomed by the family values advocates which had once bitterly complained about its output.

"This is mature family entertainment," *USA Today* quoted *Narnia* producer Mark Johnson, as saying. "It would be a big mistake if the creatures appear to be cuddly stuffed animals on a little girl's bed."[7]

"Just as *The Little Mermaid* rescued Disney animation from going off the deep end in 1989, *Narnia* aspires to restore the studio's legacy as the leading maker of all-ages, live-action escapism," the paper noted. "And in the nick of time. With its house-brand animation in decline and its partnership with Pixar (*The Incredibles*) in disrepair, Disney's family entertainment crown has lost its luster."[7]

Industry observers agreed that *Narnia* gave Disney a great chance to recover lost ground:

"Disney used to be the only game in town," noted Paul Dergarabedian of Exhibitor Relations. "They were the gold standard of family films, but the rest of the world has gotten more competitive. A big prestige picture could boost the entire studio."[7]

If the effort to get viewers in seats were a war, then Disney began recruiting for the campaign early, enlisting the help of the Ground Force Network, a group that had worked on *The Passion* campaign which promptly announced that it was looking for a few good men and women to carry the banner for *Narnia*. In a press release entitled, "How To Become A Narniac General," the group coined a new term and solicited for recruits:

"This is the most influential and ground-breaking campaign we've ever been a part of since *The Passion* of the Christ, and we'd like YOU to team up with us from the beginning," the group enthused. "It will be an exciting adventure you'll never forget...starting July 11th, Ground Force is going to be working with Disney, Walden Media, & Motive Entertainment to be a part of the grassroots campaign for C.S. Lewis' *The Chronicles of Narnia: The Lion, The Witch, and The Wardrobe.*

If you read these books when you were younger, you know they were magical and the movie will be nothing short of a masterpiece. We'll be starting a campaign for The Chronicles of *Narnia* in July, and WE NEED YOU!"[11]

The group was looking for two kinds of recruits, "Narniacs," "field agents" who would receive and distribute materials and "Narniac Generals" who would be the city leaders for the *Narnia* campaign. Groundforce kept the military analogies rolling as it called for troops:

"The Narniac General we select in each city will need to be willing and available to take a very active role in the promotion of this film," the group said. "We'll train you to know everything you'll need to do this role successfully, so don't worry! You'll get to work closely with our staff and have incredible opportunities to be on the 'inside track' as we get closer and closer to the release of this film on December 9th."[12]

The group gave potential recruits several ways of being involved in the promotion of *Narnia*, and those interested in becoming a representative of the film in their respective cities were warned that "this is a serious job, though, so we need to be sure you understand the responsibility and commitment involved in agreeing to take this role if you're selected."[12]

Those charged with working in the area of "phone contact" were urged to be an extension of the marketing campaign:

"We'll need you to be our point person for other Narniacs and leaders in your area to call if they have questions about promoting the film," the group urged. "Don't worry, this isn't as scary as it sounds! Basically you just need to be willing to talk on the phone with others involved with the film in your area and make sure they're up-to-date on the latest *Narnia* news and are successfully carrying out events they're hosting. We'll give you all the information and help you'll need to do this job."[12]

Finally, Narniacs were urged to help coordinate local events relating to the *Narnia* campaign:

"Throughout the campaign there will be big events going on

in key cities that other family and faith-based organizations will be involved in," the group noted. "We'll be calling on you to assist in these events and be a helpful source of information for the event hosts, if needed."[12]

However, being volunteer positions, Narniacs were to be rewarded not with money but with various goodies including "exclusive movie materials, a chance to win cash and gift certificate prizes, as well as internship credit for those attending college."[12]

But reaction to the Narniac program was predictably negative from at least one outpost as film critic Peter Chattaway weighed in on his blog with a piece he titled "Disney Wants Christians To Work For Free:"

"As my friend put it, 'do we want to be known as 'Narniacs'?' Sounds a lot worse than Trekkies," noted Chattaway. "Personally, I'm quite happy to be a 'Trekkie' -- and I think those who insist on being called 'Trekkers' instead because they think it means they are being taken seriously are just way too anal, but the term itself doesn't sound so bad -- but I think 'Narniac' has to be one of the dumbest names I have ever heard. Especially if what it means in the end is 'someone who is oh-so-happy to be doing Disney's publicity work for free.' And as for whether the movie is a 'masterpiece,' ... well, of course, we'll just have to wait and see about that. Certainly the trailer making the rounds is inconclusive on this point."[11]

Chattaway even researched the term 'Narniac,' suspicious that it hadn't originated with *Narnia* fans as marketers had implied when they launched the campaign:

"My friend has been Googling this, and so far all she has found is the product description for this book which won't be out for another three months," Chattaway noted. "Well, that and some other sites of dubious moral stature that have nothing to do with *The Chronicles of Narnia*. But even if we count those, there isn't more than a page of Google results. So it would seem this word is nothing more than a marketing term that has been invented for this film's release. Heaven

help us if it actually catches on....or, as my friend puts it: 'but mostly, fandom is a grass roots phenomenon, and Google doesn't reference the term 'Narniac' on any fan sites. So I resent the marketing machine conjuring its own label for us, not to mention attempting to exploit us... what makes me sad is that there will probably be plenty of church folks ready to jump on this bandwagon because it's just the thing to do.'"[11]

As the efforts of Bock, Lauer and others continued in earnest, it became clear however that they were facing the realities of a film industry that had reached a new low point in the history of cinema as box office receipts showed a continued and steady decline.

"*Batman Begins* took in $26.8 million to remain the top movie for the second straight weekend, but it could not keep Hollywood from sinking to its longest modern box-office slump," noted the *Associated Press* in an article about the June 24th weekend box office. "Revenues for the top 12 movies came in at $116.5 million, down 16 percent from the same weekend last year, when *Fahrenheit 9/11* opened as the top movie with $23.9 million, according to studio estimates Sunday. It was the 18th weekend in a row the box office declined, passing a 1985 slump of 17 weekends that had been the longest since analysts began keeping detailed figures on movie grosses. Theater revenues have skidded about 7 percent compared to last year. Factoring in higher ticket prices, movie admissions are off 10 percent for the year, according to box-office tracker Exhibitor Relations. If the slump continues, Hollywood is on course for a third straight year of declining admissions and its lowest ticket sales since the mid-1990s."[13]

"We're working with a pretty huge deficit that would take a lot of business to overcome," added Paul Dergarabedian, of Exhibitor Relations. "Just breaking the slump is not enough. We would have to reverse the trend and see attendance on a big uptick."[13]

Daily Variety editor Peter Bart, at that time one of the most powerful figures in Hollywood who had himself once worked in film before becoming a journalist, had seen many trends come and go, and agreed with those he called "doom and gloomers" or "G&D", but only

to a point:

"Every Monday we hear their clarion call: The gloom-and-doomers peer at the box office data and conclude that the plague years are upon us," Bart wrote. "Are they right? At summer's halfway point, the definitive answer is: Yes and no. For 17 straight weekends, say the gloom-and-doomers, box office has measured lower than last year. But if you take *Passion of the Christ* out of the equation, the numbers this year would be slightly higher than in 2004. And *Passion* was, after all, a 'onetime' event, independent in its financing, release and ideology. The G & D set says this year's downturn reflects the fact that Hollywood is giving us mediocre product. OK, but consider the following: The two biggest disappointments of 2005 are *Cinderella Man* and *Kingdom of Heaven*. Both are excellent films, considerably more ambitious than *Van Helsing*, *Troy* or *the Day After Tomorrow*, which took in far more money last summer. Arguably, this year's problems stem from questionable release dates and marketing strategies, not issues of quality."[14]

Bart scoffed at those who suggested that DVD's had created structural problems for theatrical moviegoing:

"The G & Ders point to studies indicating that filmgoers in theory would prefer to watch movies at home rather than in theaters," he noted. "This is about as relevant as asking couples whether they'd prefer to have sex atop the Eiffel Tower or at a Motel 6. In point of fact, filmgoers still pay to go to theaters and, if anything, seem to be drifting away from collecting DVDs. Indeed, the pattern of DVD sales looks more and more like film: There's a two- or three-week rush for a new release, followed by apathy."[14]

Bart also questioned the conventional wisdom about overseas markets, noting that foreign moviegoers were flocking to Hollywood fare as never before:

"Listen to the G & D crowd, and they'll tell you the downturn has spread to the overseas market," Bart observed. "Again, yes and no. Last year saw a cluster of $300 million-plus releases like *The Last Samurai*, and *Troy* and even some $500 million-plus phenomenon such as

Harry Potter and *the Prisoner of Azkaban*, which soared past $540 million, and *Lord of the Rings: The Return of the King* which hit $742 million outside the U.S. And, yes, there was Mel Gibson. Mel Gibson's *Passion* again hitting $240 million overseas. Those were remarkable numbers, and 2005 won't match them, though the third *Star Wars*, *Meet the Fockers* and *Ocean's Twelve* are giving it a try. Even *Kingdom of Heaven*, which will barely scratch its way to $50 million in the U.S., has passed $150 million abroad. So, long-term, are the habits of filmgoers changing? Absolutely. Will consumers spend more time online, or on gaming or watching porn on demand? Without doubt. Will the windows separating DVD release and theatrical release continue to diminish? They sure will…..But here's a suggestion to the gloom-and-doomers: If you want to get depressed, turn your attention to Iraq. Give Hollywood a breather."[14]

Despite Bart's best attempt to put a positive spin on the bad numbers, things were not looking good, but interest in movies among the devout was increasing according to researcher George Barna. Barna, a longtime fixture in the faith world who specialized in taking the pulse of American Christianity, was widely touted as the most quoted man on the planet when it came to matters having to do with the Christian church in America and had released data shortly after Mel Gibson's *Passion* film was released, highlighting both the pluses and minuses of using films to promote Christian values.

"Despite predictions that it would become one of the greatest evangelistic tools of its time, Mel Gibson's *The Passion of the Christ* failed to capitalize on the opportunity, even though ticket sales made it the eighth highest-grossing domestic film of all time," noted the *Christian Examiner*. "Those are the findings of a new poll from the Barna Group, a research firm which determined that less than one-tenth of one percent of those who saw the film stated that they made a profession of faith or accepted Jesus Christ as their savior in reaction to the film's content. More than 1,600 people were surveyed for the poll."[15]

"Immediate reaction to the movie seemed to be quite intense,

but people's memories are short and are easily redirected in a media-saturated, fast-paced culture like ours," Barna noted "The typical adult had already watched another six movies at the time of the survey interview, not including dozens of hours of television programs they had also watched."[15]

Barna echoed the sentiments of media analyst and columnist Terry Mattingly who had long argued that the "magic bullet theory" advocated by many Christian preachers-that media could effect people like a magic bullet, leading them to conversions-was wrong, arguing instead for what he termed the "stalagmite theory" which held that many small messages over time was more effective at changing opinions and behavior.

"In an environment in which people spend more than 40 hours each week absorbing a range of messages from multiple media, it is rare that a single media experience will radically reorient someone's life," Barna argued "The greatest impact through media seems to come from constant exposure to a consistent message that is well-presented and is personally meaningful or useful."[15]

While clearly supportive of the film, Barna saw its limitations:

"*The Passion* was well received and stopped many people long enough to cause them to rethink some of their basic assumptions about life. But within hours those same individuals were exposed to competing messages that began to diminish the effect of what they had seen in Mr. Gibson's movie. That does not negate the power of the movie or the value of the message it sent, but it does remind us that a single effort that is not adequately reinforced is not likely to make a lasting impression."[15]

Barna was careful to note, however, that many Americans had indeed changed their behavior after seeing Gibson's epic:

"Don't lose sight of the fact that about 13 million adults changed some aspect of their typical religious behavior because of the movie and about 11 million people altered some pre-existing religious beliefs because of the content of that film....that's enormous influence

and you cannot fault *The Passion* for not satisfying religious agendas that some people assigned to it....more than any other movie in recent years, *The Passion* focused people on the person and purpose of Jesus Christ. In a society that revolves on relativism, spiritual diversity, tolerance and independence, galvanizing such intense consideration of Jesus Christ is a major achievement in itself."[15]

Chapter Ten
Product Placement

With or without the support of the Christian world however, it was clear that Disney had a cultural behemoth on its hands with the *Narnia* property. Though the book was wildly successful since its release a half a century earlier, because its core audience consisted of evangelical Christians whose buying habits had rarely been studied or understood, many cultural gatekeepers failed to understand the significance of the property and its potential interest to millions of Americans and other consumers the world over. Just as one of the '70's top selling books *The Late Great Planet Earth* and the '90's version *Left Behind* were not understood or known in proportion to their sales, so *Narnia* too had been severely underestimated in its potential reach. But not everybody made that mistake. In a piece which explored the commercial potential of all aspects of the *Narnia* property, *License Magazine* reporter Joyceann Cooney noted the potential windfall that the series could mean for Disney:

"For Disney, it is the beginning of a long-term franchise opportunity," she noted. "With 85 million copies sold in 29 countries, nearly 6 million copies annually, indeed, reader expectations will be high on a worldwide basis....what's more, *The Chronicles of Narnia* is highly merchandisable with its host of characters-from human to mythical to hybrid species and battle scenes, among other fantastical imagery."[1]

Disney president Dick Cook who had worked hard to obtain merchandising rights, also saw great potential in the properties:

"This is a worldwide franchise and a worldwide phenomenon," he noted. "With seven books in the series, *The Chronicles of Narnia* has the characteristics of a long-term program. Judging from the phenomenal success of the *Lord of the Rings*, while I'd never predict the success of a movie, *The Chronicles of Narnia* is in that family of great literature. It has transcended generations....projects of the scope of *The Chronicles of Narnia* are few and far between. This is well beyond a single movie."[1]

But it would be up to Andy Mooney who as head of Disney Consumer Products Worldwide was charged with overseeing the commercial aspects of Disney properties, to chart a course for *Narnia*-related merchandise that would carefully mine the series for profits, while not appearing to be excessively commercial or in any way go against the spirit of Lewis and his beloved series. It was no easy task, but Mooney seemed to be aware of the challenges that lay ahead:

"There's a level of pre-awareness of *The Chronicles of Narnia* property...and *Narnia* offers a rich world for merchandising," he noted. "We will be very careful about how we embellish merchandise, whether toys, video games, or board games, and will work in conjunction with the C.S. Lewis Estate," Mooney noted. "The consumer products are an extension of the movie, but we will work to remain true to *The Chronicles of Narnia* original intent and content."[1]

"We are not approaching *The Chronicles of Narnia* as an event which delivers product in that six-week cycle before the event," added Mooney. "The first release, *The Lion, The Witch and The Wardrobe*, is an international foray into a substantial franchise....we are treating this as a long-term franchise, analogous to *Lord of the Rings* and *Star Wars*. We would rather have the market be short on product than long on product."[1]

That prediction would be proved accurate when in early 2004 word reached fans that Hasbro would be creating *Narnia*-related products.

"It's unusual to hear me gush about a Hasbro product, not because of any issues with the company, it's just very few of their items

are comparable to the best out there," noted one observer writing at the website *Action-figure.com*. "However, that could all change as Hasbro will be releasing their *Chronicles of Narnia* toys six weeks before the movie....and you know what... they have some really nice potential...if you're a *Lord of the Rings* fan, you should start paying attention to this line."[2]

The site heaped praise on Hasbro's development work:

"The sculpting is superb, and while I have wondered all day who sculpted the figures. I now think they bear the hallmark of Gentle Giant....the action figure line comes in regular and deluxe, the deluxe containing figures like the Minotaur and Cyclops. Style-wise they reminded me a lot of the first Episode Two figures...dynamically pre-posed with limited articulation...the PVC Miniature line reminded me instantly of Armies of Middle Earth, and Hasbro had a number of figures on display from the final battle."[2]

Disney's commitment to rolling out *Narnia*-related product early was underscored by a March 8th, 2005 announcement of its plans to develop games for Playstation, Xbox, Nintendo, GameCube and other top brands.

"We have enlisted some of the top creative talent in the games industry to work on *The Chronicles of Narnia* video games," said Graham Hopper, senior vice president and general manager of Buena Vista Games. "Building on the fantastical worlds and amazing creatures portrayed in the film, the teams are developing an action/adventure epic video game where players will be captivated by remarkable characters, heart pumping combat and rich environments that could only exist in the land of *Narnia*."[3]

Disney was well aware that they were walking a tightrope when it came to ancillary products in general and video games in particular when it came to *Narnia*. Literary purists and Lewis fans were likely to look askance upon any such games but there was the added issue of religion which loomed over such enterprises. In particular, the *Left Behind* games, a product related to the film based on the 60-million

selling *Left Behind* book series had been a flop as fans failed to flock to it and critics howled at the mixing of religion and war-like imagery but in the case of *Narnia*, as officials waited with baited breath, the first reviews came in and most were positive:

"Who would've thought that a book that has been required reading for elementary schools across the world for the past few decades would one day be reincarnated in the form of a full length feature film, much less a videogame," noted reviewer Nate Ahearn who got a sneak peek and published his review in the early summer of 2005. "*The Chronicles of Narnia* is a wonderfully enjoyable story of four children and their fantastical adventures through a land that was first penned by C.S. Lewis for the acclaimed novel. At this year's E3 we were witness to a few levels of the game and surprisingly enough it came off as more of a tactical combat game in the vein of LEGO *Star Wars* rather than a children's story; much to our delight....as is expected the plot of the game clings to that of the feature length Disney film that is scheduled to release later this year. Gamers who enjoyed the gameplay mechanics of LEGO *Star Wars* should feel right at home as the same development team is helming this team-based action title. As should be expected from a fantasy based title, the game is drenched in artistic environments and surprisingly smooth character models."[4]

Ahearn was particularly complimentary of the game's portrayal of the children, noting, "the children are designed after their on-screen counterparts and pull off the look of the four prepubescent characters perfectly through the use of a little Xbox graphical muscle. The kids are all outfitted with their proper armaments and we got a look at them in our demo of the game. Peter is the melee fighter of the group and has thus been given his trusty sword. Lucy is the smallest and most innocent of the children a piece which explored the commercial potential of all aspects of the *Narnia* property."[4]

If the *Lord of the Rings* series was any indication of the merchandising possibilities that lay ahead for *Narnia* fans, they hadn't seen the half of it, for as WETA's Richard Taylor noted, the *Narnia* series

provided an even larger group of characters to draw on for commercial purposes:

"In *Lord of the Rings*, we designed 10 different races of characters," he recalled. "Here in *Narnia*, we have more than 60 different races, 60 different cultures, and 60 different species of creatures."[1]

Mooney revealed that while the target age groups for the *Narnia* series were still being discussed within Disney, there was a slight tilt toward boys:

"Historically, the books have skewed more girls than boys. But translating the movie to product with the environments, characters, and the *Narnia* world, merchandise may skew more boys than girls."[1]

What Mooney and Disney had that many films *didn't* have was time-and lots of it-for Disney planned to make all seven of Lewis's books into film-so long as fans kept coming and that made for many long-term opportunities for *Narnia*-related merchandise. Disney described a game that was likely to thrill game enthusiasts and at the same time not offend Christian fans of the series.

"In the game, players enter the world of *Narnia*, a land frozen in a 100-year winter by the evil powers of the malevolent White Witch," noted the company's press release. "In order to end this frigid captivity and free his people, the mighty lion Aslan invokes an ancient prophecy. It will become the destiny of four siblings from our world: Peter, Susan, Edmund and Lucy Pevensie to work together and use their unique combat skills, weaponry and abilities to defeat the Witch and her armies to save *Narnia*. These four heroes must battle the evil forces of the White Witch by waging war against a vast variety of creatures, including, Minotaurs, Minoboars, Cyclops, Werewolves, Wraiths, Ankleslicers, Wolves, Boggles and more....These ferocious creatures are modeled in the game after the characters being created for the motion picture, by the digital and visual effects geniuses at New Zealand-based WETA Workshop, whose credits include *Lord of the Rings: Return of the King*, *Van Helsing*, and *I, Robot*. Additional game features include intricate puzzle solving, two-player action featuring all four characters,

and seamless game play integration with real film footage."[3]

The literary world too was also catching *Narnia* fever. Writer Gene Edward Veith, an author of many books on Christians and the arts had completed a book he had titled *The Soul Of The Lion*, while critic Ted Baehr who had worked on earlier incarnations of the *Narnia* series was working on a similar book for another Christian-owned publisher. But the publisher that had the most to gain from the success of the series was Lewis's longtime publisher Harper-Collins.

"HarperCollins UK is the primary publisher of C. S. Lewis, and will publish the new film tie-in titles in all English-speaking territories," noted the British trade journal *The Bookseller*. "HC Children's Books managing director Sally Gritten said that the publishing program would cover all price points and ages...the *Narnia* backlist will be refreshed, and the classic series reissued in June, as part of a summer reading campaign for children. A teachers' pack will be sent out to 22,000 schools and HC will work closely with libraries. A new series with adult covers will also be published in June...the U.K. marketing team will start to work with retailers next month on bespoke promotional campaigns, said Caroline Paul, head of marketing and publicity for HC Children's Books. "We will also be sending monthly newsletters with the latest news, clips and images from the filming to our customers."[5]

By early summer 2005, the complete officially endorsed line of *Narnia* goods was announced and *Narniaweb.com*, the premiere site when it came to reporting on the film, published the entire list for fans to peruse:

"The end of this year will see a complete *Narnia* marketing blitz," it noted. "NarniaWeb has received the official Disney Consumer Products licensee list and it seems clear that there won't be an area of our lives not touched by the *Narnia* marketing machine. Whether it's toothbrushes, Kleenex, beach towels, rugs, cake decorations, mousepads, checks, footwear or watches, you'll be able to get your *Narnia*-themed products this year."[6]

For children, the list included a variety of toys and games from Hasbro, porcelain dolls, toothbrushes, Turkish Delight. Young men's, women's & juniors tees & fleece and sportswear, stickers, buttons, patches, key chains, bookmarks & journals, book covers, latex balloons & punch balls, balloons, posters & doodles. For adults, there were an array of *Narnia* goodies including ornaments, greeting cards, gift wrap-bags, partyware & party favors from Hallmark, Kleenex tissues, bedding, rugs, throws, beach towels, collectibles, prop replicas, jewelry boxes, book lights, snow globes, banks and frames, posters, pewter goblets, standing glass plaques, framed maps, cake decorations, bank checks, calendars and agendas, stationery sets, diaries, writing instruments, notebooks, computer imprintable papers, mousepads, photo albums, watches and footwear.

But it wasn't just *stuff* that would come out with the *Narnia* brand. One creative entrepreneur came up with the idea to launch a tour that would take fans to the heart of *Narnia*.

"A South Island tour operator reckons it is on to a winner, having gained exclusive access to land used to film *The Lion, The Witch and The Wardrobe*," noted reporter Colleen Simpson. "For more than two years Wanaka Sightseeing has offered tourists five *Lord of the Rings* tours and is planning to diversify through trading arm Canterbury Sightseeing when *The Chronicles of Narnia* films hit the big screen.... director Melissa Heath said yesterday that it took months of negotiating with the owners of Flock Hill before she clinched a deal allowing her to be the sole tour firm with access the property. The Canterbury location was used for filming the climactic battle scene from the C. S. Lewis classic and featured on the BBC's *The Lost World* in 2001."[7]

There was also no shortage of artists wanting to be involved with the soundtrack and in fact one, singer Jason Wade of the multi-platinum selling rock band Lifehouse had already written a number of *Narnia*-related songs on his own including the heart-tugging "Dear Mr. Tumnus." In 2004 a Walden executive who had begun preliminary work on the soundtrack arranged for Wade to travel to Ireland where

he met with Douglas Gresham, discussed the music and played a song for him. Although Wade's songs weren't used in the soundtrack, it was an early indication of the devotion that Lewis had among a number of artists including the band Sixpence None The Richer which named itself after a Lewis story. While the film was still being shot, the announcement about music was made:

"Walt Disney Studios/Walden Media and EMI Music are teaming to create two soundtracks for *The Chronicles of Narnia: The Lion, The Witch and The Wardrobe*," noted *Billboard Magazine*. "To be released separately in the fall, one set will feature pop and rock artists performing music inspired by the live-action adaptation of the C.S. Lewis classic, while the second will be an inspirational set comprising works by Christian acts."[8]

These offerings were to be in addition to the actual soundtrack of the film, which was being prepared by Harry Gregson-Williams.

"The appeal of C.S. Lewis' classic series is universal, and his writings have stood the test of time bringing pure enjoyment to generations of readers,"[8] said EMI Music North America chairman/CEO David Munns.

But controversy quickly surrounded the plan when it was announced that there would be separate "Christian" and "secular" CD's, which seemed out of step with the *Narnia* property itself which was being marketed as a mainstream film. There was also that matter that Lewis himself was the greatest advocate of devout believers operating in the cultural mainstream and not in isolated religious silos. At least one writer who understood Lewis objected to the moves:

"Somewhere, the real Aslan is feeling betrayed," wrote film critic Jeffrey Overstreet. "There are going to be FOUR soundtrack albums for *The Lion, The Witch, and the Wardrobe*. Not two. Not three. But four. Can you say 'overkill?' If they keep this up, my enthusiasm for this project will sour very quickly. One album will be the real soundtrack. One will be a collection of fun stuff... you know, for kids. One will be a collection of songs by pop and rock artists. And since they're not really

legitimate pop and rock artists, but they don't want to be left out, there will be an album of songs by Christian pop and rock artists. (That way, you see, young people will be able to buy an album of rock and roll and AVOID the evangelizing, while Christian young people can buy the Christian album and feel good about the idea that this movie is spreading the gospel. Moreover, this helps Christian young people continue to believe there is a line between what is 'secular' and what is 'sacred'... which is utter crap.)"[9]

Overstreet, tongue firmly in cheek, then suggested twelve of his own recommendations for other *Narnia*-related soundtracks:

12. Celine Dion's Optional Songs for the End Credits of The Lion, The Witch, and the Wardrobe

11. *Narnia* jazz, featuring Kenny G.

10. Carman's The Champion II: Aslan Vs. the White Witch

9. Aslan's Big Hair Heavy Metal collection

8. *Narnia* Serious Jazz, featuring little-known artists that know what jazz really is

7. Christopher O'Riley plays the *Narnia* soundtrack on the piano

6. American Idol contestants perform the songs from the rock-and-roll *Narnia* album

5. The best of the *Narnia* fast-food tie-in jingles

4. Leonard Nimoy's "The Ballad of Mr. Tumnus" (Hey, he DID record "The Ballad of Bilbo Baggins"!)

3. John Debney's *The Passion* of Aslan (featuring uncredited borrowings from Peter Gabriel's Passion)

2. John Williams' I Was the Obvious Choice to Score The Lion, The Witch, and the Wardrobe

and...

1. Michael Jackson in *Narnia*: Songs for Sons of Adam and

Daughters of Eve... especially Sons of Adam"

Overstreet was joking, but his joke pointed out the serious fact that Disney needed to proceed with care, and that *Narnia* fans would likely put up with a certain amount of merchandising but likely grow uncomfortable if things got out of control. And in particular, Christian fans of Lewis were going to quickly object if one set of products were created for them and another for "secular" fans.

In the end, a planned "secular" inspired by CD never materialized in spite of submissions by a number of artists, and instead, a few songs by artists like Alanis Morisette were included in the score record.

Depending on one's opinion, the rush of consumer goods was a nightmare that would cheapen the meaning of the wonderful stories that Lewis had set out to tell and introduce commercialism on a scale that Lewis could never have anticipated or a welcome marketing push that would help bring the *Narnia* chronicles-and their spiritual message-to millions of people around the globe.

Chapter Eleven
The End Game

Disney and its various consultants had carefully managed access to *The Lion, The Witch & The Wardrobe*, but by October were finally beginning to show the film to a few select groups. Among the first to see it were a small group of traditionalists, which included Barbara Nicolosi, a former nun who headed the Act One program, a Hollywood-based group that was in the business of training Christians to enter the world of filmmaking and screenwriting. On October 7th, Nicolosi got a first peek at the still unfinished film and rushed to her blog, *Church Of The Masses*, to give her fans a first look inside *Narnia*.

"The movie is lovely. The print we saw had some special effects still in stages, but it didn't detract from the stunning vision the movie radiates off the screen," Nicolosi noted. "England is musty and dreary. *Narnia* is a wonderland. The kids are going to love it. They are going to want to walk through that wardrobe with Lucy time after time....whereas Jackson's Middle Earth was mostly dark and dripping, with the battle scenes looking like collisions of filthy, toothless Viking corpses, this movie is much more resplendent and ethereal. The battle scenes here are not gory and disgusting. They look like a dream of Medieval Knights with red flags flapping and silver armor shining...and, you know, charging unicorns and fawns and things."[1]

But Nicolosi's most important duty, and what Disney likely had in mind when they invited her, was to reassure worried traditionalists, both Nicolosi's core Catholic audience and Protestants as well, that

the result would please them. Nicolosi didn't disappoint:

"But best of all, contrary to Peter Jackson's agenda-aversion manhandling of Tolkien's classic, here, the tone of LW&W is as close to the book as probably could have been achieved," Nicolosi noted. "All the lines the Christians are worrying about are in there. All the scenes you want to see are here and lovingly rendered. So everybody can relax and get ready to enjoy, and we can all take the Wonderful World of Disney back into our hearts -- and save the studio for 2005! Truly, our forgiveness is completely saving."[1]

Reacting to the Christology of the film, Nicolosi acknowledged what was likely to be a theme of the reaction to the film: that non-Christians and Christians were likely to react quite differently to Aslan the lion:

"I personally cried every moment Aslan was on the screen," she wrote. "But then, I walked in with my character development done by my Jesus thing. I so wanted to be Lucy and Susan, with their heads resting on his body on the stone table. I wonder if people who don't love Jesus will feel the same? So, I am going to say that Aslan is absolutely discernible as a figure of Jesus -- for those who have eyes to see. So, this adaptation of his books on the big screen…will be tremendously, heart-fillingly comprehensible to those of us who love Jesus. And probably a bit strange to those who don't. But whereas *The Passion* was disturbingly incomprehensible to non-believers, this film will be fascinatingly so. I want to be clear, there is plenty of stuff to love and enjoy here for non-Christians. But they aren't going to get why we Christians are going to be in ecstasy here, any more than the pagans got why we cried copious tears at *The Passion*. What I am saying is, be prepared for this new *Narnia* film to be foolishness to *The New York Times*, and a stumbling block to *Daily Variety*."[1]

Nicolosi's only beef wasn't with the film itself, but by the assembled Christians who cautioned against children being allowed to see the film:

"There was a discussion afterward as to what ages of children

could see the film," she noted. "People were saying eight-year olds could handle it fine. I agree. But I also think littler kids should go. I never buy into this idiocy that we are supposed to protect kids from our own faith story. I remember folks saying that about *Prince of Egypt* - that the scenes of the Israelites in slavery were too impressive for young kids. To borrow from Anne Lamott, I think this kind of weak-kneed sensitivity makes 'Jesus want to go lap gin out of the cat bowl.' The vision of Aslan getting shaved and killed is no harder to take than Jesus being scourged and crucified. A generation of children protected from these things breeds a generation of little unmotivated narcissists. Bring your kids to see *The Lion, the Witch and the Wardrobe*! Bring them again! On opening weekend! This movie is deep magic."[1]

A few days later Nicolosi, the possessor of a hilariously wicked wit, was back on her blog unable to resist regaling her readers with a funny occurrence that took place at the special sneak peek that her and a handful of "religious leaders" had been allowed into:

"The screening was very controlled -- only about ten people in attendance besides the Disney and Walden promotional folks," she noted. "There were some prominent religious lieutenants there who are being courted to raise the same groundswell of support for *Narnia* that they did so astoundingly for *The Passion of the Christ*. So, after the screening, all the religious leaders were all awash in enthusiasm and tangible relief that the film had retained its Christian allegoriness. The Disney head-of-PR guy, picking up on the religious leaders' enthusiasm, started getting all happy and chatty himself, leading to the following paraphrased exchange...

'A CHRISTIAN LEADER: 'I want to congratulate you all for preserving the religious themes in the work so beautifully.'

DISNEY GUY: 'Of course, we wouldn't think of doing it any other way! We aren't going to shy away from religion at Disney. After all, who ever decided that going to church was a bad thing?'

BARB: (to herself, for once) 'Um,... Miramax?'"[2]

Miramax was no longer in the Disney family but devout Christians like Nicolosi now were. Still not all Christian leaders were getting the treatment that Nicolosi was getting, for across the country other pastors and Christian leaders were getting a short 10-minute peek at the film at sneak-peek events held in hundreds of churches across the country. A handful of these events were attended by Flaherty, Gresham and others, but for the most part most were more low-key affairs that featured marketing officials explaining the merits of the film and why pastors and churches should attend. Unlike *The Passion of the Christ* around which controversy swirled which kept it *in* the media and *on* the minds of millions of Americans, the release of *The Lion, The Witch & The Wardrobe* was relatively controversy-free, something Disney wanted but which limited ticket sales. Although there was some controversy surrounding the state of Florida's decision to encourage students to read the *Chronicles* series and some articles attacking Lewis, for the most part the weekend of December 9th dawned with nary a hint of the strong box office showing that was just around the corner. As the weekend neared, official Hollywood still didn't quite comprehend the impact that *Narnia* was about to have on their business, and instead attention was focused on a film set to open the following week, *King Kong*, which *The Hollywood Reporter's* Nicole Sperling predicted would make "well north of $50 million."

What Sperling and others didn't know was that before the film had officially opened, thousands of *Narnia* fans around the country had already entered the snowy wood through a program called The Barna Preview which had opened the film the night before when churches, schools and other groups around the country began watching the film at special screenings.

In the heart of Hollywood, Mosaic, a Los Angeles-based church had purchased 3,000 tickets to premiere the film at the El Capitan, Disney's crown jewel theater on Hollywood Blvd. where the company held many of its film premieres. Mosaic's pastor, Erwin McManus had invited his congregants to bring non-Christian friends, hoping to

allow them to enjoy a fantastical version of the Christ story and to learn more about his church, which met at several locations around Los Angeles.

Thirty miles away at Downtown Disney, adjacent to Disneyland in Anaheim, Biola University was hosting its own *Narnia* showing for 5,000 students, alumni, faculty and friends with three showings at 6:45, 9:30 and midnight. And in Century City, L.A.'s swank entertainment district, at the Century City Mall in the shadow of the Fox and MGM buildings, 500 members of the Christian-oriented entertainment group Inter-Mission were screening the film and watching a panel discussion featuring guests who were associated with the film. When the lights went up and the panel moderator Craig Detweiler asked the audience for one word descriptions of the film, the audience erupted in applause and indicated their strong enthusiasm for what they had just seen. In 24 hours, the rest of the nation would be joining the party.

There was at least one clear objective sign that something was afoot that week. Fandango, the online ticketing agency that allowed filmgoers to purchase tickets for upcoming films reported that 75% of all ticket sales for the week were for *The Lion, The Witch & The Wardrobe*. But even before the film was released it was already having an impact on filmgoers and in the case of one Southern California teenager had already literally proved to be a lifesaver. Her counselor had called a Walden executive and told him about his client-a young girl who had attempted suicide multiple times. Trying in vain to get her to promise not to end her life, the counselor had learned that she was a big fan of the *Narnia* books and asked her to promise not to try again until the film's release and she had agreed. Hearing the story, the Walden executive relayed the story to Douglas Gresham who offered to talk with her but only if she were to reach out to *him*. She did and the two talked several times and at a special screening of the film on the night before it opened, the teen sat in eager anticipation for the film that had prolonged her life, to begin. Several years later she was still alive to her counselor's relief.

In ways large and small, at the box office and beyond, *Aslan was on the move.*

Chapter Twelve
The Open & Beyond

Although preliminary work had begun on future *Narnia* films, whether the other six books were to be made would largely depend on the kind of box office numbers it generated on December 9th, 2005 and beyond. Director Adamson was often asked if he would be part of any future movies, something he had obviously begun to give some thought to:

"I don't know about the REST of them. I have some thoughts about doing one or two more. I don't think I'll be up for all seven," he replied. "I'd like to work on more than just two franchises in my lifetime...I really love *Dawn Treader*, *Magician's Nephew* is a big favourite, *Silver Chair*. On the other hand, *Prince Caspian* is the next one kind of in chronology; and then the others like *Horse & His Boy* are kind of like offshoots. So it would probably be *Prince Caspian*, or *Dawn Treader* next, if we did it."[1]

But Adamson had made no commitments, preferring to keep his immediate options open:

"I actually am very deliberately not deciding," he said. "It may very well be another *Narnia* Chronicle. We've had a fairly long and intensive shoot, and if anyone asked me what I was doing next, right now I would say taking a long vacation. So no-one is asking me because they don't want that answer."[1]

In what would soon become something of a mantra, Douglas Gresham took care to remind the public that how many films in the series would be brought to film would largely be dependent on them,

the audience:

"How many movies are to be made by Walden and distributed by Disney would almost certainly depend on how many folks go to see each movie as it comes out, so really it's up to you guys," he told an interviewer. "What they call 'franchises' in Hollywood do seem to have varying life spans, the James Bond series is up to about 20 movies now I think. Hollywood dudes do seem to tie themselves into patterns very easily and find them much harder to break out of than to slide into. However, I would like to live long enough to see all seven made into good films. I would certainly not want to see any of them combined, or skipped for that matter."[2]

Whenever a production of the scope of *The Chronicles of Narnia* was undertaken, (it was reported to be the largest budget in Disney history for any single motion picture) talk inevitably turned to Academy Award possibilities, and for his part, Adamson sought to play down such talk:

"I don't want to jinx it either way," he said. "The interesting thing with film making in New Zealand now is it's become the expected thing. There're a lot of very good films that don't get nominated for anything, but I was at a New Zealand Consulate Party the other day, and they pointed out that New Zealanders have won 34 Oscars in the last four years. That's a fairly extraordinary circumstance, and obviously a lot of those were because of the *Lord Of The Rings* trilogy. You know, sure, we hope so, but you can't expect that kind of thing, and it's certainly not why any of us make films."[1]

Whether or not Adamson would be around to shepherd any of the expected future editions of *Narnia* would be an open question. Douglas Gresham on the other hand was contractually required to be around for years to come, making sure that every line in every film conformed to his beloved step-father's idea of what *Narnia* should be about. As he anticipated *Narnia*'s opening, Gresham was already waxing nostalgic:

"It's a strange experience to have a life-long dream slowly come

true before your very eyes and to see it not only coming true but exceeding your own expectations," he said. "I made a point of trying to thank as many of the folks involved as I could, because they were each, in their own task, a part of making something happen that I have longed to see for most of my life. People forget, or don't know, that behind every movie there are an army of folks whom no one ever hears about - people who cook, clean, paint, build, weld, service machinery and so on and so forth. They all play a vital role in making a movie happen. Making friends with wonderful people in make-up, wardrobe, production, and so on was a real joy. Making friends is after all one of the most fun parts of life."[2]

The success of his film was now entirely in the hands of the audience and though Hollywood may have been getting religion, it was still the religion of money and *Narnia* movies would continue to be made only if it made financial sense. Would viewers embrace Aslan and his cast of characters at their local Cineplex? All indicators pointed to *yes* as December 9th approached.

"*Narnia's* spectacular opening," blared one headline, on Monday, December 12th, as box office numbers began to trickle in. "Though buffeted by snowstorms in the Midwest and parts of the South, *Narnia* has opened with an estimated $67 million in box office receipts," added another, a number which didn't include the Barna Preview showings on Thursday, December 8th. Though not nearly as dramatic an opening as *The Passion*, it was nonetheless a large box office opening for the film that sent another powerful message post-*Passion*, indicating that films with a strong faith component could indeed do well at the U.S. box office. While many marveled at what was in Hollywood terms an unexpectedly large audience, as a result of a series of blunders that served to suppress the core audience of traditionalist Americans the film still underperformed in comparison to *The Passion of the Christ*, a film targeted at a similar audience. Because of the involvement of a major studio like Disney, the sorts of unique marketing techniques that were deployed in support of *The Passion* were unable to be used for the *Narnia* release.

The first blunder was the unwillingness of Disney and the *Narnia* production team to provide complete advance screenings to important religious and political leaders early in the process as had happened with *The Passion*. A tremendous part of the success of *The Passion* had been linked to Gibson's willingness to give early showings to key leaders who then became evangelists for the film. While a major Hollywood studio was unlikely, for a variety of reasons, to ever allow a film to be screened in its entirety so widely and so early, because Gibson was essentially running his own studio, he had no such inhibitions and showed it early and often to countless influencers. Devout Americans were particularly prone to relying upon the opinions of those whom they respected such as psychologist James Dobson or former Nixon aide Chuck Colson, just two among many who were never allowed to see the *Narnia* films early on, before their official release dates. In one memorable moment, another respected Christian leader, George Barna appeared on the Michael Medved radio program and was severely chastised on-air by the host for attempting to promote a film he hadn't seen. For Disney officials, despite partnering with Barna's group, had not allowed one of Christian's most prominent leaders to screen a film they were hoping his community would embrace.

Still another major blunder was the release date of December 9th, one of the busiest of days in the calendar of a typical churchgoer. Disney executives who would make the ultimate call as to when the film should be released were not exactly known for taking into account the views of churchgoers over the years, and their moviegoing habits were clearly not at the top of the list of their considerations. For the average churchgoing American the first three weeks of December were crowded with church Christmas pageants, special worship services, Christmas parties and all manner of faith-related events, a pace that eased only after Christmas. And, predictably enough, *Narnia* experienced a resurgence of moviegoing shortly after the holidays when it dethroned *King Kong* to become the biggest movie of the week after falling off the top spot in the weeks after its release.

But perhaps the most profound blunder of all, and the one that served to severely depress turnout among *Narnia*'s most faithful and faith-filled fans was the steady stream of contempt heaped upon them, their values and the things they accurately read into the film, by the film's director Adamson and others. When a reporter from a large religious publication, *Christianity Today*, tried to ingratiate the director with his readers by raising the fact that Adamson's parents had once been Christian missionaries, Adamson seemed annoyed, responding:

"It's a difficult thing to get into. I'm sort of in the public eye, and I don't think it's fair to drag my family into it. So I don't talk about it a lot. But yes, we did move to Papua, New Guinea when I was 11. My father worked at the university there, and my parents were involved in the church there as well."[3]

"Would it be accurate to call your parents Christian missionaries?" the reporter persisted. "Yes, it would be accurate. You're still going down that road, aren't you?" the director replied as though ashamed and annoyed by the revelation and devout Americans who had turned out in force for *The Passion of the Christ* may very well have gotten the message that he was also ashamed of them as well.[4]

Adamson also sent the wrong cues to the core audience when reports of his changing Lewis's script circulated early among faithful Lewis fans. In particular, the notion that Adamson excised parts of the book that offended his modern sensibilities offended some traditionalists who objected to Adamson changing content that Lewis may have placed in the stories intentionally. Lewis had made it clear through the words of Father Christmas that girls were not to fight in *Narnia* except in the most extraordinary of circumstances, but Adamson, the modern feminist, would have none of it and led the charge against Gresham, determined to change that. As if to add insult to injury, he bragged about it to the press:

"I always thought it was such a negative message to send to young girls and women to say, 'here's a bow and arrow. But I really should have given you a butter knife and a plate, because all you do is

get to make sandwiches,'" he noted. "To me, it's like why is he giving her a bow and arrow and then saying you have to rely on your brothers to defend you? This is where Doug and I got into it a little bit. I said maybe that was C. S. Lewis's point of view at the time, but times have changed and it's certainly not my view at this time. I've got two young daughters, and I don't want that message to go to my daughters....and Doug accepted. Well, I don't know whether he just relinquished or accepted. But she's in battle in both of them."[3]

Other questions about Adamson's judgment would be raised by observers who noticed that the relationship between Aslan the Lion and the Pevensie children seemed emotionally flat. Was this because its director lacked real world experience directing human beings and was unable to draw out performances from the children or because he didn't understand the relationship between devotees of Christ and their Master and therefore couldn't capture the emotion of the allegorical representation that C.S. Lewis was alluding to? Either way, critics contended, the relationships were flat and so were the films.

Those who raised objections to Adamson's perceived hostility toward faith brought up an obvious question: Must the director of a film with religious themes share those beliefs? While that would clearly be a stretch, it was also true that the openly gay Gus Van Sant was a smart choice to direct *Milk*, a film about an openly gay man, as opposed to, say Clint Eastwood or Mel Gibson and in much the same way it would probably be mere common sense that films such as *Narnia* or *Amazing Grace* might have been best directed by people who at the very least didn't seem to be ashamed of their religious heritage, or by a director who didn't seem to exult in stripping the religion out of faith-based stories.

Bragging about breaking down C.S. Lewis's stepson's resistance to a change in his father's work was not the formula for attracting fans to the film and matters were not helped when a number of officials, including Disney marketing executives publicly arguing that the series wasn't based on any one religious outlook, all in a misguided

attempt to reach beyond its natural base. Such moves served to depress that turnout of what should have been the film's base of fans. Even the film's producer Mark Johnson couldn't resist taking a jab at those traditionalist Lewis fans who read into the series the Christian intent of its author:

"I really believe you see whatever you want to see in the film," the producer told *USA Today*. "It's about faith, whatever kind of faith you have. The first movie was about finding faith, and this is the loss of faith and regaining of it. And that faith is whatever you want to make of it."[5]

It was of course a silly thing to say since anybody who knew the first thing about *Narnia* knew full well that the entire arc of the story was built upon the Judeo-Christian tradition and that Aslan was a stand-in for Christ. To pretend otherwise merely served to antagonize the core audience. While there was no reason to market the film as a specifically religious one or as a "Christian film" in a manner that might have made people of other faiths or no faith at all feel unwelcome, neither was it smart to insult its core audiences by pretending the movie was not what its members imagined it to be: a strong and powerful affirmation of their particular faith-the one that involved the sacrificial death, and resurrection of their Savior.

Before it made its exit from its last North American theater, *The Chronicles of Narnia: The Lion, The Witch & The Wardrobe* would earn a respectable total of $291 million, yet it was a far cry from the $390 million earned by *The Passion of the Christ*, a movie that had many strikes against it that *Narnia* didn't, an *R* rating, subtitles, and excessive violence. Even as the box office tally's were coming in, however, attention had already shifted to the next in the *Narnia* series and the respectable box office showing would ensure that Disney would be on board for the second installment, *Prince Caspian*. Adamson would once again direct, but this time it appeared to outsiders as though, empowered by the strong box office of the first *Narnia*, he would have a bit freer of a hand to do what he wanted.

Indeed, *Prince Caspian* was far edgier and darker in tone and in keeping with Adamson's stated goal of making a film that reflected how he remembered things as opposed to what was actually on the written page, it took numerous liberties with the text of the book and seemed less interested in reaching the family audience that Walden and Disney had both at least in theory attempted to please. The results were predictable and as *Prince Caspian* prepared to set sail, critics pounced, none more savagely than *San Francisco Chronicle* film critic Mick La-Salle who weighed in the day of the film's release, writing:

"It hardly seems possible. The same people who made *The Chronicles of Narnia: The Lion, the Witch and the Wardrobe* into one of the best films of 2005 have turned around and made one of this year's biggest disappointments. The second installment of C.S. Lewis' *Narnia* saga, subtitled *Prince Caspian*, is exactly one minute longer than its predecessor, but it's a dragged-out exercise, with no epic scale and no spirit worth talking about."[6]

LaSalle would also note, as others had, the problem with the children's performance and though he didn't explicitly place the blame on Adamson for missteps in directing, implied as much:

It's sad, but let's just say it: this time out, the kids are about as interesting as Chekov in a *Star Trek* sequel," LaSalle wrote. "Susan (Anna Popplewell) is sullen and unpleasant, and Peter (William Moseley), the eldest, is pompous. Edmund (Skandar Keynes) was shady last time, but he's learned his lesson, so now he's boring. And Lucy (Georgie Henley) is no longer a little girl with a cute character face, but a pretty young lady on the brink of puberty. As such, she no longer effortlessly embodies spiritually gifted innocence."[6]

Perhaps most damning, considering the religious audience that the filmmakers should have been attracting to their movie was LaSalle's noting that the film was "not a battle between absolute evil versus absolute good. Rather it's a battle between ruthless pragmatism versus ineffectual idealism.....It takes about a half hour for the bad news to sink in: *Prince Caspian* has little character interest and depicts

no earthshaking moral conflict. The Christian allegory, unmistakable in *The Lion, the Witch and the Wardrobe,* is nowhere to be found in *Prince Caspian.* Not even its former outlines are apparent. Alas, Lewis without Christianity just isn't Lewis…. the movie needed to be about an unseen but palpable force of life - it didn't even have to be denominational or identifiably Christian. But it needed some of that grandeur and ecstasy. That's the true source of epic scale. This has none, just choruses and French horns on the soundtrack telling us we should be feeling things that we're not. Very sad."[6]

The wrath of big-city film critics may have been the least of Walden and Disney's problems, however, for many of the so-called Narnia purists, devoted to ensuring that Lewis's ideas were accurately brought to the big screen, predictability howled in protest:

"In *Caspian,* they didn't understand that the story is very largely about what constitutes true chivalrous behavior," noted author Michael Ward. "All the teenage angst between Peter and Caspian was completely off-key. The overblown siege of the castle, introduced into the middle of the film, made it feel like *Lord-of-the-Rings*-lite. The director didn't seem to understand that Lewis' books have their own integrity and their own very precise internal logic, which is different from that of Tolkien's saga. *Narnia* is not simply Middle Earth for preteens. It is its own carefully constructed world—a more delicately and artistically imagined world, and therefore needs to be handled with greater sensitivity. Alas, I thought Andrew Adamson was mostly tone-deaf when it came to these two adaptations."[4]

Another critic of *Caspian* whose opinion mattered to Lewis fans was Jerry Root, a professor at Wheaton College which housed the Wade Center, a center devoted to all things C.S. Lewis. Root weighed in with a piece starkly critical of *Caspian*:

"The worst element in *Prince Caspian* was when Lucy sees Aslan for the first time on her return to Narnia. In the book she exclaims, 'Aslan, you're bigger!' Aslan responds, 'I am not. But every year you grow, you will find me bigger.' In the movie, this was seriously com-

promised to, 'Aslan, you've grown!' Aslan replies, 'Every year you grow, so shall I.' It is a horrible compromise of Lewis and really bad theology."[4]

But perhaps the most surprising of all was the reaction of Philip Anschutz himself, founder and financier of Walden who screened the film for close friends shortly before it opened.

"He was proud to be the one behind the movies and he talked about how much it meant to him to produce movies for families," noted one attendee. "But he said he wished that there had been less violence so that his all of his grandchildren could have seen it."[7]

Audiences clearly agreed with LaSalle and Anschutz's conclusions as Caspian experienced a significant dropoff in attendance and by Monday morning the picture was clear: Caspian was a serious stumble, destined to lose nearly half of the audience that came to see its predecessor.

"For the second consecutive weekend, a major Hollywood film fell short of expectations at the box office on Sunday, providing a wobbly start for the lucrative summer moviegoing season in North America," wrote *The Hollywood Reporter*'s Dean Goodman. "Walt Disney Co's *The Chronicles of Narnia: Prince Caspian*, the second film in a series based on the *Narnia* books by C.S. Lewis, opened at No. 1 with estimated three-day sales of $56.6 million, the company said. Industry analysts had expected an opening in the $80 million range, and certainly a figure above the $65.6 million start for the film's 2005 predecessor, *The Lion, The Witch and the Wardrobe*."[8]

As all film studios attempt to do when a film disappoints at the box office on opening weekend, Disney nevertheless professed to be pleased with *Caspian*'s opening:

"Disney said it was happy with the opening and that the picture had established a strong position ahead of next weekend's four-day U.S. Memorial Day holiday as well as the summer school holidays,"[8] Goodman noted.

Behind the curtain, however, Disney was deeply disappointed

by the results. Having taken much of its marketing campaign inside, Disney had relied on an in-house marketing executive with almost no experience to lead the faith-based outreach and the gamble had bombed spectacularly as religious leaders and faith-based reporters once again complained that they weren't allowed to see the film far enough in advance. A Disney executive, confident of the film's opening had even placed a bet with a skeptical colleague that the film's numbers would be strong. They weren't and with a few months he was buying lunch for his friend at the Disney commissary. Several months later the company showed its displeasure with the entire *Narnia* debacle in the most surprising of ways: it dumped the entire franchise.

"*The Chronicles of Narnia: The Voyage of the Dawn Treader* will have to sail without Disney," reported one media outlet. "The studio said Tuesday that for budgetary and logistical reasons it will not exercise its option to co-produce and co-finance the next *Narnia* movie with producer Walden Media….it is rare for a studio to pull out of a planned trilogy in midstream, but the number-crunching showed a franchise on a downward trend. *Lion* roared to $745 million worldwide. This year, *Prince Caspian* grossed just $419 million."[10]

"The latest move casts a cloud of doubt over the third *Narnia* film, which may cost around $200 million to produce. It has also drawn criticism from fans of the original book series, who blame Disney for the less-than-expected success of the second *Narnia* film, *Prince Caspian*,"[11] wrote Josh Kimball of *The Gospel Herald*.

"Disney flatly refused to have any pre-screenings of *Prince Caspian* and would not pursue any special marketing of the film to churches and other Christian markets," observed the C.S. Lewis Society of California. "In direct contrast, for the first film an extensive and highly effective marketing campaign directed by Motive Entertainment (the marketing experts from *Passion of the Christ* fame) produced an enormous response from Christian moviegoers."

The organization also blamed Adamson, who they said "refused to embrace the full story and theme of the book," thus leading to

a "weak and mangled script."[10]

For its part, Walden Media did its best to put on its game face:

"We're disappointed that Disney has decided not to go forward," said David Weil, chief executive of Walden's parent company, Anschutz Film Group, according to a report in the *Los Angeles Times*. "But we regard *Dawn Treader* as an extremely valuable property and remain committed to the franchise."[11]

Shortly after being dumped by Disney however, Walden announced a new partnership, this time with 20th Century Fox which agreed to distribute and co-finance the picture:

"One month after Disney decided to pull the plug on co-financing the third movie in Walden Media's *Chronicles of Narnia* series, Walden has found a new partner in 20th Century Fox," wrote the industry's bible *Variety*. "Fox, which was entitled to first crack at *The Chronicles of Narnia: Voyage of the Dawn Treader* after Disney dropped out because of the shared Fox Walden marketing and distribution label, has made a commitment to develop the project. The two sides are still working out budget and script issues, but the hope is to shoot the film at the end of summer for a holiday 2010 release through the Fox Walden label. Fox 2000 will spearhead development and production matters from the Fox front. Topper Elizabeth Gabler had pursued the *Narnia* franchise but was beaten out by Walden. The Century City studio seems to be an ideal fit for the *Narnia* books given that it's been looking for a family-friendly, lit-based franchise for years. Fox and Walden will split production and P&A costs for *Dawn Treader*, which is projected to go into production at a $140 million budget."[12]

The Disney-Walden partnership had always been a tense one, with Disney officials finding it exceedingly difficult to get along with certain key Walden officials. While Walden's president Micheal Flaherty was a key supporter of the relationship and easy for Disney officials to work with, Disney officials regularly complained privately about others in the Walden camp and some in the production group who

were known to make excessive demands, all of which took a toll on the overall working relationship. Free of the relationship with Disney, Walden officials now focused on the new relationship with Fox as they jointly planned work on the third in the series, *Voyage Of The Dawn Treader*.

However, it soon became obvious that a change needed to be made in the series and that change was agreed upon by all parties: *Narnia* number three needed a new director, and veteran director Michael Apted was selected to lead the project. While some saw hope in the pivot to Apted, to others, it was merely a compounding of the problem, for Apted had proudly led the charge as head of the Directors Guild in crushing traditionalist groups who had, out of a sense of sheer desperation, invented devices that allowed red-state films fans to clean up their favorite movies. He further cemented his status as being out of touch with the types of fans who made up *Narnia's* base when he seemed to brag to reporters about gutting the biopic of the devoutly religious British lawmaker William Wilberforce, *Amazing Grace*, of its religion:

"Then this script arrived, which was pretty much a straight biopic of Wilberforce – which probably veered more into his Christian side than it did the political side," he had once told a reporter. "So I thought if I could persuade them to put the politics right more in the front of it – to make that the engine of the story, and certainly deal with his belief system and his religion and all that – then this might be something that would really be good for me to do it. So I did manage to persuade that, on all sorts of levels because I said it makes the character more interesting, because his political skills and political achievements are enormous, and we would move away from the idea of kind of making him an artifact, a kind of saint-like figure; it would give him real personality, real dimension."[13]

Apted perfectly captured the attitude of many in Hollywood who sought to strip religion away from stories with strong religious characters, in some sort of misguided attempt to, in their own minds perhaps, make the story understandable to a contemporary audience.

But his previous comments and a general disappointment with *Caspian* in particular had begun to cause waves of discontent among some fans. *Washington Times* reporter Julia Duin was the first to spot the trend when in late 2009 she wrote a piece entitled "*Narnia* Drifts From Its Vision," warning filmmakers of troubled waters ahead:

"A year from now, *The Voyage of the Dawn Treader* will be released in a theater near you," Duin wrote. "The filming for the third *Chronicles of Narnia* movie just wrapped up near Brisbane, Australia. *Voyage,* one of theologian C.S. Lewis' more entertaining tales about the adventures of a group of British children on a planet ruled by the god-like lion Aslan, was to be released in May 2009. Then, Walt Disney Pictures dumped the film in December 2008 and 20th Century Fox filled in as co-financier. The release date was moved back to May 2010, then to next December. Considering some of the weird remarks uttered by directors and producers of the first two films: *The Lion, the Witch and the Wardrobe* in 2005 and *Prince Caspian* in 2008, one wonders whether the will and determination exist to finish the seven-part *Narnia* series. Considering that *Chronicles* sold 100 million copies in 30 languages since their publication in the 1950s, there is a huge fan base for these epic tales. *The Lion, the Witch* grossed $745 million worldwide but *Prince Caspian,* which veered substantially from the plot and downplayed the film's Christian message, grossed $420 million."[14]

Duin then noted a recent interview given by Gresham in which he appeared to be showing signs of exhaustion with the battle he had had to wage to keep the films true to his father's legacy:

"*The Lion, The Witch and The Wardrobe* was very close to the original book because the book was written in such a way that lent itself to being transcribed into the film medium," Duin quoted Gresham as having told an interviewer. "*Prince Caspian* we had to make some fairly major changes because the book isn't written that way. In this movie there are a lot of differences in it also to, as Hollywood says, 'derive the plot.' I'm ambivalent as to whether they're necessary or not, I don't really think so. But that's the way they wanted to do it, and it was either

that or not make a movie, so I said 'well go ahead and do it.' It will be very interesting to see the audiences reactions...I think the story in the book is better but it's still a great story."[14]

While in the same interview Gresham would also add "It's a fabulous movie," Duin and others would note Gresham's concerns at appearing to have been forced into a Hobson's Choice of either accepting certain changes or simply not proceeding with the rest of the series. Duin also tracked down more offensive comments by Apted, this time directed at the heart of *Narnia*, quoting the director as saying that the *Narnia* films "present a challenge, for me to put the material out there in an evenhanded and interesting way; and not to be, in a sense, narrow-minded about it, either narrow-minded in a faith way or narrow-minded in an agnostic way. I have to open my heart to what the stories are about."[14]

"Narrow-minded in a faith way? That's going to rev up Christians to see this movie,"[12] Duin wryly noted.

The Times also raised the issue of one of the film's executive directors, Perry Moore, described by the paper as a "gay activist" who had written a book in 2007 about the world's first gay teen superhero. As criticism of the choice of Apted mounted, fellow filmmakers came to his defense and one, producer Mark Johnson, stunningly though undoubtedly inadvertently, acknowledged that Apted may have indeed been a poor choice when he defended the selection by saying:

"My experience in movies—whether it's about theological, political, racial, or national concerns—is that often you get the most original perspective and the most faithful embracing of themes through somebody who on paper probably isn't the right person. I've worked with directors who at first glance are perhaps not the right person for the material, and they end up revealing the material in a way that somebody who would've been more likely could not. Michael Apted absolutely delivered, and I believe was able to very faithfully translate the book into film."[4]

Acknowledging that Apted may not have been a good choice

for Narnia "on paper" was a stunner considering his experience as a respected film director, but Johnson was joined in defending the Apted selection by Walden's Flaherty who was often called upon to defend decisions that were made without him.

"Can an agnostic director get the deeper meanings of the book? The answer is yes, because this agnostic did. Our interest was always to find the best director, and without a doubt, Michael Apted was the best director for this,"[4] Flaherty said.

Perhaps the most sensible voice on the matter belonged to Michael Ward, author of *Planet Narnia: the Seven Heavens in the Imagination of C. S. Lewis* who seemed open to the idea of Apted directing yet warned that it would only succeed if Apted himself had resolved to be faithful to the work and set aside his own prejudices:

"I think an agnostic or for that matter an atheist could do a good job adapting the book, since the requirements are literary sensitivity, sympathetic imagination, and aesthetic judgment, not commitment to Christ," wrote Ward. "The vital thing is that he immerses himself in the book, and maybe even some of the better literary criticism about the book, and resolves to be faithful to its spirit."[4]

"Ted Baehr, publisher of *Movieguide* and president of the Christian Film and TV Commission, read one of the earlier scripts for *The Lion, the Witch* and told me the movie would have veered in a bizarre direction had then-Disney President Dick Cook not 'held the line,' noted Duin. "As for *Voyage*, Mr. Baehr is in touch with a script adviser who left the project a year ago. 'He said it was drifting from its Christian vision,' Mr. Baehr said. 'It was not expressing the intent of C.S. Lewis nor the true story of the Dawn Treader.'"[14]

"The makers of the *Narnia* movies can't afford any more 'drift' if they wish to keep their religious fan base happy," Duin noted, "There's plenty of evangelical Christian filmmakers and producers out there. Why couldn't Disney and now Fox hire them?"[14]

It was one of many questions that would haunt the series as it geared up for the third and, if box office results disappointed, perhaps

final theatrical release of a *Narnia* film since officials at Walden had long said publicly that they would keep making *Narnia* films only until the public said it was time to stop by showing a lack of interest at the box office.

Obviously sensing that the franchise was in trouble, in early 2010 Walden invited a group of religious leaders to enjoy a game at the Anschutz-owned Staples Center, see clips of the film and meet some of the filmmakers. Word of the meeting was leaked to reporter Mark Moring of *Christianity Today* who noted that Walden executives had invited "100 Christian leaders to a 'Narnia Summit' held Feb. 16-18 in Los Angeles, where they showed clips from *Dawn Treader* and went through the entire script. Apted was flown in from London to join producers Johnson, Micheal Flaherty, and Douglas Gresham for the presentation to an audience of Narnia fans—potentially their biggest critics. Invitees included representatives from big churches (including Tim Keller of New York's Redeemer Presbyterian and Mark Brewer of Bel Air Presbyterian), parachurch organizations (like Young Life, Focus on the Family, and Youth for Christ), publishing companies (Relevant and Group among them), Lewis experts (like Stan Mattson of the C. S. Lewis Foundation), and online fan sites (*NarniaWeb, Narnia Fans*). 'You could call it the world's largest accountability group, so we were definitely nervous,' said Flaherty, president of Walden Media. 'We had folks with an encyclopedic knowledge of C. S. Lewis and the Narnia books. But we went through every line of dialogue and every scene with them to make sure it was a really faithful adaptation.'"[4]

Flaherty had long been a champion of Narnia and was committed to doing everything he could to ensure that the films were faithful to Lewis's vision. But ensconced in his offices in Boston, 3,000 miles away from Hollywood, his powers were limited, and he spent more and more time on the company's publishing division. Still, many in the private viewing audience were suitably impressed by what they saw that day:

"The verdict? Decidedly thumbs up, according to those at-

tendees we spoke with," noted *Christianity Today*. "What we saw on film, and some of the behind-the-scenes stuff, was pretty exciting," said Steve Bell, executive vice president of the Willow Creek Association, who attended with wife Valerie. "It looks very compelling, a nice treatment. There seems to be a high level of respect for the material. My sense was that they really want to go to the authenticity of C. S. Lewis, maybe more so than ever. They're very aware that they have to turn the corner from *Prince Caspian*. They know that the ball got dropped, and they're trying to recapture that momentum."[4]

"They're clearly making an effort to say that they respect and understand the spiritual focus of the book in a way that perhaps [*Prince Caspian*] did not," added author Philip Yancey, who attended with wife Janet. "They don't seem to be cutting any corners; they're throwing the whole ball of wax at this, and that's a good thing. If they can capture the universal love for these books, it'll be great."[4]

"Kathy Keller, wife of Redeemer Presbyterian senior pastor Tim, arguably has the most personal ties to Narnia of the invitees: She corresponded with Lewis in her young teens (four of his replies are printed in *C. S. Lewis' Letters to Children*), became a Christian solely as a result of reading Lewis, wrote her college thesis on "C. S. Lewis' Mythopoetic Understanding of Literature," and today regards the author "as my personal mentor, my touchstone for clear and effective writing, and my private possession,"[4] noted *Christianity Today's* Moring.

CT also quoted Keller's husband Tim, one of the most prominent Christian pastors in the U.S. as satisfied that the filmmakers had gotten things right the third time around:

"Keller is most concerned 'that they get Aslan right,' in *Dawn Treader*, and says she was mostly satisfied with what she saw and heard," the journal noted. "I'm glad the final interaction between Aslan and Lucy was there in its unadulterated entirety, because I consider that the pinnacle of the entire seven books."[4]

But a scant six weeks before the film's scheduled release on December 10th, 2010, *Dawn Treader* once again hit rough seas when

the film's controversial director Michael Apted, just as he had with the film *Amazing Grace*, made more controversial comments that elicited howls from *Narnia* fans. Speaking to the British publication *SFX*, Apted incredibly suggested that he had based part of the film on material that Lewis *hadn't* written.

"We were able to steal, really, from the book C. S. Lewis didn't write, which is one that would have gone between *The Dawn Treader* and *The Silver Chair*," said Apted. "He starts *The Silver Chair* with the witches building an up an army underground to attack the above world, and *Caspian*, having married The Blue Star of is an old man with a son, and he married the Blue Star of Ramandu. In other words, a lot of things had happened between the books. So there were elements that we were able to draw out of the non-existent story and inject into this story to give it a bit more sense of purpose. And the C. S. Lewis estate didn't seem to mind that, because there is a big hole in the story if you're going to be literal about it. Whereas *Star Wars* and *Harry Potter* are a bit more attentive to that flowing stream of franchise narrative, Mr. Lewis wasn't so keen on it. But it enabled us to find a stronger reason for the journey, since there is no real reason for the journey as it stands."[15]

The response to Apted's comments was swift and mostly negative, represented well by E. Stephen Burnett of Speculativefaith.com:

"To be sure, many *Chronicles of Narnia*...fans have been disturbed by this line," he wrote. "We have had such faith in Apted, who might have supervised a film that is based on a better book and echoed its themes. Yet *Narnia* fans were already bothered about the film trailers clearly showing some cliched modern-sounding dialogue (a plague infesting the first films, especially *Prince Caspian*) the White Witch, and more. And now this. As a friend of mine quipped: 'The book C.S. Lewis never wrote? Last I checked, there's a term for that: fanfiction.'"[16]

On November 10th, the backlash reached a fever pitch when an interview given by *Narnia* producer Mark Johnson to an independent *Narnia* fan-site, *Aslancountry.com*, was taken down just twelve hours after it was posted. In it, the producer was asked: "A quote by

Michael Apted has baffled fans; are you essentially writing a new *Narnia* book?"[17]

Hours later the text of the interview had been replaced with these words from the interviewer: "I've been asked to take the interview down until further notice."[17]

December, the release date of *The Voyage Of The Dawn Treader*, was just around the corner, and soon enough the American moviegoer would render a verdict that would likely decide the fate of C.S. Lewis's beloved *Narnia* series. The man who had brought it to the big screen, Philip Anschutz, had succeeded at nearly everything he had attempted in life, amassing a multi-billion dollar fortune and buying and selling profitable ventures. He had not lost his shirt in Hollywood as many had predicted and he had made important contributions to the culture of Tinseltown with an impressive array of both A and B-list movies which promoted the kind of positive values that he had intended to. In attempting to faithfully bring the *Narnia* stories to life in partnership with Lewis's stepson Douglas Gresham, Anschutz had encountered a world which was difficult to control and he was often forced to trust people who appeared to be competent at their craft but were sometimes in opposition to the material they were charged with creating. In Hollywood, he would encounter a culture fraught with difficulty and sabotage. Yet in spite of such challenges, he had, through the sheer power of his will and with the help of his vast resources, managed to do what no one else had been able to do in half a century: credibly bring the *Narnia* stories to life.

And if Lewis's vision of the afterlife were the correct one, somewhere, Anschutz, Gresham and the others who shared his worldview were likely being cheered on by Lewis, even as he looked askance at others, as his stories continued their often difficult voyage to the big screen and went around the world, influencing a generation of world citizens and imparting important moral lessons.

Bibliography

Chapter 1

1. Russell, James. Narnia as a Site of National Struggle: Marketing, Christianity, and National Purpose in The Chronicles of Narnia: The Lion, the Witch and the Wardrobe. Cinema Journal - 48, Number 4, Summer 2009, pp. 59-76

2. "Walden Media hires Ann Peacock to adapt 'The Lion, The Witch and The Wardrobe'" December 2005 http://www.prnewswire.co.uk/cgi/news/release?id=88699

3. Ross, Matthew M. Charles Lyons. "C.S. Lewis' "Narnia" Series Headed to Big Screen." December 2001, (Variety), http://www.variety.com

4. Anschutz, Philip F. "Whatever Happened to the Family Film?" 24 February, 2004, (Hillside National Leadership Seminar in Naples, Florida).

5. Chattaway, Peter T. "Ella Enchanted (Review)," April 2004, (Christianity Today), http://www.christianitytoday.com

6. Beardsley, John. "Frequently Asked Questions About C.S. Lewis". http://rapidnet.com/~jbeard/bdm/exposes/lewis/cs-lewis.htm

7. Harlow, John. "The Lion, the Witch and the Weirdo," 3 December, 1995, (The London Times).

8. Douglass, Jane. "An Enduring Friendship," C.S. Lewis at the Breakfast Table (1979).

9. Lewis, C.S. The Collected Letters Of C.S. Lewis, Harper One, 2004

10. NarniaWeb, "Interview with 'Narnia' Director Andrew Adam-

son," July 2002, http://www.Narniaweb.com

11. Lecture at Torrey Honors Institute, Biola University.

12. Darden, Kathryn and Doug Gresham. In The Lion's Mouth, Christian Activities, 11/6/2005

13. Coffin, Andrew. "Winter Wardrobe," February 2005, (World Magazine). http://www.worldmag.com

Chapter 2

1. Southern Baptist Convention. "Southern Baptists Convention's "Disney" Resolution". June 12, 1996 sbc.net/resolutions/amResolution.asp?ID=45

2. The Southern Baptist Convention, "Ethics and Religious Liberty Commission," June 2001, http://www.religioustolerance.org

3. Willoughby, Karen L. "Dobson decries moral decay in challenge to Southern Baptists," 12 June, 1998, (Baptist Press), http://www.bpnews.net

4. Pinsky, Mark. "Disney ventures into religious markets with 'Chronicles of Narnia'," 30 March, 2005, (The Arizona Republic) http://www.azcentral.com

5. Eisner, Michael. 60 Minutes Interview, 19 November, 1997, http://www.religioustolerance.org

6. AFA Online, "AFA ends Disney boycoctt," 2006, http://afa.net

7. Hastings, Dwayne. "AFA ends Disney boycott it launched in mid-1990s," 24 May, 2005, (Baptist Press), http://www.bpnews.net

8. The Advocate, "Antigay group ends longstanding Disney boycott," 25 May 2005, http://www.advocate.com

9. Walden Media, "The Walt Disney Studioes Enter into Agreement with Walden Media to Produce 'The Chronicles of Narnia: The Lion, the Witch and the Wardrobe," 1 March, 2004, http://www.walden.com

10. Grossberg, Josh. "Disney Doing 'Narnia'," 2 March, 2004, (Walden Media), http://www.walden.com

11. Martin, Paul. "Michael Flaherty Interviewed by CCM," 15 April, 2005, (CCM Magazine Narnia Web), http://www.Narniafans.com

Chapter 3

1. NarniaWeb, "Interview with 'Narnia' Director Andrew Adamson," July 2002, http://www.Narniaweb.com

2. Narnia Memo, 2003.

3. Horn, John. "Will this 'Lion' roar?" 6 November, 2005, (Los Angeles Times), http://www.latimes.com

4. Brady, Erik. "A closer look at the world of 'Narnia,'" 1 December, 2005, (USA Today), http://www.usatoday.com

5. Easterbrook, Gregg. "In Defense of C.S. Lewis," October 2001, (Atlantic Monthly), http://www.theatlantic.com

6. NarniaWeb, "NarniaWeb Exclusive Interview with Douglas Gresham," 13 April, 2005, http://www.Narniaweb.com

7. NarniaWeb, "Michael Flaherty Interviewed by 'CCM'," 15 April, 2005, http://www.Narniaweb.com

8. Newstalk ZB:Auckland 89.4, http://www.newstalkzb.co.nz

9. The New Zealand Herald, "Director Andrew Adamson talks 'The Chronicles of Narnia: The Lion, the Witch and The Wardrobe'," 15 June, 2004, http://www.nzherald.co.nz

10. Hart, Steven. "The real fellowship of the ring," 3 December, 2003, (Salon), http://www.salon.com

Chapter 4

1. Lindentree: C.S. Lewis, "C.S. Lewis (to Kathryn Lindskoog), "29 October, 1957, http://www.lindentree.org

2. Carvajal, Doreen. "Marketing 'Narnia' Without A Christian Lion',"3 June, 2001, (The New York Times), http://

www.nytimes.com

3. Olsen, Ted. "Grief Observed Over Abolition of Lewis's Mere Christianity,' 1 June, 2001, (Christianity Today), http://www.christianitytoday.com

4. Olasky, Marvin. "Off with his head," 16 June, 2001, (World Magazine), http://www.worldmag.com

5. Mere Lewis Email list, http://listserv.aol.com/archives/merelewis.html

Chapter 5

1. The Australian Associated Press. March 5, 2004

2. NewstalkZB:Auckland 89.4, http://www.newstalkzb.co.nz

3. Davidson, Paul. "Narnia Actors Speak," 29 July, 2004. http://www.ign.com

4. Sev, Indiana. "Interview: Tilda Swinton" Jan, 2005, Joblo.com

5. Martin, Paul. "Tilda Swinton Interview". New Straits Times. May 2005.

6. NarniaWeb, "From Tennis to Tumnus: McAvoy Talks Narnia," 10 October, 2004, http://www.Narniaweb.com

7. Davidson, Paul. "Aslan Finds His Voice," 9 December, 2004, (IGN), http://www.ign.com

8. Martin, Paul. "Another BIOLA Media Conference Report," 25 April, 2005, http://www.Narniafans.com

9. NarniaWeb, "Brian Cox No Longer Aslan" 23 April, 2005, http://www.Narniaweb.com

10. Wloszczyna, Susan. "'Narnia' nearly ready despite vocal debate,'" May 2005, (USA Today), http://www.usatoday.com

Chapter 6

1. Alberge, Dalya. "Middle Earth triumph leads film-makers towards the magical world in a wardrobe," 13 May, 2004, The Times (London).

2. NarniaWeb, "Andrew Adamson Interview," 4 March, 2005, http://www.narniweb.com

3. NarniaWeb, "Interview with Narnia Director Andrew Adamson," 31 July, 2002, http://www.Narniaweb.com

4. Baillie, Russel. "Adamson Interview," 15 June, 2004, (NarniaWeb), http://www.Narniaweb.com

5. The New Zealand Herald, "Director Andrew Adamson talks The Chronicles of Narnia: The Lion, The Witch and The Wardrobe," 15 June, 2004.

6. Cooney, Joyceann. "The Chronicles of Narnia: There are 1,000 tales to tell in the land of Narnia. One is about to be told," 1 June, 2004, (License magazine), http://www.licensemag.com

7. Overstreet, Jeffrey. "Film Forum: Commanders, Cartoons, and Columbine," 20 November, 2003, (Christianity Today), http://www.christianitytoday.com/movies

8. Otto, Jeff. "Narnia at New Zealand's Pulp Expo!," 30 September, 2004, (IGN), http://www.ign.com

Chapter 7

1. Shumway, Suzanne Rosenthal. "Reading LEwis From A Christian Christian Perspective."

2. Kish, Cassandra. "Narnia Revisited," March 2003, (Ashbrook Center), http://www.ashbrook.org

3. C.S. Lewis, Letters (p. 167).

4. Bane, Mark. "Myth Made Truth: The Origin of The Chronicles of Narnia."

5. Dager, Albert James. "C.S. Lewis: The Man and His Myths," http://www.professionalserve.com

6. Lewis, C.S. Mere Christianity (p. xv)

7. Mueller, Steven P. "Beyond Mere Christianity: an assessment of C.S. Lewis," http://www.inplainsite.org

8. Noll, Mark A. "C.S. Lewis's 'Mere Christianity' (the Book and

the Ideal) at the Start of the Twenty-first Century," Seven 19 (2002): 36-37.

9. Lewis, C.S. "Reflections on the Psalms." (New York: Harcourt Brace Jovanovich, 1958), 172.

10. Lewis, C.S. Letters of C.S. Lewis, 287.

11. Lewis, C.S. The Great Divorce, 39.

12. Lewis, C.S. Mere Christianity,172.

13. Lewis, W.H. Letters of C.S. Lewis, 307.

14. Lewis, C.S. The Last Battle, 165.

15. Lewis, C.S. Mere Christianity, 176-77.

16. Lewis, C.S. The Great Divorce, 72.

17. Cloud, David. "C.S. Lewis And Evangelicals Today."

18. Kennedy, John W. "Southern Baptists Take Up the Mormon Challenge," 15 June, 1998, (Christianity Today), http://www.christianitytoday.com

19. Lewis, C.S. "Reflections on the Psalms." (New York: Harcourt Brace Jovanovich, 1958), 110.

20. Lewis, C.S. The Great Divorce, 65.

21. Wirt, Sherwood E. "An interview with C.S. Lewis (1963)."

Chapter 8

1. Martin, Paul. "'The Chronicles of Narnia: The Lion, The Witch and The Wardrobe' Begins Filming; Shrek's Andrew Adamson Directs Beloved C.S. Lewis Book In His Native New Zealand," August 2004, http://www.Narniafans.com/?id=88

2. Linder, Brian. IGN Exclusive: The Portal to Narnia. "The first in a series of set reports from The Lion, the Witch and the Wardrobe," August 2004, http://filmforce.ign.com/Narnia/articles/535/535423p1.html?fromint=1

3. Narniaweb.com, "Andrew Adamson and Crew Welcomed to NZ," April 6, 2004, Contributing sources: One News, TVNZ.co.nz, http://www.Narniaweb.com/news.

asp?id=28&dl=299180

4. Tirian, "NarniaWeb Exclusive Interview with Douglas Gresham," April 2005, http://www.Narniaweb.com/news. asp?id=239&dl=2553715

5. Newstalk ZB, "Mark Johnson's Radio Interview," April 7, 2004, http://www.Narniaweb.com/news.asp?id=30

6. IGN FilmForce, IGN Exclusive Narnia Report #2: Mr. Tumnus' House. "... how would it be if you came and had tea with me?" October 2004, http://movies.ign.com/articles/554/554117p1. html

7. Martin, Paul. "Evanescence's Amy Lee Doing 'Narnia' Music" November 2004, http://www.Narniafans.com/archives/117

8. "Movie Benefits From Environmental Double Standard" November, 2004. http://www.scoop.co.nz/stories/PO0411/ S00070.htm

9. Martin, Paul. "JoBlo Interviews Tilda Swinton, Publicist Ernie Malik" January 2005, http://www.Narniafans.com/page/198

10. Sev, Indiana. "Joblo.com visits the set of The Chronicles of Narnia: The Lion, The Witch, and The Wardrobe" Part 1, December 2004, http://www.joblo.com/index.php?id=5940

11. Sev, Indiana. "Joblo.com visits the set of The Chronicles of Narnia: The Lion, The Witch, and The Wardrobe" Part 2, December 2004, http://www.joblo.com/index.php?id=2941

12. Bucher, Glen. "A Visit to The Chronicles of Narnia Set!" December 2004, http://www.comingsoon.net/news.php?id=7420

13. Tehanu, "Narnia Set Report 2: Gloomy Halls and Golden Pillars," January 2005, http://archives.theonering.net/perl/news-view/18/1106403902

Chapter 9

1. Lobdell, William. (2001, November 24)" A Shepherd of Movies Into the Religious Flock" Los Angeles Times.

2. Martin. Paul. "Christian Allegory In The Lion, the Witch, and the Wardrobe." March, 2005. http://www.narniafans.com/archives/202

3. Coffin, Andrew. "Winter Wardrobe," World Magazine (Feb. 12, 2005, VOL. 20, No. 6), http://www.worldmag.com/articles/10307

4. Tirian, "Narnia Trailer Rundown," April 23, 2005, http://www.Narniaweb.com/news.asp?id=248&dl=2649880

5. Kehr, David. "Disney's Next Hero: A Lion King of Kings," February 2005, The New York Times, http://www.nytimes.com/2005/02/20/movies/20kehr.html

6. Pinsky, Mark I. "Disney markets 'Chronicles of Narnia' to evangelicals," Orlando Sentinel, March 2005, http://www.gazettetimes.com/articles/2005/03/26/news/religion/satrel04.txt

7. Wloszczyna, Susan. "The Wonderful World of 'Narnia,'" May 2005, USA TODAY, http://www.usatoday.com/life/movies/news/2005-05-02-Narnia_x.htm

8. Tirian, "NarniaWeb Exclusive Interview with Douglas Gresham," April 2005, http://www.Narniaweb.com/news.asp?id=239&dl=2553715

9. Kjos, Berit. "Disney's Pocahontas," http://www.crossroad.to/text/articles/Pocahontas.html

10. Martin, Paul. "Another Biola Media Conference" April, 2005. http://www.narniafans.com/archives/tag/the-professor

11. Chattaway, Peter T. "Disney wants Christians to work for free", June 8, 2005, http://filmchatblog.blogspot.com/2005_06_01_archive.html

12. Martin, Paul. "Help Promote Narnia In the US" June, 2005. http://www.narniafans.com/archives/280

13. Associated Press "Batman Begins Tops Box Office For 2nd Weekend." http://www.ctv.ca/ctvnews/entertainment/20050626/batmanbegins_boxoffice_050626

14. Schauffhauser, Diana. "Clarion Announces NEw Release of Development Language" http://www.accessmylibrary.com/comst/summary_0286-9245177_itm

15. CE Staff Reporter, "Barna survey shows 'Passion' had little evangelistic effect. Numbers higher for personal behavioral changes", November 2004, The Christian Examiner, http://www.christianexaminer.com/Articles/Articles%20Nov04/Art_Nov04_08.html

Chapter 10

1. Cooney, Joyceann. "The Chronicles of Narnia. There are 1,000 tales to tell in the land of Narnia. One is about to be told." June 1, 2004, License! USA, http://www.licensemag.com/licensemag/article/articleDetail.jsp?id=98090&pageID=1&sk=&date= Look at the link... licensing fees need to be paid to republish this in book!

2. Adrian, "Hasbro: UK TOYFAIR: Chronicles of Narnia." January 27, 2005, action-figure.com, http://www.action-figure.com/modules.php?op=modload&name=News&file=article&sid=13779&mode=thread&order=0&thold=0

3. Disney Interactive (April 28, 2006) "Disney Interactive Reveals New Details on The Chronicles of Narnia Video Games". Press Release. http://www.ttgames.com/node/23

4. Ahearn, Nate. "The Chronicles of Narnia Preview (Xbox)", June 6, 2005, http://previews.teamxbox.com/xbox/1059/The-Chronicles-of-Narnia-The-Lion-The-Witch-and-The-Wardrobe/p1/

5. Martin, Paul. "HC Puts Big Money Behind The Chronicles of Narnia", March 15, 2007, Contributing sources: The Book Standard, http://www.Narniafans.com/?id=200

6. Tirian, "Narnia Marketing Partners," May 18, 2005, http://www.Narniaweb.com/news.asp?id=273

7. Martin, Paul. "Operator gets Narnia tour deal", June 14, 2005, Contributing sources: Stuff.co.nz, http://www.Narniafans. com/?id=281

8. Jeckell, Bary A. "Disney, EMI Plan Multiple 'Narnia' Soundtracks", May 23, 2005, Billboard, http://www.bill-board.com/bbcom/news/article_display.jsp?vnu_content_id=1000930160

9. Overstreet, Jeffrey. "The Lion, the Witch, and the Musical Merchandising", May 25, 2005, Lookingcloser.org, http://lookingcloser.wordpress.com/2005/05/25/the-lion-the-witch-and-the-musical-merchandising/

Chapter 11

1. Nicolosi, Barbara. "Narnia: Deep Magic", October 8, 2005, Source: Church of the Masses, http://churchofthemasses. blogspot.com/2005/10/Narnia-deep-magic.html

2. Nicolosi, Barbara. "Disney Re-Discovering It's Soul… OR… Greed Makes People Funny", October 10, 2005, Source: Church of the Masses, http://churchofthemasses.blogspot. com/2005_10_01_archive.html

Chapter 12

1. Holding, Rob. (Host). (2005, March 4). Interview with Andrew Adamson. [Radio broadcast]. Auckland, NZ: Radio Rhema. http://www.Narniaweb.com/news.asp?id=208&dl=2222480

2. Tirian, "NarniaWeb Exclusive Interview with Douglas Gresham," April 2005, http://www.Narniaweb.com/news. asp?id=239&dl=2553715

3. Moring, Mark. "The Weight of Story" May 2008. http://www. christianitytoday.com/

4. Moring, Mark. "Will the Dawn Treader Float?" March 2010.

http://www.christianitytoday.com/

5. Clark, Cindy. "Young Stars Of 'Narnia' Stake A Claim On Summer Landscape" USA Today. May 2008. www.usatoday.com/life/movies/news/2008-05-13-prince-caspian_n.htm

6. LaSalle, Michael. "Movie Review: 'Narnia' Sequel Lacks Magic" SFGate.com. May 2008. http://articles.sfgate.com/2008-05-15/entertainment/17152719_1_prince-caspian-georgie-henley-anna-popplewell

7. Notes from Private Executive Memo. 2003.

8. Goodman, Dean. "New Narnia Film Falls Short at Box Office." May 2008. http://www.reuters.com/articles/idUSN1848808720080518?sp=true

9. Kit, Borys. "Disney Jumps Ship on next 'Narnia'". http://www.reuters.com/article/idUSTRE4BNOM520081224

10. Kimball, Josh. "3rd 'Narnia' Film to Set Sail Without Disney". January 2009. www.gospelherald.net/article_print.html?id=44956meat=entertainment

11. Eller, Claudia. "Disney Voyages Out Of 'Narnia'". December 2008. http://articles.latimes.com/2008/dec/25/business/fi=narnia25

12. Roush, George. "Fox Picks Up Chronicles "Voyage of the Dawn Treador" January 2009. latinoreview.com/news/fox-picks-up-chronicles-voyage-of-the-dawn-treador-6068

13. Monroe, Chris. "An Interview with 'Amazing Grace' Director Michel Apted". 2007. http://www.christiananswers.net/spotlight/movies/2007/amazinggrace2007-interview.html

14. Duin, Julia. "Narnia Drifts From Its Vision". December 2009. http://www.washingtontimes.com/news/2009/dec/31/narnia-drifts-from-its-vision/

15. DGolder. "The Voyage Of The Dawn Treader Film Uses Material From the Book CS Lewis Didn't Write". October 2010. http://www.sfx.co.uk/2010/10/20/the-voyage-of-the-dawn-treader-film-uses-material-from-the-book-cs-lewis-didn't-

write/

16. Burnett, E. Stephen. "The book C.S. Lewis didn't write?" October 2010. http://www.speculativefaith.com/2010/10/the-book-c-s-lewis-didnt-write/

17. Cyclops. "Exclusive: Interview With Mark Johnson!" November 2010. http://www.aslanscountry.com/2010/11/exclusive-interview-with-mark-johnson/